exploring

ILLUSTRATOR CS

MONTGOMERY COLLEGE ROCKVILLE CAMPUS LIBRARY ROCKVILLE, MARYLAND

exploring

ILLUSTRATOR CS

Annesa Hartman

APR 1 2 2005

Exploring Illustrator CS Annesa Hartman

Vice President, Technology and Trades SBU:

Editorial Director: Sandy Clark

Acquisitions Editor: Iames Gish

Development Editor: Iaimie Wetzel

Marketing Director:

Cyndi Eichelman

COPYRIGHT © 2004 by Delmar Learning, a division of Thomson Learning, Inc. Thomson Learning™ is a trademark used herein under license.

Printed in Canada 2 3 4 5 XXX 06 05 04

For more information contact Delmar Learning Executive Woods 5 Maxwell Drive, PO Box 8007, Clifton Park, NY 12065-8007 Or find us on the World Wide Web at www.delmarlearning.com Channel Manager: William Lawrensen

Marketing Coordinator: Mark Pierro

Production Director:

Mary Ellen Black

Production Manager:

Larry Main

Production Editor:

ALL RIGHTS RESERVED. No part of this work covered by the copyright hereon may be reproduced in any form or by any means—graphic, electronic, or mechanical, including photocopying, recording, taping, Web distribution, or information storage and retrieval systems—without the written permission of the publisher.

For permission to use material from the text or product, contact us by
Tel. (800) 730-2214
Fax (800) 730-2215

Fax (800) 730-2215 www.thomsonrights.com Art/Design Specialist:

Rachel Baker

Technology Project Manager:

Kevin Smith

Editorial Assistant:

Marissa Maiella

Series Cover Design: Stephen Brower

Cover Image:

Outside the Box, Oil on Canvas © David Arsenault

Library of Congress Cataloging-in-Publication Data

Hartman, Annesa, 1968– Exploring Illustrator CS/Annesa Hartman. p. cm. ISBN 1-4018-4362-X 1. Computer graphics. 2. Adobe Illustrator (Computer file) 1. Title. T385.H3473 2003 006.6'86—dc22 2003024642

NOTICE TO THE READER

Publisher does not warrant or guarantee any of the products described herein or perform any independent analysis in connection with any of the product information contained herein. Publisher does not assume, and expressly disclaims, any obligation to obtain and include information other than that provided to it by the manufacturer.

The reader is expressly warned to consider and adopt all safety precautions that might be indicated by the activities herein and to avoid all potential hazards. By following the instructions contained herein, the reader willingly assumes all risks in connection with such instructions.

The publisher makes no representation or warranties of any kind, including but not limited to, the warranties of fitness for particular purpose or merchantability, nor are any such representations implied with respect to the material set forth herein, and the publisher takes no responsibility with respect to such material. The publisher shall not be liable for any special, consequential, or exemplary damages resulting, in whole or part, from the readers' use of, or reliance upon, this material.

FOR MY FATHER, TERRY, THE MOST INSPIRING TEACHER I KNOW

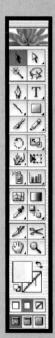

contents

contents

	Preface	X
1	A Discovery Tour Jumping In 4 About Illustrator 20 Summary 21	2
2	The Lay of the Land Historical Landmarks 26 A Closer Look 37 Summary 42	24
3	Survival Techniques It's More Than Cool Tools 46 Characteristics of Bitmaps and Vectors 46 Design Principles with Illustrator 51 Summary 63	44
4	Drawing Lines and Shapes The Simplicity of Lines and Shapes 68 Geometric, Freeform, and Precision Drawing 70 Summary 98	66
5	Using Color Seeing Is Not Necessarily Believing 102 Choosing a Color Model 103 Getting in the Mode 107 Applying Color 108 Color in Design 125 Summary 126	100
	ADVENTURES IN DESIGN: THE MOODS OF COLOR 130	

6	Value and Texture Implying Surface 136 Stroke and Fill Attributes 137 Summary 171	134
7	Working with Type Creating Type in Illustrator 176 Formatting Type 185 The Story of Fonts 187 Designing with Type 205 Summary 211	174
8	Object Composition Combining Paths and Shapes 216 About Composition 235 Summary 259	214
	ADVENTURES IN DESIGN: MAKING A WINE LABEL	262
9	Spatial Illusions Making Space 268	266
	Summary 294	
10	Print Publishing A Friendly Conversion 298 Getting into Details 301 About the Print Dialog Box 306 Summary 311	296
10 11	Print Publishing A Friendly Conversion 298 Getting into Details 301 About the Print Dialog Box 306	296 314
	Print Publishing A Friendly Conversion 298 Getting into Details 301 About the Print Dialog Box 306 Summary 311 Web Publishing Optimization 316 Image Slicing 333	

preface

preface

INTENDED AUDIENCE

You are here. Destination, Adobe Illustrator. Your guide, this book. *Exploring Illustrator CS*, like other books in the Delmar Learning Design Exploration series, takes an inventive approach to the introductory study and application of popular computer graphic software programs.

A new student to digital illustration, a computer graphics or arts educator, or a professional graphic artist looking for fresh ways to use Adobe Illustrator will find this book's content relevant, straightforward, and engagingly accessible. It speaks clearly to the artist in all of us, approaching what could be complex design concepts practically, visually, and in the context of the many tools, effects, and workflow features currently available for both print and web artwork creation in Adobe Illustrator CS.

BACKGROUND OF THIS TEXT

Pablo Picasso once exclaimed, "Computers are useless. They can only give you answers." True, perhaps. However, accompanied by the right questions, such answers can bring an enlightened perspective to mundane tasks, complicated procedures, and traditional methods of creative endeavor. The intention of this book is to:

- explore the questions that face today's illustrator artist and provide some educated answers through the use of Adobe Illustrator's digital tools and features;
- offer process-oriented lessons developed from actual implementation in the classroom and production firms;

- develop an understanding of core concepts related to digital artwork creation through fundamental design principles and methods;
- and, most importantly, open the door for continued, self-guided discovery.

As you will learn in the first chapter, Illustrator is a powerful program for the reworking, repurposing, and reproduction of artwork, as well as for the development of completely new digital imagery. Its fundamental way of making illustrations, which is explained and demonstrated step-by-step in this book, is through the use of something called vectors, making lines and shapes point by point. Yes, having taken a few traditional drawing and design classes can more quickly move along your understanding of how Illustrator works, but they are not necessary. This book provides not only the fundamentals of using Illustrator, but also the creation of digital artwork in general and within the context of established design principles. All you really need to get started is some motivation to venture forth.

TEXTBOOK ORGANIZATION

The organization and features—the instructional design of this book—and all the books within the Design Exploration series, has been a well thought-out process through the collaborative efforts of the authors within the series and the dedicated staff at Delmar Learning. As the author of Exploring Illustrator CS, I began with about two months of researching the content and layout of other Illustrator books and the writing styles of textbooks in general. I talked with many digital artists and computer graphics instructors and students about their training needs, both with general design concepts and practical application. Confirming my suspicions, I discovered that their learning of best practices for infusing design concepts with tool-based software programs is becoming increasingly more complicated (so many tools, so little time) without clear instruction, practice, and practical application. Furthermore, so is the experience of making the learning fun and exploratory; providing timely, yet innovative ways for artwork creation. The way in which the content in this book is organized and presented is the result of my findings from this interesting investigation.

Each chapter builds upon itself, and the material is presented in a linear fashion, introducing design principles and Illustrator tools and features on a "need to know" basis. Consequently, this streamlines the amount of information a reader must know to successfully render a task. However, I don't discourage jumping around to get certain facts when you need them, especially if you are already somewhat familiar with the program. As well, to accommodate those who appreciate alternative methods to learning information, I provide both textually and visually succinct explanations of the important concepts to grasp in each chapter. For those who prefer structured hands-on experiences, step-by-step lessons are provided, and for those who prefer to wander around a bit, final project files, samples, and suggestions for further exploration are available for deconstruction.

The following is a brief overview of what is learned in each chapter. Since this book is all about a design program, notice that the content learned in most chapters corresponds with the fundamental design principles of line, shape, value, texture, and color, and then finally composition and space.

Chapter 1: A Discovery Tour

Right away build a logo in Illustrator, and discover the purpose of the Illustrator program.

Chapter 2: The Lay of the Land

Get comfortable with the Illustrator interface, and learn the important landmarks of the program to get around with ease.

Chapter 3: Survival Techniques

Develop a general understanding of how digital graphics are constructed. Learn about the design principles—line, shape, value, texture, and color—and then with these design principles in mind explore the use of some of Illustrator's tools and features.

Chapter 4: Drawing Lines and Shapes

Learn the process of creating illustrations in Illustrator by first creating basic lines and shapes, then more precise objects with the Pen tool.

Chapter 5: Using Color

Uncover some fundamental concepts of using color in digital art and design, then play with the color features and tools in Illustrator.

Chapter 6: Value and Texture

Create value and texture in your drawing by working with Illustrator brushes, filters, effects, graphic styles, and patterns.

Chapter 7: Working with Type

Practice methods for creating, formatting, and importing type in Illustrator, and get an overview of design techniques when choosing and working with fonts and type layouts.

Chapter 8: Object Composition

Go beyond the basic components of drawing in Illustrator and produce more complex paths, shapes, and complete illustrations and graphic layouts.

Chapter 9: Spatial Illusions

Move into the third dimension and learn the tools and techniques in Illustrator to produce more spatial depth, organic form, and space in your drawing and design.

Chapter 10: Print Publishing

Learn about the different types of printing processes and what it takes to prepare your artwork for print.

Chapter 11: Web Publishing

Learn about image optimization and what it takes to prepare your artwork for the web.

FEATURES

The following list provides some of the salient features of the text:

- Learning goals are clearly stated at the beginning of each chapter.
- Written to meet the needs of design students and professionals for a visually oriented introduction to basic design principles and the function and tools of Illustrator.
- Client projects involve tools and techniques that a designer might encounter on the job to complete a project.
- Full-color section provides stunning examples of design results that can be achieved using Illustrator.

- Exploring on Your Own sections offer suggestions and sample lessons for further study of content covered in each chapter.
- In Review sections are provided at the end of each chapter to quiz a reader's understanding and retention of the material covered.
- A CD-ROM at the back of the book contains tutorials, exercises, and Illustrator plug-ins.

HOW TO USE THIS TEXT

The following features can be found throughout the book:

★ Charting Your Course and Goals

The introduction and chapter objectives start off each chapter. They describe the competencies that the reader should achieve upon understanding the chapter material.

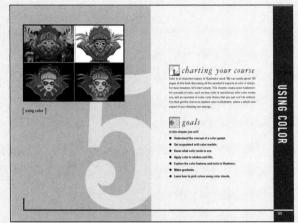

★ Don't Go There

These boxes appear throughout the text, highlighting common pitfalls and explaining ways to avoid them.

■ Review Questions and Exploring on Your Own

Review Questions are located at the end of each chapter and allow the reader to assess his or her understanding of the chapter. The section, Exploring on Your Own, contains exercises that reinforce chapter material through practical application.

★ Adventures in Design

These two-page spreads contain client assignments showing readers how to approach a design project using the tools and design concepts taught in the book.

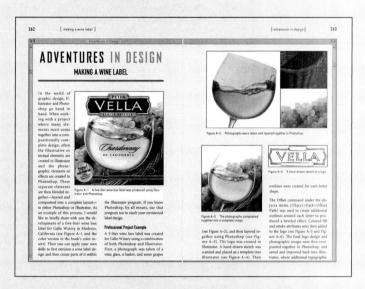

★ Color Insert

The color insert demonstrates work that can be achieved when working with Adobe Illustrator.

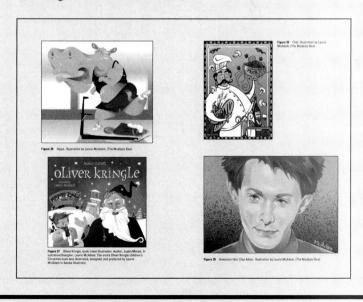

THE LEARNING PACKAGE

E.Resource

The instructor's CD was developed to assist instructors in planning and implementing their instructional programs. It includes sample syllabi for using this book in either an 11- or 15-week semester. It also provides answers to the end-of-chapter review questions, PowerPoint slides highlighting the main topics, and additional instructor resources.

ISBN: 1-4018-4363-8

FILE SET-UP

Located in the back of this book is a CD-ROM containing all the files to complete the lessons in this book. These lesson files are compatible with Illustrator CS. To download a trial version of Illustrator CS, visit http://www.adobe.com/products/tryadobe

Before starting any of the lessons, create a folder on your local computer called My Lessons (or whatever name you prefer). From the CD, drag a copy of the lesson files to the folder. As you work on the lessons, open the lessons, assets, and sample files from this location. You can then also save your work in the same place.

ABOUT THE AUTHOR

Annesa Hartman holds a masters in Teaching with Internet Technologies, focusing her attention on instructional design for online technologies, web and graphic design concepts and programs. She

is the Manager of Technology Learning Services at Landmark College, in Vermont, where she coordinates and instructs technology teaching and learning programs for the college's faculty, staff, and students. She also teaches computer graphic courses online, and is the author of a previous book, *Producing*

Interactive Television. When she is not pushing pixels she is digging dirt in her garden or teaching yoga classes.

Formerly, Annesa was the director and Softimage instructor for Mesmer Animation Labs in Seattle, Washington (1994–1998) and was cofounder and consultant for Sway Design in New York City (2000–2002). Specializing in graphic art production, corporate training, online learning, and curriculum development, Annesa has spoken at many conferences and has developed and taught unique training programs for Accenture, Morgan Stanley Dean Witter, AOL/Moviefone, St. John's University (Queens, NY), Universidade Lusófona de Humanidades e Tecnologias (Lisbon, Portugal), and Macromedia. Annesa also is a certified Photoshop instructor and was the subject matter expert and curriculum designer for Macromedia's Design Techniques with Flash course.

ACKNOWLEDGMENTS

When writing a software book there are many challenges, mainly the short time frame in which to write the book and the creation and acquisition of the materials, lesson sources, and images for it. I tend to find my material (and inspiration) through close friends, family, students, and professional colleagues. First, I would like to acknowledge Adam Linkin, not only for the use of his face in my book, but for his constant and gentle reminding of why I write software books at all—because I can and really do enjoy it. Thank you, dear friend. Next, special thanks goes to my mother, Carolyn Murov, who is never without a camera around her neck, is a graphic artist by profession, and provided many of the photographs I used throughout the book. A big thanks also to Andrea Linkin-Butler, Dave Garcez, Gregory Sinclair, Suzanne Staud, Laurie McAdam, Dave Joly, Annie Gusman, Wai Har Lee, Shari Cheves, Brenden Cheves, and Karen Claffey for providing realworld content that I have used in demonstrating Illustrator concepts and design techniques. My good friends Geoff Burgess and his wife Karen Kamenetzky also deserve tremendous thanks for poring through the rough drafts of my chapters and providing valuable feedback and support. You're the best! Thanks also to Charmaine Wesley for so many supportive emails and phone calls right when I needed them. As well, my experience with the staff at Delmar Learning has been utterly commendable—thanks for your patience and expertise, Jaimie Wetzel, Developmental Editor; Tom

Stover, Production Editor; Marissa Maiella, Editorial Assistant; Jim Gish, Acquisitions Editor; and Larry Goldberg and his team at Shepherd Incorporated. Jim, my fellow Vermonter, I really appreciate the opportunity to help kickoff this exciting new book series. Finally, many kudos to the students and instructors in the Graphic Design department at Modesto Junior College, California, where I am an adjunct online instructor, alumni, and daughter of one of the college's dedicated fine arts and computer graphics faculty, Terry Hartman. Dad, I very much enjoy discussing with you the idiosyncrasies of current technology books and instructional methods, and putting into practice with our students interesting and innovative ways to learn about graphic design. But mostly I appreciate your love and support. This book is for you.

Delmar Learning and I would also like to thank the following reviewers for their valuable suggestions and technical expertise:

RUTH ANN ANDERSON

Digital Media Arts Department California State University at Northridge Northridge, CA

STEVE CAMPBELL

Technology Department Lewis and Clark Community College Godfrey, IL

ROB JOHNSON

Graphic Design Technology Department Minnesota State Community and Technical College Moorhead, MN

DEBBIE ROSE MYERS

Graphic Design Department Art Institute of Fort Lauderdale Fort Lauderdale, FL

LINDA RZOSKA

New Media Department Kalamazoo Valley Community College Kalamazoo, MI

QUESTIONS AND FEEDBACK

Delmar Learning and the authors welcome your questions and feedback. If you have suggestions that you think others would benefit from, please let us know and we will try to include them in the next edition.

To send us your questions and/or feedback, you can contact the publisher at:

Delmar Learning Executive Woods 5 Maxwell Drive Clifton Park, NY 12065 Attn: Graphic Arts Team 800-998-7498

Or the author at:

Landmark College Manager of Technology Learning Services P.O. Box 820 River Road South Putney, VT 05346 ahartman@landmark.edu

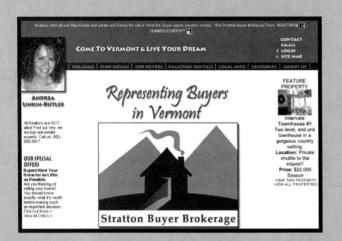

a discovery tour

charting your course

If you're the adventurous type with an inclination to jump into new experiences feet first, this chapter is for you. On the other hand, if you prefer to proceed with caution, a more of the "stand on the edge and dip your toes into the water" type, this chapter is also for you. Right away we begin with a hands-on investigation of Adobe Illustrator, but depending on your learning style you can choose to "do" the discovery tour or simply read it. Perhaps, you're a type A, such as myself, and will choose both these options. You'll also discover in this chapter the purpose and scope of learning this program, shedding some light on such impending questions as—What's so great about Illustrator? What does it do? How can it help me?

goals

In this chapter you will:

- Get excited about Illustrator.
- Build a logo.
- Explore the use of some of Illustrator's tools and features.
- Discover the purpose of Illustrator, who uses it, and why.

JUMPING IN

You have a problem. It's your first day on the job and the creative director arrives at your desk with a logo design cursorily sketched on a somewhat used dinner napkin (see Figure 1–1). She needs the sketch recreated on the computer *asap*, so that it can be printed on business cards by the end of the week. What do you do?

- **a.** Pack up your belongings and move to the mountains.
- **b.** Politely explain that it's "just not possible."
- C. Learn Adobe Illustrator.

The best answer is "c" (of course!). Without a doubt, learning Adobe Illustrator will solve your dilemma and your success as a graphic designer will be greatly improved. Let's not waste another minute, and get this logo done.

figure | 1-1 |

A logo sketched on paper.

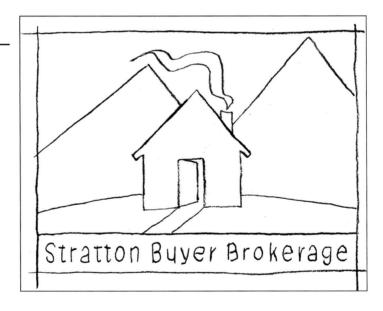

Lesson: Connect-the-Dots Logo Tour

This lesson is an initial foray into what Illustrator can do. It's not meant to get into any great detail (that's coming soon enough in later chapters), but rather an opportunity to experience right away how Illustrator might solve a very common problem—recreating a traditional drawing (a logo design) into a digital format using Illustrator. See Figure 1–2. Let's assume that you've already figured

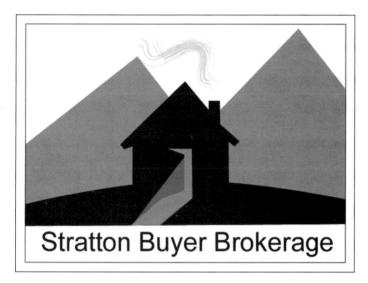

figure | 1-2 |

Completed lesson: A logo redraw using Illustrator.

out how to scan the dinner napkin sketch onto your computer. Next, follow these steps using Illustrator.

Importing the Sketch

- **1.** Open the Illustrator program.
- 2. Choose File>Open from the main menu, and on your local hard drive browse for the Exploring Illustrator **chap1_lessons** folder. Open the file **chap1L1.ai**. Note: As mentioned in the File Setup, in order to save your work, you must make a copy of the chapter lessons to your local hard drive, and select files from that location.

In the middle of the document you will see a blank artwork area with a black border. This is your drawing space. To the left of the interface is your toolbox (see Figure 1–3). You will access the toolbox more than any other part of the Illustrator program.

- **3.** Select Shift-Tab on the keyboard to hide unnecessary window palettes (at least for the time being).
- **4.** Choose View>Actual Size. Your viewing area should look similar to Figure 1–3.
- **5.** Choose Window>Layers to open the Layers palette. Layers are a way of organizing parts of an image. You can add, delete, rearrange, hide/unhide, lock/unlock, and duplicate layers. In this lesson the layers have already been created for you.

figure | 1-3 |

The Illustrator viewing area.

figure 1-4

The Layers Palette with the napkin sketch layer selected.

- **6.** Click once on the layer called **napkin sketch** to select it. See Figure 1–4.
- 7. Choose File>Place and browse for chap1_lessons/ assets/logo.jpg. Click Place to import the image into Illustra-

tor. This is our original scanned sketch, which will be used as a template to trace your new logo design.

- **8.** Be sure the Selection tool (black arrow) is selected in the toolbox. See Figure 1–5.
- **9.** Click and drag on the imported image and position it so it's centered directly over the artwork area (if not already).
- **10.** Lock the **napkin sketch** layer by clicking on the blank box to the left of the layer's name (a little lock icon will appear). See Figure 1–6.
- 11. Save your file by choosing File>Save As. Rename the file chap1L1_yourname.ai, and save it in your lessons folder.

figure | 1-5 |

The Selection tool selects objects on the document.

Drawing the Background Mountains

1. Unhide the **mountains guide** layer by clicking on the blank box far left of the layer name—an icon appears that looks like a series of geometric shapes. See also Figure 1–7. Note: This icon indicates that a template object on this layer is visible. Objects on template layers are usually used as guides that you

figure | 1-6 |

Lock the napkin sketch layer, to make it uneditable.

figure 1-7

Reveal the dots hidden on the mountains guide layer.

can trace over. Other layers are visible when you see an "eye" icon in the visibility column of the Layers palette.

A series of numbered dots appear on the document, strategically placed over the mountain drawn in the sketch. You will create the logo as if you were drawing an image in a connect-the-dot coloring book that perhaps you enjoyed as a kid.

2. Click the **draw mountains** layer to select it. See Figure 1–8. This layer will contain your final drawing of the mountains.

figure | 1-8 |

Select the draw mountains layer.

figure | 1-9 |

Select the Fill color box.

- **3.** Let's prepare the color you will use for the mountains. Click the Fill color box on the toolbox to bring it forward (if not already). See Figure 1–9.
- **4.** Next, choose Window>Swatches to open the Swatches palette.
- **5.** In the Swatches palette choose the 40% gray color swatch as the Fill color. See Figure 1–10.
- **6.** Next, select the Pen tool in the toolbox. See Figure 1–11.
- **7.** Position the Pen tool on point 1 on the document, and click the Pen tool; then click point 2 to create a straight path. Continue clicking each point 3, 4, 5, 6, and 7.

figure | 1-10 |

Select the 40% gray swatch as the Fill color.

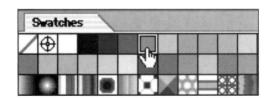

figure | 1-11 |

Selecting the Pen tool in the toolbox.

Note: If you make a mistake choose Edit>Undo (Command-Z on Mac or Ctrl-Z on Windows), or hit Delete on your keyboard.

When drawing in Illustrator you might find that even though you have your Pen tool selected you are unable to draw on the document. An icon comes up that looks like a pencil with a line through it.

When and if this happens it means that the layer you have chosen to draw on is either locked or hidden, or you are simply on the wrong layer.

- **8.** Close the path by clicking one more time on point 1. You now have a completed mountain shape. See Figure 1–12.
- **9.** For now, hide the **mountains guide** and **draw mountains** layers by clicking on the icons to the far left of each layer (one icon looks like a series of shapes, the other like an eye). See Figure 1–13.
- **10.** Save your file.

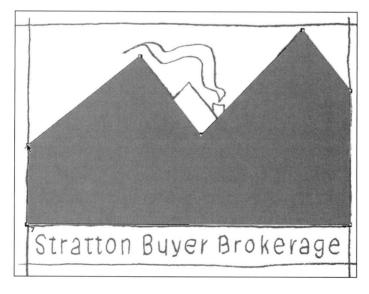

figure | 1-12 |

A completed mountain shape.

figure | 1-13 |

Hide the contents on the mountains guide and draw mountains layers.

Drawing the Hill

1. Unhide the **hill guide** layer to see the dots that will guide your drawing. See Figure 1–14.

figure | 1-14 |

Unhide the hill guide layer.

- **2.** Click the **draw hill** layer to select it. This is the layer you will draw on.
- **3.** Let's prepare the color we will use for the hill. Click the Fill color box on the toolbox to bring it forward (if not already).
- **4.** In the Swatches palette choose the color black.
- **5.** Select the Pen tool in the toolbox.
- **6.** Position the Pen tool on point 1 on the document, and click the Pen tool.
- 7. This next step is a little tricky . . . at point 2, click, hold and then drag the Pen tool to the right of the point to create a curved path. As you pull out on the point it creates a curve to form the rounded hill shape. (See Figure 1–15.) Remember, if you make a mistake Edit>Undo is always there for you (Command-Z on Mac, Ctrl-Z on Windows).
- **8.** Next, continue clicking each point 3, 4, and 5, creating straight paths.
- **9.** Close the path by clicking one more time on point 1. You now have a completed hill shape. See Figure 1–16.

figure | 1-15 |

Click, hold, and drag to create a curved path.

figure | 1-16 |

The completed hill shape.

- **10.** For now, hide the **hill guide** and **draw hill** layers by clicking on the icon to the far left of each of the layers (one icon looks like a series of shapes, the other an eye).
- **11.** Save your file.

Drawing the Path

- 1. Unhide the **path guide** layer to see the dots that will guide your drawing.
- **2.** Select the **draw path** layer. This is the layer you will draw on.
- **3.** Let's prepare the color you will use for the path. Click the Fill color box on the toolbox to bring it forward (if not already).
- **4.** In the Swatches palette, select the 40% gray swatch (7th swatch in the top row).
- **5.** With the Pen tool connect the dots starting with point 1 and ending on point 1. The finished path should look something like Figure 1–17.

figure | 1-17 |

The completed path shape.

- **6.** Hide the **path guide** and **draw path** layers by clicking on the icon to the far left of each of the layers.
- **7.** Save your file again.

Drawing the House

1. Unhide the **house guide** layer to see the dots that will guide your drawing. Hmmm, a bit more complicated, but you can do it! See Figure 1–18.

figure | 1-18 |

Reveal the guide dots to create the house shape.

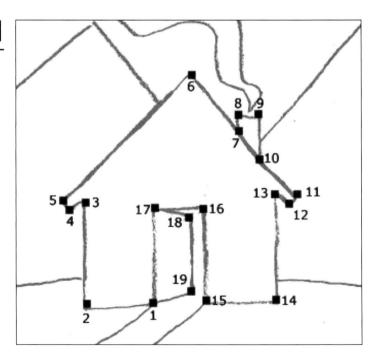

- **2.** Select the **draw house** layer. This is the layer you will draw on.
- **3.** Let's set the color for the house—a bit different this time. Click on the Fill box in the toolbox and choose the "none" option (white box with a red line through it). See Figure 1–19.

Note: For now, you will work with no fill to make it easier to draw the house.

- **4.** Now, click on the Stroke box in the toolbox to bring it forward. See Figure 1–20.
- **5.** Select the black color swatch in the Swatches palette to set the stroke (outline) color to black (if not already).
- **6.** Select the Pen tool (if not already selected).

figure | 1-19

Choose the "none" option to have no color fill.

figure | 1-20 |

Set the stroke (outline) color.

- **7.** Position the Pen tool on point 1 on the document, and click the Pen tool; continue clicking each point 2, 3, 4, 5, 6, . . . etc. Close the path by clicking on point 1 again when you've connected all the dots.
- **8.** Now, select the Fill box in the toolbox and choose a black swatch to fill the house with the color. See Figure 1–21.
- **9.** For now, hide the **house guide** and **draw house** layers by clicking on the icons to the far left of each layer.
- **10.** Save your file.

figure 1-21

The completed house drawing.

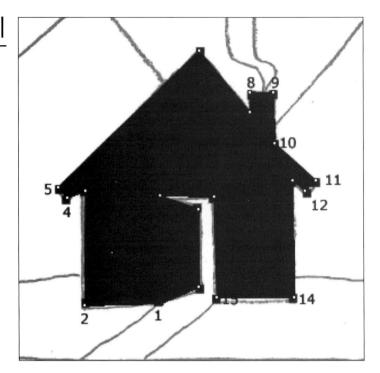

figure 1-22

Set the stroke box to "none."

Drawing the Light Beam

- 1. Unhide the **light beam guide** layer to see the dots that will guide your drawing.
- **2.** Select the **draw light beam** layer. This is the layer you will draw on.
- **3.** Set the Stroke box in the toolbox to "none." See Figure 1–22.
- **4.** Click the Fill box in the toolbox to bring it forward of the Stroke box.
- **5.** For the fill color, select the 40% gray swatch in the Swatches palette.
- **6.** Choose Window>Transparency and set the Opacity to 75%. This makes the gray color slightly transparent. See Figure 1–23.
- **7.** With the Pen tool connect the dots to create the light beam shape. See Figure 1–24.
- **8.** Hide the **light beam guide** and **draw light beam** layers.

figure | 1-23 |

Set the color opacity.

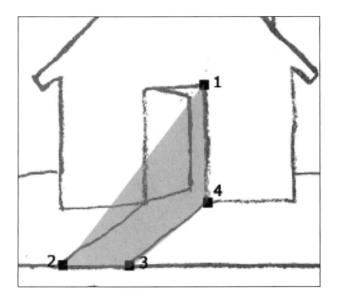

figure | 1-24 |

Completed light beam shape.

Making Smoke

- 1. Select the **draw smoke** layer.
- 2. Choose Window>Brushes.
- **3.** From the brush list select the Dry Ink brush. See Figure 1–25.
- **4.** From the toolbox select the Paintbrush tool. See Figure 1–26.
- **5.** From the toolbox choose "none" for the fill color. Note: When using a brush, the color comes from the color of the stroke and not from the color of the fill.
- **6.** With the Paintbrush tool draw some smoke coming out of the chimney. Click and drag a wavey line. See Figure 1–27.
- **7.** Save the file—you're almost there!

figure | 1-25 |

Select the Dry Ink brush.

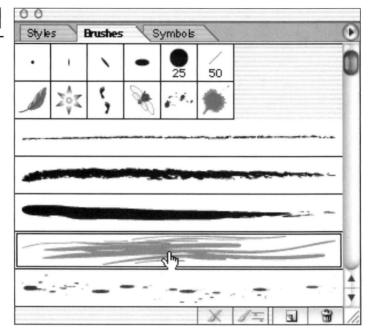

figure | 1-26 |

Select the Paintbrush tool.

Creating the Title

- 1. Select the layer called **title**.
- **2.** Select the Type tool in the toolbox. See Figure 1–28.
- **3.** Choose Type>Size>Other from the Menu bar. The Character window pops up. For Font enter Arial. For Size enter 50 pts. See Figure 1–29.
- **4.** Position the Type tool at the beginning of the word **Stratton** on the template.
- **5.** Click down (you will see a blinking cursor). Then type in **Stratton Buyer Brokerage.** See Figure 1–30.
- **6.** With the Selection tool (black arrow) click and drag on the text block to position it in place. Click once away from the type to deselect it.

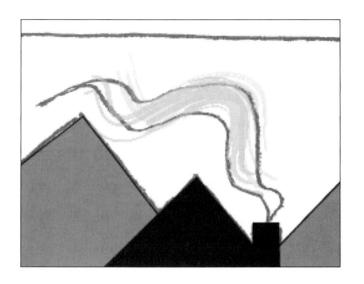

figure | 1-27 |

Create smoke using the Paintbrush tool and Dry Ink brush.

figure | 1-28 |

The Type tool in the toolbox.

figure | 1-29 |

The Character palette for adjusting type.

Stratton Buyer Brokerage

figure | 1-30 |

The completed text line.

figure | 1-31 |

The Rectangle tool in the toolbox.

figure | 1-32 |

Fill and Stroke options for the logo border.

Making the Final Border

- **1.** Now, for the final touches. Select the layer called **border** in the layers palette.
- **2.** Select the Rectangle tool in the toolbox. See Figure 1–31.
- **3.** In the toolbox select "none" for the fill color.
- **4.** For the stroke, select a black swatch from the Swatches palette. Your final color selections should look like Figure 1–32.
- **5.** Starting at the top left edge of the logo's frame click and drag to the opposite corner of the frame, creating a rectangular border around the image. See Figure 1–33.

Unveiling the Final Logo

1. Unhide the drawing layers by clicking to reveal the eye icon on each draw layer. This includes the border, title, draw smoke, draw light beam, draw house, draw path, draw hill, and draw mountains layers.

Draw a rectangle from corner to corner of the napkin sketch's frame.

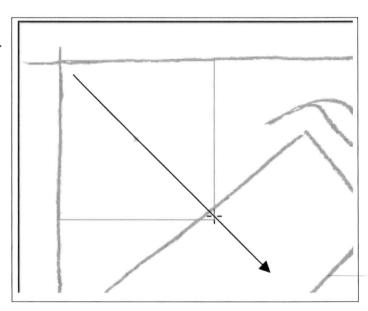

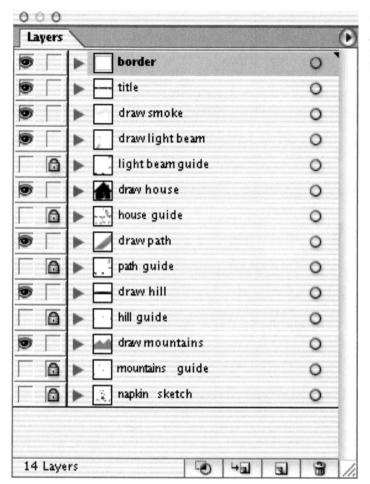

figure | 1-34 |

Unhide the drawing layers.

- **2.** Hide the **napkin sketch** layer. Your final image is revealed. See Figure 1–34 and Figure 1–35.
- **3.** Save your file—you've done it!

figure | 1-35 |

The completed Illustrator logo.

ABOUT ILLUSTRATOR

As you began to experience in the logo lesson, Adobe Illustrator is a great resource to reproduce, redo, revise, rework, and re-envision traditionally and digitally created artwork and imagery. Even if you're new to drawing or working with digital imagery, Illustrator (along with this book) is a great place to start stirring up some creative energies. It also gets you out of many time-crunching, sticky situations that unsuspectedly await you as a graphic designer and offers a versatile new environment to draw, paint, and edit graphic images.

Lucky for you, each new version of Illustrator is significantly more sophisticated than the previous version. As the demand grows for more malleable and cross-product integration of digital content, new tools and effects are introduced and workflow techniques are added and improved, as is the product's ability to fuse into all types of graphic disciplines (i.e., interactive media, animation, and the web). For all its capabilities it's no wonder that Illustrator has been the most popular digital drawing program on the market since its inception; a necessary provision for print, web and interactive designers, architects, animators, and traditional artists.

Fundamentally, however, Illustrator hasn't changed that much. Its underlying magic is the use of something called vectors, a way in

which computer-generated objects are drawn using points and lines. You got a taste of this in the logo design lesson. Alternatively, digital images created by pixels, square-like elements gathered together in a grid, are mainly handled using Illustrator's companion product, Adobe Photoshop. Chapter 3 goes into greater detail of the important differences between these two ways of generating digital graphics, respectively known as vectors and bitmaps. For now, however, it's good to know that Illustrator has the ability to:

- Create, color, edit, and add special effects to original or traced drawings.
- Effectively format and render type and enhance typographic layout and design.
- Produce objects and design layouts that can be resized and reformatted for print, web, and multimedia publication without losing their quality (resolution).
- Export graphics to other vector-based formats, such as Macromedia's Flash (SWF) and the new, web vector standard SVG (Scalable Vector Graphics)—more on this in the last chapter.

SUMMARY

As you initially explored, Illustrator is a powerful program for the reworking, repurposing, and reproduction of artwork, as well as the development of completely new digital imagery. Its fundamental way of making illustrations is through the use of vectors, making lines and shapes point by point. Without a doubt, Illustrator is a vital part of any graphic designer's repertoire.

in review

- 1. What's the use of having a template image in Illustrator?
- 2. What are layers? How are they useful?
- 3. How do you know when a layer is hidden?
- 4. What's opacity?
- 5. Name at least two uses of the Illustrator program.
- 6. Who uses Illustrator?

★ EXPLORING ON YOUR OWN

- Visit the Illustrator area of the adobe site—http://www.adobe.com/products/ illustrator/main.html
- 2. Find some inspiration in the section appropriately called "Inspiration."

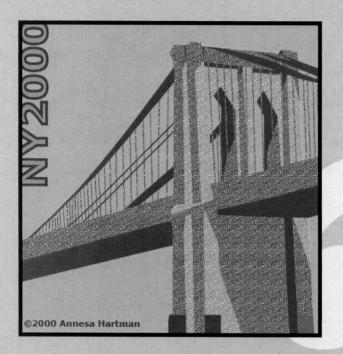

the lay of the land

charting your course

In the first chapter, you might say you were a sightseer on the Illustrator tour bus. You got to wander around a bit, visit a few tourist attractions, like the Layers palette and the Pen tool and even build something that you can slap into a scrapbook and say, "I did that!" Chapter 2 prepares you for the longer journey into Adobe Illustrator. Now, you actually open up the atlas and take a good look at the programs landscape. In one lesson you'll visit the historical landmarks of the Illustrator interface—the most important parts of the program that you get from point A to B. Then you put on your binoculars (theoretically!) and take a closer look at the program's navigational features that help you see where you are going no matter how lost you might think you are.

In this chapter you will:

- Feel comfortable with the Illustrator interface.
- Set and delete Preferences.
- Navigate around the work space.

HISTORICAL LANDMARKS

I live at the end of a long winding dirt road in the back woods of Vermont. The UPS guy gets lost every time he comes to deliver a package. I usually get a phone call from the UPS dispatcher inquiring on how to get to my house. Instead of giving street names already indicated on any map or sophisticated GPS (global positioning system), I point out a few notable landmarks—go across the covered bridge, stay to the left of the big pine tree, turn at the tilted mailbox, and go straight up the driveway to the end. In a matter of minutes UPS is at my door. My point here is that you can be handed a detailed map of how to get around a new place, but that doesn't necessarily get you to where you want go, at least not as directly. You can memorize the map and realize later, when you've talked to some of the locals, that a few historical landmarks can get you where you want to go much faster. You learn the shortcuts or discover there is more than one way to go depending on which direction you are coming from. The Illustrator interface or work area is no exception. For example, in Illustrator there are at least two ways to get to every tool—click on it in the toolbox or use a keyboard shortcut (Edit>Keyboard Shortcuts). You'll learn all the secret routes over time, but for now let's get familiar with some tried and true historical landmarks of program—this includes the artboard, toolbox, menu bar, palettes, status bar, context menus, and preferences.

Lesson 1: Interface Highlights

In this lesson you identify the main interface elements of Illustrator.

Identifying Landmarks

- **1.** Open the Illustrator program. Bypass the Welcome window by choosing close. See Figure 2–1.
- **2.** Choose File>New from the menu bar at the top.
- **3.** In the New Document dialog box type in **myfile** for the document name and for Artboard Setup choose: Letter. Select OK. See Figure 2–2.
- **4.** Depending on if you are using a Macintosh or Windows computer, the nuances of the interface look slightly different. In general, however the landmarks are the same. Compare your open Illustrator interface with Figure 2–3, and note where the various parts of the program are located.

figure | 2-1 |

Illustrator's Welcome window

New Document		
	ОК	
Width: 612 pt	Cancel	
Orientation:		
O RGB Color		
	Width: 612 pt Height: 792 pt Orientation:	

figure | 2-2 |

The New Document dialog box.

- **Arthoard** The arthoard is the big white space smack in the middle of the screen. When you chose File>New in the step above you created a specified size for the arthoard. The area bounded by the solid line is the region that contains your artwork. However most printers cannot print right to the edge of this region; therefore only the area within the dotted line is printable. The white space outside the arthoard is called the scratchboard (or scratch area). This is your doodling space, where you can create, edit, and store images that you might or might not use on the final arthoard area.
- Toolbox To the left of the screen is the toolbox. You'll use this panel a lot; it contains all the tools necessary to select, create, edit,

figure | 2-3 |

The Illustrator interface (Macintosh version).

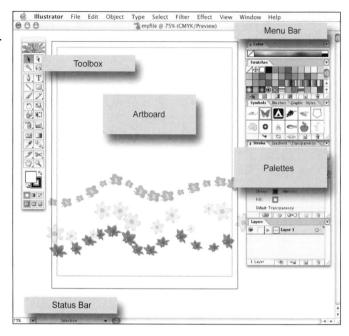

and manipulate your illustrative objects. When you hold your cursor (pointer) over a tool, the name of the tool appears—this is called a "tool tip" and it is incredibly helpful when you're first learning which tool is which. There are actually many more tools than initially visible in the toolbox; some tools have tools hidden beneath them (sneaky). When you see a small triangle in the lower, right corner of a tool icon, click and hold on the icon and more tools are revealed. For a very useful visual of each of the tools and what they do see Help>Illustrator Help. Go to the section "Looking at the Work Area" and choose Toolbox Overviews 1–5. Also view Figure 2–4.

- Menu Bar On the top of the screen is the menu bar, which contains drop-down selections of various features, tools, and commands within the Illustrator program. Don't bother memorizing everything in the menu bar; it will come on a need-to-know basis.
- Palettes Palettes usually located to the right of the interface allow you to monitor and modify your work. You select palettes from the menu bar under the Window heading. Palette windows come grouped together, but you can also separate them by clicking on their title tabs and dragging them to another area of the screen. See Figure 2–5. Of course, you can re-dock any palette back into a group by dragging the separated palette's title bar over the desired palette group. Often, you will not want all your palettes open all

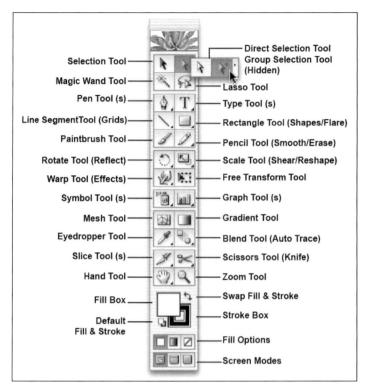

figure | 2-4 |

The Illustrator toolbox.

figure 2-5

Move a palette window.

the time. Conserve valuable work space by closing unneeded palettes. To do this, click on the close button in the upper left corner (Mac) or upper right corner (Windows) of any of the palettes. To bring a closed palette back, go to Window on the menu bar and select the palette name again. Or, to temporarily hide all the visible palettes, choose Shift-Tab on the keyboard. To bring them back choose Shift-Tab again. (By the way, if you choose just Tab on the keyboard you hide or unhide all palettes plus the toolbox.)

figure | 2-6 |

Right-click (Windows) or Ctrlclick (Mac) to get to the context menus.

- Status Bar The status bar is located at the lower left edge of the document window. It contains the Zoom pop-up and Status pop-up menu items. The Zoom pop-up allows you to change the magnification of the document window. The Status pop-up contains specific information, such as the current tool in use, date and time, amount of memory Illustrator will allocate for your open file, number of undos and redos, and the document's color profile.
- Context Menus Hidden under the right click option of your mouse if you're a Windows user or when you Ctrl-click as a Macintosh user, you'll discover what are called context menus. Context menus are drop-down menus that give you quick access to various features of a tool you might be using. See Figure 2–6.

Marking the Territory

1. Place the cursor (don't click!) over the Rectangle tool in the toolbox. Notice that a text equivalent (a tool tip!) of the tool name appears. Next to the tool name there is also a shortcut key indicated. See Figure 2–7.

figure 2-7

The tool tip for the Rectangle tool is revealed.

- **2.** Now, click and hold on the Rectangle tool to open up further shape tool options. See Figure 2–8.
- **3.** Select the Star tool.
- **4.** Click and drag on your artboard to create a star shape. Make two or three.

figure | 2-8 |

Click and hold over the Rectangle tool to reveal more Shape tool options.

- **5.** Place the cursor directly over one of your stars, and hold down Command (**%**) (Macintosh) or Ctrl (Windows) on your keyboard to change the cursor to the Selection tool.
- **6.** Keeping the Command/Ctrl key selected, click and move the star to a different location on the artboard. By selecting or releasing the Command/Ctrl key on the keyboard you can toggle between the currently highlighted tool and the Selection tool. This is a nifty trick to quickly make objects, and select and move them too.
- 7. Now, hold down Option + Command (Mac) or Alt + Ctrl (Windows) at the same time while you click and move one of the stars. Release the mouse-click first, and if your coordination is on, you will make a duplicate of the star. The Option/Alt key makes quick duplicates of currently selected objects. (Or, you can take the longer route and choose Edit>Copy, then Edit>Paste). See Figure 2–9.

Note: If you make a mistake simply choose Edit>Undo or Command + Z (Mac), or Ctrl + Z (Windows). Here are a few things you should know about Undo:

- Repeatedly choose Edit>Undo to undo, in reverse order, the last operations you performed. To redo choose Edit> Redo.
- Depending on the amount of memory available on your computer, you can undo an unlimited number of the last operations you performed.

figure 2-9

Make stars.

- You can use Undo even after you've chosen the Save command, as long as you haven't closed and reopened the file.
- If an operation cannot be undone, the Undo option is dimmed.
- **8.** Unless you want to tromp around some more on your own, we're done with this file and identifying interface landmarks. Choose File>Save. For Format make sure Adobe Illustrator Document is selected. Save **myfile.ai** in your lessons folder. You use it again in the next lesson.

Note: You might be wondering what's the ".ai" at the end of your file name. This is the native file extension for all Illustrator files. If you see a file with this extension on the end you know that it was created in Adobe Illustrator.

Lesson 2: Getting Personal

Every time you open up the Illustrator program and begin to open windows, set import options, determine ruler units, and grid and guide colors (basically customize things to your liking), Illustrator creates a file on your hard drive that defines these preferences. This is really great when you want to open up the program again and have everything preset just your way. Let's set some preferences and see how this works:

Setting Preferences

- **1.** Open the Illustrator program.
- 2. Choose File>Open and look for your myfile.ai.

Note: If you don't have a **myfile.ai**, choose **chap2L2.ai** in the **chap2_lessons** folder.

- **3.** Close all palette windows (except for the toolbox) by clicking on the Close icon in the upper left corner (Mac) or upper right corner (Windows) of each palette window. See Figure 2–10.
- **4.** Select the Paintbrush tool in the toolbox. Notice the cursor becomes the same icon as the tool selected. See Figure 2–11.

figure 2-10

Close unneeded palette windows.

figure 2-11

The selected Brush tool changes the mouse cursor to a brush icon.

figure | 2-12 |

Choose a star pattern to paint on the artboard.

- **5.** Choose Window>Brush Libraries and select the Celestial_ Stars and Sky option. See Figure 2–12. Pick one of the stars in the library and proceed to paint some stars on the artboard.
- **6.** Let's change some preferences. If you are a Mac user, choose Illustrator>Preferences>General. If you are a Windows user, choose Edit>Preferences>General. Any change you make in this box will be recorded in a Preferences file for the next time you open the program. There are lots of Preference options—we'll only tinker with a few, but it's a good idea to look through all of them just in case you want to make a change down the road.
- **7.** Under the General option select the Use Precise Cursors and deselect Show Tool Tips. See Figure 2–13. Tool tips come up by default when you hold your cursor over a tool in the

Preferences		
General		
Keyboard Increme Constrain Ang Corner Radiu	le: 0 °	Cancel Previous
✓ Use Precise Cursors Show Tool Tips ✓ Anti-aliased Artwork	Disable Auto Add/Delete Use Japanese Crop Marks Transform Pattern Tiles Scale Strokes & Effects Use Preview Bounds	Next
Reset All Warnin	ng Dialogs	

figure | 2-13 |

Select general preferences.

toolbox, for example, and a text equivalent name for the tool is revealed.

- **8.** Go to the drop-down menu at the top of the Preferences window and choose Guides and Grids. Change the Grid color to Magenta.
- **9.** Select OK to close the Preferences window.
- **10.** Test out your Preference choices. First, roll your cursor over a tool in the toolbox and notice that the text equivalent Tool Tip is no longer available.
- 11. Next, choose the Paintbrush tool again and notice that the cursor icon has changed. It no longer is in the shape of the brush icon, but is a cross mark. This cross mark indicates a precise cursor—the center of the cursor is the exact spot where you will draw—much more accurate than the traditional icon cursor.
- **12.** Finally, choose View>Show Grid to see the magenta colored grid.
- **13.** Save your file. Call it **myfile2.ai.**
- **14.** Choose Illustrator>Quit Illustrator to completely shut down the program.
- 15. Now, open the program again and open your myfile2.ai.
- **16.** Notice your Preferences have not changed. Even the Brushes palette is still open.

Deleting Preferences

- 1. It's quite possible you might want to go back to Illustrator's default Preference settings. To do this, first close down the Illustrator program (Illustrator>Illustrator Quit for Mac users, File>Exit for Windows users).
- **2.** Now, depending if you are on a Mac or a Windows computer do one of the following:
 - In Windows, go to the Documents and Settings\
 user name\Application Data\Adobe\Adobe Illustrator
 CS Settings folder. Place in the trash the AIPrefs file.

Note: Before deleting the Preferences file, you might want to rename the Preferences file and move it to the desktop as a safety copy.

• In Mac OS, go to the Preferences folder in the System Folder (Mac OS 9.x) or Library/Preferences folder (Mac OS X), open the Adobe Illustrator CS Settings folder and place the Adobe Illustrator Prefs file in the trash.

Note: Before deleting the Preferences file, you might want to rename the Preferences file and move it to the desktop as a safety copy.

3. Once you've deleted the Preferences file, reopen Illustrator to view the default set-up. It will look something like Figure 2–14.

figure | 2-14 |

The Illustrator interface with its default preferences.

A CLOSER LOOK

Okay, so you now have a bird's-eye view of the Illustrator landscape. Next, you take a closer look at some of the navigational features of the program, such as the Hand and Zoom tools, the Navigator palette, Screen and View modes, and the status bar.

Lesson 3: Navigational Features

Magnification Tools

- In Illustrator open the file chap2L3.ai in the chap2_lessons folder. Note: If you get a convert color mode warning window, choose CMYK and proceed.
- **2.** Choose View>Fit in Window to magnify the file to fit in the window area.
- 3. Notice the document title bar indicates the current magnification of the artwork. See Figure 2–15. Depending on the size of your document window this number will vary. Try this: Scale the lower right corner of your document window smaller and choose View>Fit in Window again—the artwork is repositioned in the window area, indicating a new magnification level in the document title bar.
- **4.** Now, choose View>Actual Size to set the document to 100% scaling. This shows you the actual size of the artwork if it were to be printed on paper.
- **5.** Select the Zoom tool in the toolbox. Refer to Figure 2–4. Click once on the document to zoom the artwork closer. Click again to zoom even closer.
- **6.** Hold down the Option (Mac) or Alt (Windows) key to reverse the Zoom tool (notice the minus sign in the Zoom tool cursor). Continue to hold the Option/Alt key down has you

figure | 2-15 |

click once on the artwork to zoom back. Click again to zoom even farther away.

- 7. Let's zoom into a particular area of the artwork. With the Zoom tool selected, click and drag from upper left to lower right a rectangular shape over the copyright notice in the lower left corner of the document. With this area marqueed, let go, and notice how the area selected zooms in close. Cool! See Figure 2–16.
- **8.** Select the Type tool (the "T") in the toolbox and change the text from 2000 to 2004. See Figure 2–17.
- **9.** Select the Hand tool in the toolbox (the tool right next to the Zoom tool). Click and drag with the Hand tool over the document, pushing it down until you see the NY2000 text on the left side of the artwork.
- **10.** Select the Type tool again and change NY2000 to NY2004.
- **11.** Select View>Actual Size to see the complete artwork. Or, alternatively double-click on the Zoom tool in the toolbox. See Figure 2–18.

figure | 2-16 |

Select an area to zoom in close.

figure | 2-17 |

Change the text with the Type tool.

figure | 2-18 |

The completed artwork

The Navigator Palette

- 1. Another way to get a proper view of your artwork is to use the nifty Navigator palette. Choose Window>Navigator to open it up. A small view of your artwork with a red border around it is shown in the Navigator window. See Figure 2–19.
- **2.** In the Navigator palette slide the small arrow in the lower part of the window to the right to magnify the document or to the left to reduce it. Notice the red border adjusts in the viewing window to indicate what area is viewable in the document.

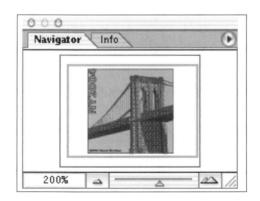

figure | 2-19 |

The nifty Navigator palette.

Note: Alternatively to moving the slider to zoom in and out, you can also click on the mountain-looking icons on each side of the slider. Also, you can type in a zoom percentage in the lower left corner of the Navigator window.

- **3.** Magnify the graphic by sliding the arrow in the Navigator window to the right. The red border area should grow smaller in the window.
- **4.** Locate a specific area of the graphic by placing the cursor over the red border area in the Navigator window (notice the cursor changes to the Hand tool). Now, click and drag the red border area until you locate the copyright (©) symbol in the lower left corner of the document.

Other Viewing Modes

- **1.** Choose View>Actual Size to see the complete artwork.
- **2.** Select the Selection tool in the toolbox. Dragging from upper left to lower right marquee a selection of the Brooklyn Bridge. See Figure 2–20. Notice the edges (paths) of the artwork are now visible for editing.

figure | 2-20 |

Edges are visible for editing the artwork.

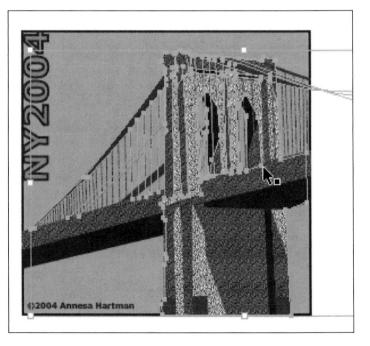

- **3.** You can turn these edges (paths) off by choosing View>Hide Edges. I don't like to hide the edges of my artwork, because then I can't see the selected paths when editing, and sometimes I accidentally select View>Hide Edges when I don't mean to. Who knows, though, this feature might come in handy someday, so it's good to be aware that it's there.
- **4.** Choose View>Show Edges to toggle the selected edges back on.
- **5.** Now, choose View>Show Artboard to view the outline of the document. Remember, the artboard is the visible region that contains your artwork.
- **6.** To view the artwork in outlines, choose View>Outline. This option views only the paths of the artwork, not the paint attributes. Viewing artwork without paint attributes speeds up the time it takes to redraw the screen when working with complex artwork.
- **7.** Choose View> Preview to see all the artwork attributes again.

Screen Modes and Status Bar

- 1. You can also view artwork at different screen sizes. In the toolbox, you can choose Full Screen Mode with Menu Bar, Full Screen Mode (without Menu Bar), or Standard Screen Mode. See Figure 2–21, and try out all three options.
- **2.** In the toolbox choose the Standard Screen Mode. Notice in the lower left corner of the document window the status bar, containing pop-up information for Zoom options and Document status options. See Figure 2–22.

figure | 2-21 |

Select screen modes in the toolbox.

figure | 2-22 |

The Status Bar.

- **3.** From the pop-up menu near the magnification number choose a new magnification for the artwork.
- **4.** From the pop-up menu near the document status indicator explore each of the following options: current tool use, date and time, number of undos and redos available, and document color profile (more on that option later).
- **5.** Close the file—you're done with this lesson.

SUMMARY

Hopefully after this chapter you have a better command of the interface elements and navigational features of Illustrator. No more wandering around dark alleys trying to find where you want to go. With a little practice you'll be zooming in and out, selecting tools, and opening and closing palette windows with ease. Who needs a sophisticated GPS when you have historical landmarks and shortcut keys to aid you on the Illustrator journey?

in review

- 1. What's the difference between a scratchboard and an artboard?
- 2. The nonprintable area of a document is indicated by what visual on the Illustrator artboard?
- 3. What does ".ai" at the end of a file name indicate?
- 4. What are tool tips? How can you turn them off?
- 5. What's a precise cursor?
- 6. What's the shortcut key to undo a mistake?
- 7. What steps are necessary to go back to Illustrator's default preferences?
- 8. What's the difference between View>Actual Size and View>Fit in Window?

★ EXPLORING ON YOUR OWN

- 1. In the Illustrator program, go to Help>Illustrator Help and read over the section on "Looking at the Work Area."
- Create a new file and explore the different shape options available in the toolbox—rectangle, ellipse, polygon, stars, and flares. Use the Navigator palette to practice zooming in and out of the document window. Reset your Preferences.

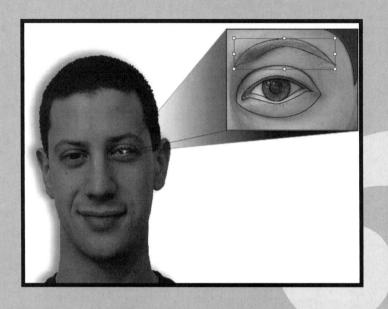

survival techniques

charting your course

Okay, so you've got your feet wet with Illustrator. Now we excavate a little deeper. Because this chapter is essential for aspiring graphic artists, please pay attention. If you can grasp what's coming up next, you'll be well equipped for creative expeditions not just in Illustrator, but any computer graphics program.

In this chapter you find out that because Illustrator uses something called vector technology it opens up a world of possibilities for you, the artist. Furthermore, an understanding of how to produce an illustration in Illustrator and use its extensive toolset can begin with what you might already know—a fundamental understanding of design principles. I'll start with some brief explanation of what it takes to be an Illustrator artist. Then venture into the differences between vector and bitmap images, as well as image formats. In conclusion, I'll guide you through a hands-on deconstruction of an Illustrator file with design principles in mind.

goals

In this chapter you will:

- Find out that being an Illustrator artist is more than just knowing the tools.
- Develop a basic understanding of the two types of digital images: bitmap and vector.
- Learn about image formats and get an overview of common image format types.

- Find out how Illustrator, through the understanding of fundamental design principles, can be used as an effective art medium.
- Explore the use of some of Illustrator's tools and features with design principles in mind.

IT'S MORE THAN COOL TOOLS

I'm going to tell it to you straight—being a graphic artist is not about knowing how to use the millions of tools in the hundreds of computer graphic software programs currently available. That's like saying you're going to master all the tools at Home Depot before you build a house. Why learn how to use a miter saw, until you need something specific to cut?

Obviously, it helps to know what tools do exist. And having some versatility with a few common tools, such as a hammer if you're building a house or the Pen tool if you're working in Illustrator (see Chapter 4), does make things easier. Such knowledge allows you to better conceptualize how a project might come together. Truly mastering all the tools and features of a program, however, comes when you have a real-life project to work on—with schedules and deadlines and picky clients. And that kind of experience comes with time.

More important to comprehend is not just the tools, but rather the principles behind how they are used. Understanding how digital images are created is key to your survival as a successful graphic artist. This includes knowing an image's distinguishing characteristics, its format type, and in particular to Illustrator, how it's created in relation to fundamental design principles. Most books out there on Illustrator don't get into any of this stuff until much later (if it all), and I believe it's a crime to the designer intellect. It's like sending you out on an African safari with a shotgun, but no training on when and how to use it. I don't want to be responsible for you being swallowed by a lion, so please read on.

CHARACTERISTICS OF BITMAPS AND VECTORS

There are two types of digital graphics—bitmap and vector. An eventual understanding of bitmaps and vectors is as important as a mechanic knowing what's going on under the hood of a car. If you want the creative engine to work you need to know how the parts

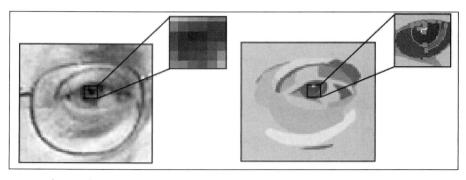

figure 3-1

On the left is a photograph comprised of bitmaps—a grid of pixels (small elements of data)—which describe the image's color and size. On the right is an illustration comprised of vectors, specific points that define the object's outline using a mathematical, coordinate system.

fit together. Having a clear picture of the differences between bitmap and vectors enables you to more effectively create, format, edit, or alter digital artwork—as I mentioned before, not just in Illustrator but every computer graphics program you might encounter. That being said, if it all seems a bit too technical at first, don't worry—the differences will become obvious once you start working with digital graphics. The key point now is to be aware that these differences exist, as shown in Figure 3–1.

About Bitmap Images

When describing what bitmaps are, I like to think of beautiful mosaics made up of individual tiles. Each tile has its own color and location and when combined with other tiles it produces a complete image, pattern, or design. To equate this with computer graphics, each complete image, pattern, or design is what would be defined as a bitmap, and each tile, individual piece of the bitmap, is a pixel, a square element containing specific information, such as color and location data. Figure 3–2 demonstrates this makeup.

A bitmap image contains a fixed number of pixels (information), measured by pixels per inch (ppi). This measurement is called the image's *resolution*. An image with a high resolution contains more, and therefore smaller, pixels than an image of the same printed dimensions with a low resolution. For example, if the 1-by-1-inch black and white photo in Figure 3–3 was designed to go to print it needs a resolution of about 150 pixels per inch (ppi). The total

figure 3-2

Zooming in close to a bitmap image can reveal the individual pixels that it's made of.

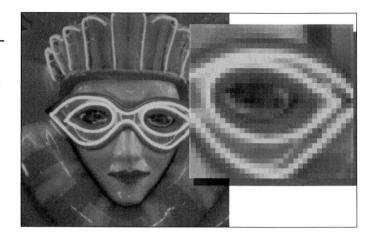

figure 3-3

An image of the same dimensions (for example, 1-by-1-inch) can have a different resolution (number of pixels per inch) depending on its intended use.

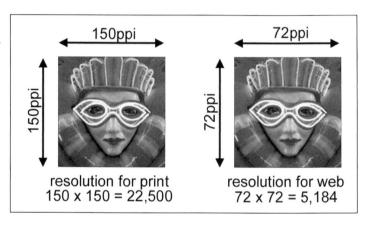

number of pixels in this image would be 22,500 (150 ppi \times 150 ppi = 22,500). If it were to be viewed on a screen, such as via the web, it would be best at 72 ppi, making a total image resolution of 5,184 pixels. Setting the proper resolution of an image is key to effectively saving it for its intended use. Also keep in mind that the higher the resolution of an image, the bigger the file size and usually the better its visual quality. We'll come back to the topic of resolution in Chapters 10 and 11 when we get into more specifics about preparing images for print and web output.

To sum up our discussion of bitmap images, remember (for now) a few things: they are distinctly unique because they are made up of a grid of pixels, and their visual quality, file size, and intended use are dependent on resolution. Also, bitmap images are most common for continuous tone images, like photographs. They are really good at representing subtle graduations of color and shading.

About Vector Graphics

One way to visualize vectors is to think of those coloring books where you connect a series of dots and a complete image appears. Remember, you experienced this idea in Chapter 1, when you made a logo. Each dot defines a particular point in space with lines in between. Each line, in turn, connects to create the shapes that comprise an object or illustration. Unlike the static pages of a coloring book, however, the cool thing about connecting dots in Illustrator is you can add, delete, and edit those dots and lines over and over again until you get your vision just right; its flexibility is its asset and this is what makes drawing digitally truly fun.

If you recall, bitmap images are dependent on their resolution, which makes them a bit tricky to work with. With vectors this is not the case. In Illustrator, instead of trying to push around square pixels, you actually construct an image with straight and curved paths, point by point. Additionally, a vector image can be scaled big or small and its quality always looks good. Because of this, graphics made with vectors are usually bold and illustrative, with qualities that retain crisp lines and solid colors when scaled to various sizes and used for different purposes, like text and logo treatments, for example.

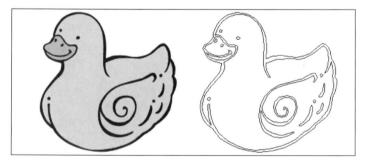

figure | 3-4 |

On the left is an illustrative vector image. On the right are the editable lines that it is made up of.

In short, it's good to know that vector graphics are made up of points that describe an object's outline or shape. See Figure 3–4. In contrast to bitmap images, vector images are also resolution independent—they don't depend on pixels to determine their visual quality. They can be scaled any size and printed to any output device without loss of detail or clarity. Vectors are what Illustrator is all about and soon enough you'll be more than intimate with them.

Convergence of Image Types and Image Formats

Before moving on, I should mention a couple more vital things about vectors and bitmaps. Programs such as Adobe Photoshop and Macromedia Fireworks are designed to work specifically with bitmap-constructed images. Adobe Illustrator, Macromedia Freehand, Macromedia Flash, and Corel Draw are designed to work with vector-based graphics. However, most programs to some extent have the ability to import and translate both vector and bitmap graphics. Illustrator in particular has the option to convert vector objects into bitmap objects. This process is called *rasterization*. For example, by selecting Object>Rasterize in the Illustrator program a basic shape can be converted from vector outlines to bitmapped pixels. Why would you do this, you might ask? This step might be taken if you want to apply a certain effect or filter that worked only on bitmapped objects.

It's also good to know there are different image formats for different types of images. A format is described by an extension at the end of the file name, like **image.jpg** or **mywork.tiff**. An image's format indicates the makeup of the image, whether it's made of bitmaps or vectors. A file format also indicates the file size and visual quality of the image, which is determined by the format's compression setting. A highly compressed image is lower in file size and visual quality than an uncompressed or minimally compressed image. There are many kinds of image file formats depending on where you are going to use the image (i.e., print or web). Most graphic programs support the use of the following:

Bitmap-only based formats:

- BMP A limited bitmap file format not suitable for web or print.
- **GIF** A highly compressed format mainly used for Internet graphics with solid colors and crisp lines.
- **JPEG** A compressed format used for Internet graphics, particularly photographs.
- PNG A versatile bitmap compressed format used mainly for Internet graphics.
- TIFF Saves bitmap images in an uncompressed format, most popular for print and compatible for virtually all image editing and page layout applications.

Note: To maintain the highest quality, images are usually saved uncompressed in TIFF format. However, in Illustrator you can apply what's called LZW compression on a TIFF, which compresses the file smaller without discarding detail from the image.

Vector- and bitmap-based formats:

- **EPS** Flexible file format that can contain both bitmap and vector information. Most vector images are saved in this format.
- PICT Used on Macintosh computers, and can contain both vector and bitmap data.
- SWF The Macromedia® Flash™ file format. A common vectorbased graphics file format for the creation of scalable, compact graphics for the web and handheld devices.
- **SVG** An emerging XML-based, vector format for the creation of scalable, compact graphics for the web and handheld devices.

DESIGN PRINCIPLES WITH ILLUSTRATOR

Okay, so we've covered some nitty-gritty about how images are digitally created, now we can progress to something a bit more right brain. You might be relieved to know that the approach to creating an illustration in Illustrator is not unlike traditional drawing and painting. Whether sketching by hand or computer mouse, the principles of design are essentially the same. With this in mind, you can begin to learn the tools and techniques of Illustrator as they apply to the fundamental building blocks of visual art. "The corresponding structural elements of art are line, shape, value, texture, and color," explain the authors of *Art Fundamentals, Theory and Practice:* "In art the artist is not only the contractor but also the architect; he or she has the vision, which is given shape by the way the elements are brought together."

Each chapter of this book builds on the elements of art as they pertain to your growing understanding of the Illustrator program. With the elements of line, shape, value, texture, and color, a direct correlation can be made with understanding how a vector illustration is constructed to the structural elements of art and design. As you will learn in greater detail in Chapter 4, a digital illustration is composed of vector objects, each having one or more paths (shapes) made of line segments having anchor points at each end. Each object's lines and shapes become distinctly unique, unified,

and/or spatially whole by application of value, texture, and color. On a cursory level, you'll explore this relationship in the next lesson. Additionally, a visual diagram of this correlation might help (Figure 3–5).

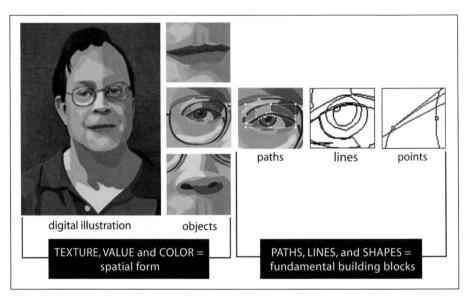

figure | 3-5 |

Anatomy of an illustration with the elements of art and design in mind.

As an artist would use watercolors, charcoal sticks, or clay to bring a vision to form, Illustrator is also a medium toward a creative end. See Figure 3–6. Its numerous tools and features are designed to support the elements inherent in visual artwork and beyond, as you'll discover throughout this book.

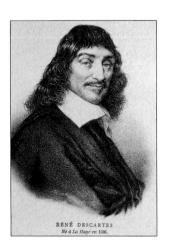

figure 3-6

Notice how line, shape, value, and texture make up the illustration of René Descartes, shown here. Value is indicated by the light and dark shapes in the drawing. Textural line effects bring out the subtle softness and depth of his hair and robe. Note: René Descartes can be considered one of the foremost fathers of vector illustration. A seventeenth-century mathematician and philosopher, he developed analytic geometry, in particular coordinate systems, which provide a foundation for describing the location and shape of objects in space.

Lesson: Adam's Eye

In this lesson you take a guided tour of a premade Illustrator file. Step-by-step you import and place a bitmap image, add a warp effect, unlock layers, and explore the different stages of vector object construction—all the while keeping design principles in mind. See Figure 3–7 of the completed lesson.

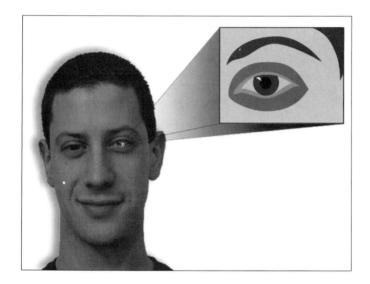

figure | 3-7 |

Completed lesson: Adam's Eve.

Setting Up the File

- **1.** Open the Illustrator program.
- **2.** Choose File>Open and, on your local hard drive, browse for the Exploring Illustrator **chap3_lessons** folder. Open the file **chap3L1.ai.**

Note: As mentioned in the File Set-up, in order to save your work, you must make a copy of the chapter lessons to your local hard drive, and select files from that location.

- **3.** Choose Window>Layers to open the Layers palette (see Figure 3–8). Layers organize the various elements of an Illustrator document. There are already several layers created for this document.
- **4.** Unhide the layers called **magnification_box** and **sparkle** by turning on the visibility option for each layer in the Layers palette (Figure 3–9 and Figure 3–10).

figure | 3-8 |

The Layers palette.

figure | 3-9 |

The Layers visibility option is indicated by an eye icon on the left of the Layers palette.

figure | 3-10 |

Unhiding Layers reveals more parts of the illustration.

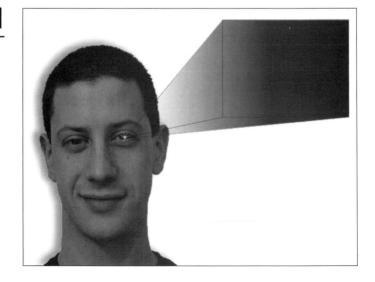

Importing a Bitmap

- 1. Select the **sparkle** layer. See Figure 3–11.
- **2.** Click the Create New Layer option at the bottom of the Layers palette (next to the trash can icon) to make a new layer above the **sparkle** layer. See Figure 3–12.
- **3.** Double click on the new layer (called Layer 8) to open the Layer options. Alternatively, click on the arrow in the upper right corner of the Layers palette and select Options for "Layer 8." See Figure 3–13.

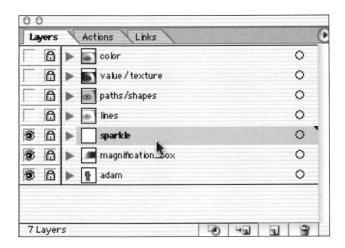

figure | 3-11 |

Sparkle layer is selected (highlighted in blue).

figure | 3-12 |

The Create New Layer option.

figure 3-13

Opening the Layer options.

- **4.** For the layer name type in: **eye_bitmap**, and choose OK. See Figure 3–14.
- **5.** With the **eye_bitmap** layer selected choose File>Place from the main menu.
- **6.** Browse for **chap3_lessons/assets** and open the **adam_eye.jpg**.
- **7.** Choose Window>Transform and in the Transform palette window type in: **W: 240 pt,** and **H: 180 pt** to reduce the bitmap's size. See Figure 3–15.
- **8.** Select and drag the bitmap image to fit into the magnification box. For a precise fit, hit the up/down, right/left arrow keys on the keyboard to move the image in 1-pt. increments. See Figure 3–16.

figure | 3-14 |

Naming the Layer.

figure 3-15

Exactly size the bitmap in the Transform palette window.

figure | 3-16 |

Position the eye bitmap.

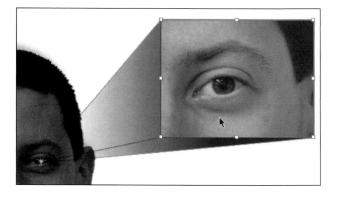

- **9.** For fun, choose Effect>Warp>Fisheye. In the Warp Options window, adjust the Bend option by moving the slider to 72%. Preview the effect on the bitmap by selecting the Preview option (Figure 3–17). (Note: you might need to move the Warp Options window aside to see the eye bitmap effect on the document below). Select OK to close the Warp Options window.
- **10.** Double-click the **eye_bitmap** layer to open the Layer options. Select the **Dim Images to** option and set it at 75%. This option dims the bitmap located on this layer, which will be useful when you trace over the image in the next section.
- 11. Lock the **eye_bitmap** layer by selecting the lock option on the left of the Layers palette (Figure 3–18). Locking layers is useful when you want to make them uneditable when working on other layers.

figure | 3-17 |

Preview the Fisheye Warp settings.

figure | 3-18 |

Lock a layer to make it uneditable.

figure | 3-19 |

The Selection tool is the black arrow that allows you to select objects in your document. **12.** Save your file by choosing File>Save As. Rename the file **chap3L1 yourname.ai,** and save it in your lessons folder.

Exploring Lines

- 1. Unhide and unlock the layer called **lines** in the Layers palette. Some lines, traced around the image of the eye, have already been created. Constructing lines and paths are the first step in the illustrative process.
- **2.** Be sure the selection tool is chosen in the Toolbox (Figure 3–19).

Note: By default your toolbox should be open. If not, choose Window>Tools to open the palette.

- **3.** Explore selecting the different lines and paths on the eye image. Notice how each line segment is comprised of connecting anchor points. See Figure 3–20.
- **4.** Each line created is indicated in the **lines** layer. To see the sub list of lines (labeled <Path>) click the gray arrow next to the **lines** layer icon. To quickly select the various lines/paths in the document, click on the target circle to the right of any of the layers (Figure 3–21).
- **5.** Let's make a new line object, by outlining the eyebrow of the eye bitmap image. First, select the Zoom tool in the toolbox (the magnifying glass icon toward the bottom of the palette), and then click once on the eye bitmap to magnify it.

Note: If you make a mistake, double-click on the Zoom tool icon in the toolbox to zoom back out to full view, and then try again.

figure | 3-20 |

Select lines and paths.

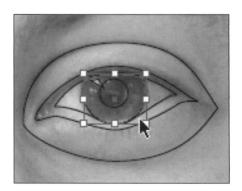

figure | 3-21 |

To organize all the elements of an illustration, layers can be further subdivided into sublayers.

- **6.** Now, select the Pencil tool in the toolbox (Figure 3–22).
- **7.** With steady hand, click and drag a continuous line around the eyebrow (Figure 3–23). Be sure to close the shape by ending the line in the same place where you began the line. If you make a mistake, simply choose Edit>Undo Pencil and try it again.

Note: There are numerous ways to edit and reshape the line you created, which will be covered in later chapters. For now, just get a feel for what it's like to trace over an image.

8. Save your file.

figure | 3-22 |

The Pencil tool is just one of the tools to create lines and paths.

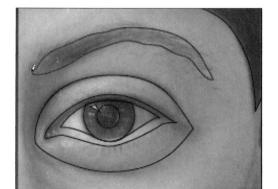

figure | 3-23 |

Drawing an eyebrow with the Pen tool and your mouse takes a steady hand.

Filling a Shape

- **1.** Unhide the **paths/shapes** layer. Here, you see the lines created filled with flat shading, resulting in distinct shapes.
- **2.** Select your eyebrow and choose Window>Swatches. Select the 80% black (dark gray) swatch to fill the eyebrow (Figure 3–24 and Figure 3–25).

figure | 3-24 |

The Swatches palette.

figure | 3-25 |

The filled eyebrow shape.

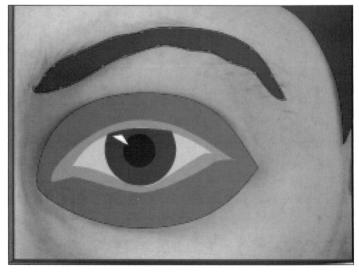

Adding Value and Texture

- 1. In the Layers palette unhide the **value/texture** layer. Notice here, the variations of line—width, intensity and quality—adding value and texture to the illustration.
- **2.** Select your eyebrow and choose Window>Brushes.
- **3.** In the Brushes palette choose the charcoal art brush (Figure 3–26 and Figure 3–27). A charcoal-like style is added to the stroke (outline) of the eyebrow. Explore the other available brushes by selecting them in the Brushes palette, as they automatically update on the selected path.

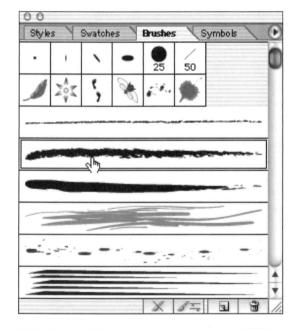

figure | 3-26 |

Select the charcoal brush in the Brushes palette.

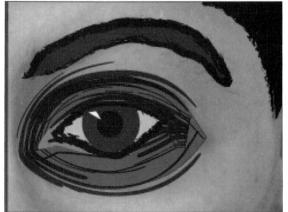

figure | 3-27 |

The eyebrow outline has texture and value.

figure | 3-28 |

The Fill box in the toolbox

figure | 3-29 |

Choosing a color in the Color palette.

Adding Color

- **1.** Unhide the layer named **color.** As crazy as they are, colors have been added to the eye image, creating an illusionary effect and mood.
- **2.** Select your eyebrow and then click on the Fill box in the toolbox to open the Color palette. See Figure 3–28.
- **3.** In the Color palette drag your cursor over the color spectrum bar in the lower part of the window to select a fill color. See Figure 3–29.

figure | 3-30 |

Bring the Stroke option forward in the Tool palette.

Note: If your color palette doesn't look like Figure 3–29, you might need to expand it. Click on the down arrow located on the color palette's title tab.

- **4.** Change the stroke (outline) color of the eyebrow by first selecting the Stroke box in the toolbox. Clicking on the Stroke box brings the stroke option forward and editable (Figure 3–30).
- **5.** In the Color palette drag your cursor over the color spectrum bar in the lower part of the window to select a color.
- **6.** Hide the **eye_bitmap** by toggling its visibility off in the Layers palette.
- **7.** Choose View>Fit In Window.
- **8.** Save your file.

SUMMARY

Vital survival techniques for gung-ho graphic artists were revealed in this chapter. You learned that tools are cool, but knowing about digital image construction and design principles is what really keeps you alive in the Illustrator jungle. Briefly described were characteristics of bitmap and vector graphics, image formats, and resolution; all which help to prepare you for the idiosyncrasies of drawing digitally. Lastly you progressed through the creation of an illustration by building on the principles of design, including line, shape, value, texture, and color.

in review

- 1. Briefly describe the differences between bitmap and vector graphic types.
- 2. Illustrator's underlying magic is its ability to work with what type of images?
- 3. Bitmap images are most common for what type of images? Why?
- 4. Text and logo treatments are created best as what type of a graphic? Why?
- 5. What's image resolution? Why is it important to know?
- 6. What is an image file format?
- 7. What are the five elements of art that can be explored in the Illustrator program?

★ EXPLORING ON YOUR OWN

- Access the Help>Illustrator Help menu option. Search for and read up on the following topics: About vector graphics and bitmap images; Changing vector graphics into bitmap images; About resolution in bitmap images.
- 2. Do an online search for "design principles" and read-up on traditional design concepts and current trends.

drawing lines and shapes

charting your course

The last chapter introduced you to the essential elements of visual imagery—line, shape, value, texture, and color. By focusing on the first two elements—line and shape—this chapter further solidifies your understanding of how to draw in Illustrator. Illustrator has numerous tools to produce lines and shapes. Some of them create geometric shapes, others more freeform styles, and one in particular, the Pen tool, offers a more precise drawing experience. As you practice the methods for drawing lines and shapes, you'll also encounter useful terminology for describing various shapes, and the vector points, line segments and paths from which they are made.

goals

In this chapter you will:

- Review the process of creating illustrations in Illustrator.
- Learn the difference between open lines and closed lines/shapes.
- Draw and transform basic shapes and describe shape types in design.
- Explore the freeform drawing tools.
- Discover the characteristics of Bezier lines and curves using the Pen tool.
- Create, move, and edit straight and curved paths.
- Combine straight and curved paths into object shapes.
- Select and edit individual anchor points.

THE SIMPLICITY OF LINES AND SHAPES

Look closely at Figure 4–1. It's a candlestick, right? Look at it again; this time squint your eyes, and focus on its form—the outline and shapes—that distinguish the object. It has a cylindrical shape at the top, some various shaped circles along the stem, each connected by smaller cylinders, and a cone-like base. What initially looks like an intricate candlestick is essentially a series of geometric shapes (Figure 4–2). It's the eye of the artist that has the ability to visually break down objects into simple and familiar lines and shapes; to look at common objects as objective forms.

Looking, and thus drawing, objects in this way takes an awareness of what you might think very obvious—what's a line and what's a shape? A line in drawing is simply an edge or a boundary. Within Illustrator, and most other graphic drawing programs, a line can have several different names, which gets a bit confusing. Generally speaking, a line can also be referred to as a stroke, an outline, and/or a path. Lines can be either opened or closed. A closed line is usually referred to as a shape. See Figures 4–3 through 4–7 for clarification. Lines can also have different values (thicknesses) and colors, which we get into in later chapters.

With an artist's eye, you'll practice your line and shape design abilities in the next series of lessons using basic shapes, freeform, and precision drawing tools and techniques.

figure **| 4**-1 **|**

An intricate candlestick.

figure **| 4-2 |**

On closer inspection the candlestick is really just made up of geometric shapes.

figure | 4-3 |

A shape is defined as a line enclosing an area. In the study of design, shapes actually have specific definitions depending on what they look like.

figure | 4-4 |

Geometric shape constructed mathematically.

figure | 4-5 |

Rectilinear shape bound by straight lines, which are not related to each other mathematically.

Biomorphic (organic) shape bound by free-flowing curves, suggesting fluidity and growth.

figure 4-7

Irregular shape bound by straight and curved lines, which are not related to each other mathematically.

GEOMETRIC, FREEFORM, AND PRECISION DRAWING

To match the visual image you might have in your mind's eye with what actually materializes on the Illustrator artboard, totally depends on three things—the tools you use, the methods you use, and the process by which you go about the whole endeavor. Take

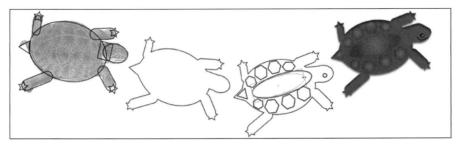

figure 4-8

A simple drawing of a turtle using geometric shapes, then adding color and texture.

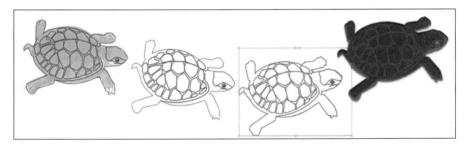

figure 4-9

A more complex drawing of a turtle constructed using the Pen tool.

for example, my idea to draw a turtle—where do I begin? Do I want the turtle to look more cartoon-like or more like the real thing? To make a cartoon-like turtle I opted to trace over a photograph using the basic shape tools and then combine them together. Check out Figure 4–8. To make it more realistic I traced over a photograph again but used the Pen tool, which gave me the flexibility to draw a more complex reptile. See Figure 4–9. Both methods produced an illustration of a turtle, but each with a different visual result depending on the tools I used.

Now it's your turn to practice making lines and shapes using various tools and methods. You've already had some opportunity to play with some of these shape creation tools in Illustrator. In the first chapter you tackled the connect-the-dots logo design using the very precise Pen tool, and in Chapter 3 you cursorily sketched an eyebrow in the Adam's Eye lesson using the more freeform pencil tool. As promised, we now get more specific with these

tools, starting with Illustrator's options for creating geometric and freeform shapes, and then working with the more accurate Pen tool

Lesson 1: Basic Lines and Shapes

In this lesson you practice creating geometric and freeform shapes. To do this, you draw on a template that defines the different shape types in art and design.

figure | 4-10 |

Set the Stroke and Fill to the default.

Setting Up the Stroke and Fill Attributes

- **1.** In Illustrator, choose File>Open and open the **chap4L1.ai** in the **chap4_lessons** folder.
- **2.** Choose Shift-Tab to temporarily hide any palettes and give you more room to work.
- **3.** Before you begin to draw it's a good idea to set up the fill and stroke (outline) color attributes. First, select the default color option in the toolbox, making the fill area white and the stroke black. See Figure 4–10.
- **4.** Click on the fill box (the white one) to activate it if it's not already. See Figure 4–11.
- **5.** Choose the "none" option to indicate no color for the fill. See Figure 4–12.

figure 4-11

Click the Fill box to activate it.

Making Geometric Shapes

- **6.** Select the Zoom tool and zoom in close to the first quadrant of the file labeled Geometric Shapes. In the blank area below the row of geometric shapes you will practice drawing the shapes. Let's call this the "drawing area."
- **7.** Select the Rectangle tool in the toolbox.
- **8.** Starting in the upper left corner of the first quadrant drawing area, click and drag down to create a rectangular shape. See Figure 4–13.
- **9.** Practice moving the rectangle in different directions by clicking incrementally on the up/down or right/left arrow keys on

figure | 4-12 |

Choose the None option to indicate no color for the fill.

figure | 4-13 |

Create a rectangle in the Geometric Shapes drawing area.

the keyboard. Of course, you can also use the Selection tool to translate the shape as well.

- **10.** Delete the rectangle, by selecting it (if not already) and hitting Delete on the keyboard.
- 11. Select the Rectangle tool again. This time, place your cursor anywhere over the drawing area and click down once to open the Rectangles option box. Here, you can add in an exact width and height for the rectangle. Let's make a perfect square, type in $1.5 \text{ in} \times 1.5 \text{ in}$ in the dialog box. Hit OK to create the shape.
- **12.** Practice making a few more rectangle or square shapes by clicking and dragging to create the shape or clicking once on the drawing area and indicating exact dimensions in the rectangle dialog box.
- **13.** Select the Selection tool in the toolbox. Select one of the rectangle shapes you made, then hold down the Shift key and click on each of the others to add them to the selection. See Figure 4–14.
- **14.** Hit Delete on the keyboard to delete the selected shapes and clear the drawing area.
- **15.** Click and hold on the rectangle tool in the toolbox to open the other shape options. See Figure 4–15. Choose the Rounded Rectangle tool option.

figure | 4-14 |

Select multiple shapes to delete them all at once.

figure | 4-15 |

Select the Rounded Rectangle tool option.

- **16.** Click once on the drawing area to open the Rounded Rectangle options. For Width put in 1.2 inches, Height 1.2 inches, Corner Radius 0.2. Hit OK to see the result. See Figure 4–16.
- **17.** I don't know about you, but I don't find it intuitive to put in a number for the corner radius. I prefer doing this interactively. Here's how: first, select the Rounded Rectangle tool again.
- **18.** Now, click and drag to create the shape, *BUT then* keep your finger pressing down on the mouse button. With the mouse button held down, also hold down the up arrow (Page Up) key on the keyboard. The corner radius of the shape changes before your eyes!

figure 4-16

Enter options for the Rounded Rectangle tool.

- **19.** With your finger still pressing the mouse button try holding the Down Arrow key—the corner radius goes the opposite direction. What happens if you choose the right and left arrow keys?
- **20.** Select all your rounded rectangles and delete them.
- **21.** Now, click and hold on the Rounded Rectangle tool in the toolbox to open the Shape options. Choose the Ellipse tool.
- **22.** Click and drag to create an ellipse shape on the drawing area. As you draw the shape notice how it draws from the edge out.
- **23.** Let's draw the shape from the center out. To do this, first select the Ellipse tool.
- **24.** Place your cursor over the drawing area and select the Alt/ Option key—notice how the cursor changes to a box with a cross mark in the middle.
- **25.** Keeping the Alt/Option key held down, click and drag to make the circle. Notice how your circle is now being constructed from its center out. This option is very helpful to create more accurately placed circular shapes.
- **26.** Delete all your ellipse and circle shapes.
- **27.** Click on the Ellipse tool in the toolbox to open the Shape options again. This time choose the Polygon tool.
- **28.** Now that you have an idea of how shapes are drawn, create some polygonal shapes. Try clicking and dragging to create the shapes. Try clicking, dragging, and then keeping your mouse button pressed, hold the Up or Down arrow keys to interactively add or subtract sides to the shape. I know this

takes some coordination, but it's definitely a handy little trick. Using this method, see if you can make a triangle from the polygon shape. How about a circle?

29. Finally, choose the Star tool in the Shape tool options list and practice the same method learned in the last step to draw and adjust the star shape. Use the Up key to make more points on the star, or the Down key to make less.

Transforming Lines and Shapes

- **1.** Select and delete (Edit>Clear or hit the Delete button on the keyboard) all the geometric shapes you created in the first quadrant of the lesson file.
- **2.** Make a new star shape in the first quadrant drawing area.
- **3.** Choose the Selection tool (black arrow) in the toolbox, and select the star shape. A Free Transform bounding box appears around the object; a blue box with positioning nodes (squares) on each corner and side. This bounding box is really a time saver—it's a Move, Scale, and Rotate tool in one. You'll use it in the next steps and a lot in later chapters.

Note: If you don't see the bounding box around the object, go to View>Hide Bounding Box to unhide this option.

4. Move the star by clicking on its edge (the black outline) and dragging it to a new position on the drawing area. See Figure 4–17.

figure | 4-17 |

Move the star shape.

In this particular lesson you've been making shapes with a stroke (outline) color only, no inside fill color. (If you recall, you played with strokes and fills somewhat in Chapter 1, but it's also covered more in the next chapter.) The rule for successfully selecting and moving an object is that you must click on a part of the object that actually has color applied to it. If, for example, you click in the center of an object where no fill color is indicated, you end up deselecting the object—oops!

5. Scale the star by clicking on a corner of the bounding area and dragging the shape to a new size. See Figure 4–18.

Note: To uniformly scale, hold down the Shift key as you scale the object.

6. Rotate the object by first positioning the cursor slightly outside one corner of the bounding box. The cursor shifts to an icon of a bent line with an arrow at each end. See Figure 4–19. Click and drag to rotate the object.

figure | 4-18 |

Scale the star shape.

figure | 4-19 |

Rotate the star shape.

Making Rectilinear shapes

- **1.** Still working on the **chap4L1.ai** file set your viewing area to the second quadrant labeled Rectilinear Shapes. Two rectilinear shapes have already been created for you. You will trace over these shapes.
- **2.** Select the Line Segment tool in the toolbox. The Line Segment tool allows you to create individual straight lines called line segments—how convenient! See Figure 4–20.
- **3.** Position the cursor in the upper left corner of the first rectilinear shape, click and drag to the right creating a line segment that defines the top of the shape. See Figure 4–21.

figure | 4-20 |

Select the Line Segment tool.

figure | 4-21 |

Draw a line segment.

4. Continue making line segments to construct the shape. To make a perfectly straight line, constrain the line as you draw it by holding down the Shift key.

Note: To move or transform a line, hold down Command (Mac) or Ctrl (Windows) and the Line Segment tool will temporarily switch to the Free Transform option.

5. Go ahead and practice using the Line Segment tool to trace over the other rectilinear shape. Then, make your own rectilinear shapes in the drawing area below the templates.

Making Biomorphic Shapes

- **1.** Okay, free yourself from the rigidness of the Line Segment tool and let's go organic. Set your viewing area to the third quadrant—Biomorphic Shapes.
- **2.** Select the Pencil tool in the toolbox. See Figure 4–22.
- **3.** With steady hand, draw a continuous line around the first biomorphic shape. Yeah, I know it's not easy (this is why you learn the Pen tool later, when you'll have more control). Nevertheless, try it again. Delete the shape or select Edit>Undo Pencil and then redraw the shape. See how close you can get.
- **4.** Try tracing the other biomorphic shape.
- **5.** Make your own organic shapes in the drawing area below the templates.

figure | 4-22 |

Select the Pencil

Making Irregular Shapes and Grouping Them

- 1. Set your viewing area to the last quadrant—Irregular Shapes. These type of shapes have a combination of linear (straight) and biomorphic (curved) lines. You'll use a different tool for each type of line.
- **2.** Select the Line Segment tool in the toolbox. Trace the straight lines of the first shape (hint: there are three of them). See Figure 4–23.
- **3.** Now, click and hold on the Line Segment tool in the toolbox to open the other Segment options. Choose the Arc tool. See Figure 4–24.
- **4.** Click where you want the arc to begin (in this case, the upper left point of the first irregular shape) and drag to create the arc. See Figure 4–25.

figure | 4-23 |

Trace lines with the Line Segment tool.

figure 4-24

Select the Arc tool.

Note: When drawing lines with the Line Segment and Arc tools each line created is separate from the next. Test this out—choose the Selection tool in the toolbox and individually select each line created.

5. Let's group the individual lines of this irregular shape—select one of the lines in the object, then hold down the Shift key and select each of the other three line segments of the shape.

Note: Using the Shift key while selecting objects subsequently adds the objects to the selection.

- **6.** Choose Object>Group from the menu bar to group the selected line segments together.
- **7.** Using the Selection tool, move the irregular shape to see its grouped state. By grouping line segments and shapes they become easier to move around, scale, and rotate.

Note: To undo a group is easy—simply select the grouped object and choose Object>Ungroup.

8. Use the Line Segment tool and Arc tool to trace the other irregular shape.

Note: To change the direction of an arc hold down the Up or Down arrow keys (depending on which way you want the arc to bend) as you click and drag to draw the shape.

- **9.** Create your own irregular shapes in the drawing area below the templates. Select the individual lines and arcs and group them together.
- **10.** Save your file in your lessons folder, if you like.

figure | 4-25 |

Create the arc shape.

Mastering the Precise Pen Tool

My first attempt with the Pen tool was mediocre at best. I felt as if I was drawing with an Etch A Sketch®—remember that toy? Moving my computer mouse with any sort of grace reminded me of turning those awkward little red knobs. Luckily, however, I never gave up learning how to use this tool. Now it's my weapon of choice, and for most other professional Illustrator artists, when drawing just about anything in the program. Think of the Pen tool as King Arthur's sword, the Excalibur (the one stuck in solid rock); it was unwieldy at first, but once mastered, mighty and faithful

Exactly like Illustrator's other drawing tools you've encountered so far, the Pen tool creates vector-based lines and shapes. However, to be successful using the Pen tool, it helps to take a more detailed look at a vector illustration's anatomy. See Figure 4–26. A vector illustration is comprised of vector objects, such as the head, mouth, and eye of the turtle in Figure 4–26. Each object contains one or more paths (lines), which are made up of line segments. A line segment has an anchor point at each end. Anchor points are the most fundamental component of a vector illustration—they are the dots that connect paths together. Through direction lines and direction points (together called direction handles), anchor points define the position and curve attributes of each line segment. Here's a little trivia for you—the name for the resulting curve attributes of a line segment are called Bezier (pronounced beh-zee-ay) curves. Pierre Bezier, a French mathematician, was the

figure | 4-26 |

The turtle's head illustrates the various parts of a vector's anatomy.

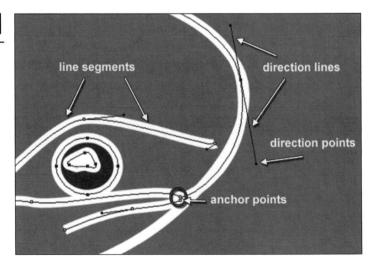

very smart fellow who developed the method for defining these curves mathematically. You'll get to define your own curves—the Illustrator way—in the next lessons.

Lesson 2: Drawing Precise Straight and Curved Paths

In this lesson you practice drawing with the Pen tool to create, move, and adjust straight and curved paths.

Setting Up the Stroke and Fill Attributes

- 1. In Illustrator, choose File>Open and open the **chap4L2.ai** in the **chap4_lessons** folder.
- **2.** Choose Shift-Tab to temporarily hide any palettes. You'll need lots of space to work.
- **3.** Select the default color option in the toolbox, making the fill area white and the stroke black. (Refer back to figure 4–10.)
- **4.** If not already, click on the fill box (the white one) to activate it. Refer back to Figure 4–11.
- **5.** Choose the "none" option to indicate no color for the fill. Refer back to Figure 4–12.

Starting with Straight Lines

- 1. Zoom in close to the first quadrant of the lesson template labeled Straight Paths.
- **2.** Select the Pen tool in the toolbox. See Figure 4–27.
- **3.** Click (but don't drag) on the red dot on the top straight line. This defines the first point.
- **4.** Click (don't drag) again at the end of the line to create the straight segment. See Figure 4–28.

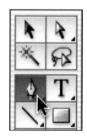

figure | 4-27

Select the Pen tool.

figure | 4-28 |

Click to make another anchor point at the end of the line segment.

Straight Paths			
			parameter et ma

DON'T GO THERE

There's a big difference between a "click" and a "click and drag" to define an anchor point of a line segment. To create straight lines you simply click once to make each point. If direction lines appear, you've accidentally dragged the Pen tool. Fix this by choosing Edit>Undo and click again. The click and drag action comes later when you start making curves. Also, the first point you draw will not be visible until you click a second anchor point. It takes two anchor points to make a complete line segment.

- **5.** Prepare to start another line segment by doing one of the following things:
 - Command-click (Mac) or Ctrl-click (Windows) anywhere away from all objects.
 - Choose Select>Deselect,
 - Or click on the Pen tool icon in the toolbox again.

Note: You know you're ready to make a new path when the cursor for the Pen tool has a little cross mark next to it. See Figure 4–29.

- **6.** Using the guide, practice making another straight line segment under the one you first created. To do this, click on one end and then the other.
- 7. Next, select and hold the Command (Mac) or Ctrl (Windows) key to initiate the Free Transform bounding box around the line. Click on the line and practice moving it around. Remember you can use the Free Transform box to move, rotate, or scale any object.

figure | 4-29 |

A cross mark next to the Pen tool cursor sets the Pen tool to make a new path. Note: If you don't see the bounding box around the line, go to View>Hide Bounding Box to unhide this option.

- **8.** Choose Select>Deselect to deselect all objects.
- **9.** Select the Pen tool again and click down on the red dot of the zigzag line.
- **10.** Continue clicking down points at each corner angle of the line until completed. See Figure 4–30.

figure 4-30

Anchor points to make a zigzag line.

- **11.** Select (with the Selection tool) the zigzag path and practice moving, scaling, and rotating the line.
- **12.** In the first quadrant area of the lesson, practice creating your own straight and zigzag paths.

Making Closed Straight Paths/Shapes

- 1. Still working in **chap4L2.ai**, choose View>Actual Size.
- **2.** Zoom in closer to the second quadrant area labeled Closed Straight Paths/Shapes.
- **3.** Select the Pen tool.
- **4.** Click to place a point at the red dot of the triangle shape, click at the next corner, then the next.
- **5.** To close the path, position the cursor over the starting point again, and notice that the cursor has an open circle next to it (See Figure 4–31)—this indicates you are ready to close this path. Click again on the starting point to close the path.

Note: Closing a path ends a path. In contrast to what you learned earlier, to end an open path you have to click the Pen

Close a path.

tool in the toolbox or choose Command (Mac) or Ctrl (Windows) and click away from the path.

6. On your own, practice drawing closed shapes using the snowflake shape on the template as a guide.

Drawing Curved Paths

- 1. Still working in chap4L2.ai, choose View>Actual Size.
- **2.** Zoom in close to the third quadrant area labeled Curved Paths. To make things a little easier, guides indicating the direction lines and/or placement points for the path are provided.

Note: In case you're wondering, direction lines and points do not print.

- **3.** Select the Pen tool.
- **4.** Click and hold on the red dot of the first curve. Begin to drag up to release the direction handles. Extend the handles to the length indicated on the guide. See Figure 4–32 and Figure 4–33. If you make a mistake, Edit>Undo Pen and try it again.
- **5.** Continue the curved path by clicking on the center anchor point and dragging down handles to match the guide. Your first curve is formed. See Figure 4–34 and Figure 4–35.
- **6.** Complete the curved path by clicking and dragging up on the last anchor point. See Figure 4–36 and Figure 4–37.

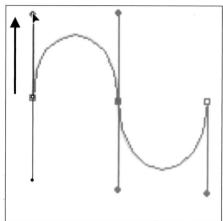

figure | 4–32 and 4–33 |

Start off the curve.

figure | 4-34 and 4-35 |

Complete the first curved segment.

figure | 4-36 and 4-37 |

Finish the curved path.

When first learning how to make curves it's common to get what I call "click happy." The tendency is to click down many points while drawing, thinking to get a more accurate shape. However, in this case, more is not necessarily better. The trick is in the placement and adjustment of the anchor points and direction handles; if you play them right, you can create simpler and cleaner lines. For example, to achieve a more symmetrical line, place points at the ends of a curve, rather than at the high point of a curve. Check out Figure 4-38 and Figure 4-39.

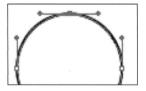

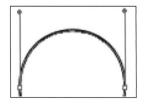

figure | 4-38 |

Place a point at the high point of the curve-not very efficient when creating symmetrical lines.

figure | 4-39 |

Place points at the ends of a curve and adjust the handles more efficient.

- **7.** Practice your anchor point placement on the second curve in the Curved Path's quadrant. In this example the direction handles are not provided for you, but the point placements are. Position each point and drag the handles out sideways until you create each desired curve. See Figure 4–40.
- **8.** Make some of your own curves in the drawing area of the Curved Paths quadrant.

figure | 4–40 |
Practice curves.

Drawing Closed Curved Paths/Shapes

- 1. Still in chap4L2.ai choose View>Actual Size.
- **2.** Zoom in to the last quadrant area, labeled Closed Curved Paths/Shapes.
- **3.** Select the Pen tool.
- **4.** Let's create a circle with only two points—click on the red dot of the circle and drag up to match the handle in the guide. See Figure 4–41 and Figure 4–42.

Note: If you hold down the shift key as you drag you can constrain the angle of the handles.

figure | 4-41 |

figure | 4-42 |

- **5.** Now, click on the point opposite the circle and drag the handles down to form the top curve. See Figure 4–43 and Figure 4–44.
- **6.** Click again on the first point and drag the handles up to create the bottom curve and close the shape. See Figure 4–45 and Figure 4–46.
- **7.** Now, practice your curved paths on the guide that looks like a flower. Because each petal of the flower is not a symmetrical curve, I suggest adding points not only at the ends of each petal curve but also at the top of each to more easily get the correct shape. Check out Figure 4–47 to get the idea.
- **8.** On your own practice, make some more closed curved shapes. Can you make a butterfly shape? Some tree leaves?
- **9.** Save this file **chap4L2_yourname.ai** if you would like. We are done with this lesson.

figure | 4-43 |

figure | 4-44 |

figure | 4-46 |

figure | 4-47 |

Make a flower shape.

Lesson 3: Combining and Editing Straight and Curved Paths

So far you've got the almighty Pen tool drawing straight and curved paths. Next you use it to skillfully make and edit paths made up of both straight and curved segments.

Setting Up the Stroke and Fill Attributes

- 1. In Illustrator open the lesson file **chap4L3.ai** in the **chap4_ lessons** folder.
- **2.** Choose View>Actual Size.
- **3.** Choose Shift-Tab to temporarily hide any palettes.
- **4.** As you've done previous lessons, select the default color option in the toolbox, making the fill area white and the stroke black.
- **5.** Click on the Fill box (the white one) to activate it.
- **6.** Choose the "none" option to indicate no color for the fill. Now, you're ready to start drawing.

Putting Straight and Curved Lines Together

1. Zoom in close to the gear-like object in the upper left of the file.

- **2.** Select the Pen tool.
- **3.** Click once on the red dot to define an anchor point.
- **4.** Moving clockwise, click on the other end of the first curve and drag to make the curve segment. For reference, see Figure 4–48.
- **5.** Now click on the next top point of the next curve in the shape. See Figure 4–49. Oops, the curve is going in the wrong direction—this is because you are attempting to draw around a sharp corner in the shape. To change the direction of the curve you must "break" the direction handle. See Figure 4–50 and Figure 4–51. Let's break the handle in the next step.

figure | 4-48 |

Click and drag to make a curve.

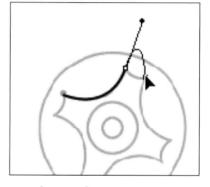

figure | 4-49 |

The curve goes in the wrong direction.

figure | 4-50 |

An unbroken direction handle produces a continuous curve.

figure 4-51

A broken direction handle creates a corner point, which changes the direction of the curve.

- **6.** First, choose Edit>Undo Pen to delete the faulty anchor point.
- **7.** Now, place your cursor right over the last anchor point—notice the Pen tool has a little upside down V shape next to it—see Figure 4–52. This indicates that the Pen tool is prepared to break the direction handle, converting the point to a corner point—click down on the point to do this.
- **8.** Now, click and drag on the next top arch of the curve to produce the correct line. See Figure 4–53.

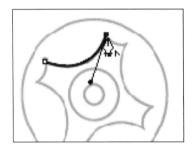

figure | 4-52 |

Convert the direction of the curve by breaking the direction handle.

figure | 4-53 |

Create the new curve.

- **9.** Place your cursor over the point you just placed until you see the upside-down V-shape icon—click again on the point to break the direction handles.
- **10.** Now, go to the next top arch of the curve and click and drag to make the line.

If at this point you're about to give up on the Pen tool, please don't! Like anything new, it takes practice. Once you get it, however, I guarantee it will open up your Illustrator world. One thing I like to do if I find myself getting stuck, is to delete the whole lesson or the part I am working on and try doing it again (and again . . .) from step 1.

11. Continue drawing around the shape, breaking the direction handles as you draw each curve segment.

12. Two other templates have been provided to practice combining curved and straight line segments—a photograph of a pumpkin and the silly salamander. Hone-in your pen coordination skills and trace over these objects. Try to be efficient with your point placement—less is better, in this case. Once again, if you make a mistake my motto is always "delete and do over . . . and over . . . and over." It does get easier, I promise.

Converting and Editing Straight and Curved Paths

- 1. Still working in **chap4L3.ai** choose View>Actual Size.
- **2.** Zoom in closer to the lower section of the file labeled Converting Straight and Curved Paths/Shapes.
- **3.** Choose the Direct Selection tool. See Figure 4–54.

Note: The Direct Selection tool lets you select individual anchor points or path segments by clicking on them. Any direction lines and direction points then appear on the selected part of the path for adjusting. Cool!

figure | 4-54 |

Choose the Direct Selection tool.

- **4.** Select the flower shape on the lesson file. Notice that all the points that make up the shape are visible—points that are hollow (white inside) are unselected. Points that are solid black are selected.
- **5.** Select one of the points on the rounded part of one of the petals and move it up. See Figure 4–55. Notice how the unselected points stay anchored in position, hence the name anchor point.

figure | 4-55 |

Edit a petal with the Direct Selection tool.

- **6.** Select one of the direction points (an end of a direction handle) and drag it out to make the petal wider. See Figure 4–56. Extend the other direction point.
- **7.** Lengthen and expand each petal on the flower.
- **8.** What the heck, let's convert the flower into a star. Hold your cursor over the Pen tool to open the other pen options (yep, there are options!) and select the Convert Anchor Point tool. See Figure 4–57. This tool will look somewhat familiar because we played with it in a different way in the last lesson section.
- **9.** Place the Convert Anchor Point tool over one of the petal points and click to convert the curved line to a straight line. See Figure 4–58. Continue clicking on each point to make the star.

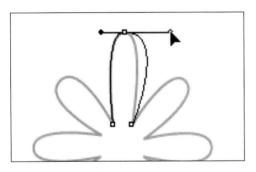

figure | 4-56 |

Adjust the petal by clicking and pulling on the direction lines.

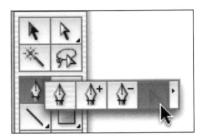

figure | 4-57 |

Select the Convert Anchor Point tool.

figure | 4-58 |

Convert an anchor point.

Note: If you get an annoying warning sign that says something like "Please use the Convert Anchor Point tool on an anchor point of a path" (see Figure 4–59), don't panic. It usually pops up when you missed the anchor point you were attempting to click on with the Convert Anchor Point tool. Simply try clicking directly on the anchor point again. If the points are difficult to see, zoom in closer to the area you are working on.

- **10.** Now, change the star back to a flower—click and drag out on each of the petal points to convert the straight lines back to curved lines. See Figure 4–60.
- 11. Now, let's change the flower into a circle. Hold your cursor over the Convert Anchor Point tool in the toolbox and choose the Delete Anchor Point tool. See Figure 4–61. Notice, for future reference, the Add Anchor Point tool as well.

figure | 4-59 |

Warning for Convert Anchor Point tool usage.

figure | 4-60 |

Convert to curves.

figure 4-61

The often-needed Delete Anchor Point tool. Right next to it is the Add Anchor Point tool to click and add points to a shape if necessary.

- **12.** Click on each of the innermost points of the flower shape to delete them and produce a circular shape.
- **13.** Select again the Direct Selection tool in the toolbox. For fun, select the angular shape (outlined in black) to the right of your mutated flower.
- **14.** Now, select the Convert Anchor Point tool again in the toolbox (an option under the Pen tool).
- **15.** Click and drag on each of the points of the selected angular shape to match the gray template behind it—what materializes? See Figure 4–62.
- **16.** You've completed this lesson.

figure | 4-62 |

Create a profile of a face.

SUMMARY

This chapter covered a lot of important stuff about lines and shapes: what they are, how they are constructed, and what tools and techniques are used to create, edit, and adjust them. You practiced making various types of shapes, developed your hand—eye coordination with the powerful Pen tool and mastered some foundation skills for a more flexible and precise drawing experience.

in review

- 1. What are some of the different names for a line in digital illustration?
- 2. Name the four types of shapes in design.
- 3. What keyboard command do you use to add objects to a selection?
- 4. What keyboard command do you use to draw an ellipse from the center out?
- 5. What part of an object must you click on to select it?
- 6. What's the purpose of a direction handle?
- 7. What's a Bezier?
- 8. What's the difference between a "click" and a "click and drag" when defining anchor points with the Pen tool?
- 9. What tool do you use to select individual anchor points?
- 10. How do you convert the direction of a curve?

≠ EXPLORING ON YOUR OWN

- Access the Help>Illustrator Help menu option. Under Contents read up on the topic of Basic Drawing.
- 2. Practice your pen drawing skills by tracing over the sample images provided in the **chap4_lessons/samples** folder.

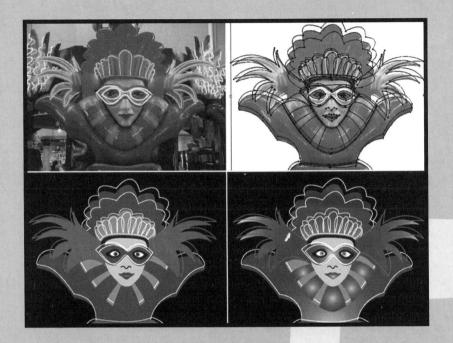

using color

charting your course

Color is an important aspect of illustrative work. We can easily spend 100 pages of this book discussing all the wonderful aspects of color in design. For now, however, let's start simple. This chapter covers some fundamental concepts of color, such as how color is reproduced, what color modes are, and an overview of some color theory that you just can't do without. You then get the chance to explore color in Illustrator, where a whole new aspect of your drawing can emerge.

goals

In this chapter you will:

- Understand the concept of a color gamut.
- Get acquainted with color models.
- Know what color mode to use.
- Apply color to strokes and fills.
- Explore the color features and tools in Illustrator.
- Make gradients.
- Learn how to pick colors using color chords.

SEEING IS NOT NECESSARILY BELIEVING

Have you ever heard the saying "what you see is what you get"? Well, it's not always the case when working with color on a computer screen. Monitors can view millions of colors, but even so, that's not all the colors available in our universe. Every device that has the capability to reproduce color has its own color range (or limits), which defines its *color space* or *gamut*. The human color device—our eyes—can see many more colors than a computer or printer device. Take a good look at Figure 5–1. The chart indicates the visual (human), computer screen (RGB), and printer color (CMYK) gamuts. (You'll learn more about RGB and CMYK in the next section.) Also, a color version is available to view in the color insert located in the middle of this book (Figure 2). Notice the marked areas indicating the gamuts—all the gamuts overlap, each able to view like colors; however the print (CMYK) gamut has the least amount of color possibilities.

So you can imagine what might happen if you pick a color for your digital image in Illustrator (which, by default uses the RGB screen gamut), only to find out when you print it off that the color is completely different. Most likely the color you picked in Illustrator is not available in the printer's gamut. Admittedly this predicament is very frustrating, but once you understand why it happens there are many ways to achieve the result you want. We can't cover all the ways in this chapter, but I'll get you started with some explanation of color models and modes and provide you with some additional reading in the Exploring On Your Own section.

figure | 5-1 |

The visual, screen, and print color gamut areas.

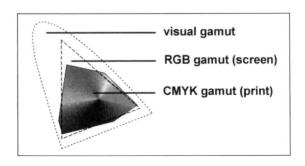

CHOOSING A COLOR MODEL

A *color model*, quite simply, is a system for describing color. You use color models when choosing and creating colors for your artwork. There are many different color models, but in computer graphics and specifically in Illustrator we will look at the following: Grayscale, RGB, Web Safe RGB, HSB, and CMYK.

Grayscale

The Grayscale color model is used to select tints of black ranging in brightness from 0 (white) to 100% (black). In Illustrator when you convert color artwork into grayscale the luminosity (tonal level) of each color in the artwork becomes a representation of a shade of gray. To work in grayscale you select an object you are working on and choose grayscale in the Color palette options, or choose Filters>Colors>Convert to Grayscale. See Figure 5–2.

RGB and Web Safe RGB

The RGB model represents the primary colors of light—red, green, and blue (RGB). The mixing of red, green, and blue light in various proportions and intensities produces a wide range of colors in our visual spectrum. RGB color is also referred to as *additive* color. When R, G, and B light are added together they create white: what occurs when all light is reflected back to the eye (by the way, the absence of colored light is black—what you get when you turn out the lights before going to bed). When R, G, or B overlap each other they

figure | 5-2 |

The Color palette with the Grayscale color model selected.

figure | 5-3 |

The RGB color model.

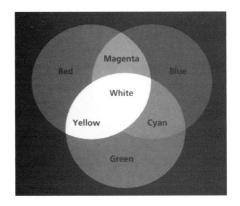

figure | 5-4 |

The Color palette with the RGB model selected.

create the colors cyan, magenta, or yellow (CMY). See Figure 5–3 and also the same figure in the color insert (Figure 3). Devices that reproduce color with light are using the RGB color model, such as your television set or your computer monitor.

Each component, red, green, or blue, in the RGB color model is labeled a value ranging from 0 to 255. This means you can have a total of 256 shades of red, 256 shades of green, and 256 shades of blue, and any combination thereof (a lot of colors!). For example the most intense red color is represented as 255 (R), 0 (G), 0 (B), and a shade of deep purple is represented as 40 (R), 0 (G), 100 (B). See Figure 5–4.

Illustrator also includes the Web Safe RGB, a modified RGB model that indicates a spectrum of colors most appropriate for use on the web. The color components in the Web Safe RGB space are measured using hexadecimal, a combination of numbers and letters to represent a color. For example a color of red in hexadecimal is indicated as #FF0000. See Figure 5–5.

figure 5-5

The Color palette with the Web Safe RGB selected.

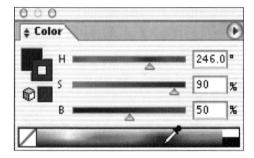

figure 5-6

The HSB color model in the color palette.

HSB

Color can also be defined as levels of HSB-hue, saturation, and brightness. Hue identifies a main color property or name such as "blue" or "orange." It's measured by a percentage from 0–360 degrees, as if picking colors from a standard color wheel. (See Figure 4 in the color insert). Saturation is the strength or purity of color. It is measured as an amount of gray in proportion to the hue, ranging from 0 (gray) to 100% (fully saturated). Brightness is the relative lightness or darkness of a hue, measured as a percentage from 0 (black) to 100% (white). See Figure 5–6.

As a designer I enjoy picking colors using the HSB color model because it offers a more natural way to identify and modify related colors. Take a look at the section, Adventures in Design: The Moods of Color at the end of this chapter.

CMYK

You learned that the RGB color model reproduces color based on light. In contrast the CMYK model reproduces color based on pigment or ink. The primary colors of CMYK are cyan (C), magenta (M), yellow (Y), and what you get when you mix them all

figure | 5-7 |

The CMYK color model.

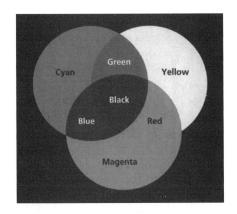

figure | 5-8 |

The CMYK color model selected in the color palette.

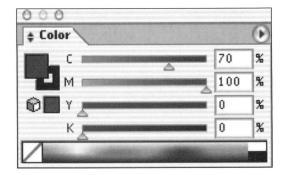

together, which is black (K). We call cyan, magenta, and yellow *subtractive* colors because when you add these pigments to a white page or canvas they subtract or absorb some of the light, leaving what's left over to reflect back to your eye. When the colors overlap, interestingly, they produce red, green, and blue (RGB). See Figure 5–7 and the color insert (Figure 5).

Note: The "black" part of the CMYK color model is a bit illusive. First of all why "K" and not "B" for black? That's easy enough, "B" is already taken by the color blue in the RGB model. Also, to produce a true black color in a printed format, a higher percentage of cyan is mixed with magenta and yellow; it's not really an equal amount of mixing of each color as the Figure 5–7 diagram might lead you to believe. An equal mixing would actually result in "muddy brown," not black, because of the absorption that occurs when ink hits paper.

Each color component of the CMYK color model is represented by a percentage ranging from 0–100%. To produce some purple paint, for example, you mix together 70% cyan, 100% magenta, 0% yellow, and 0% black. See Figure 5–8. In the print industry this

combining of the CMYK colors is appropriately called four-color processing. And the individual colors produced by the mixing of any of these four colors are identified as process colors. To help identify process colors as they actually look when printed, you can purchase color swatch books. Swatch books contain samples of colors printed on various types of paper, similar to swatches you might get when choosing colors to paint your house. These colors are actually coded with specific names, such as Pantone®107C or TRUMATCH 23-a7. You can match these color names with equivalent Swatch Libraries available in Illustrator. Go to Window>Swatch Libraries>TRUMATCH or Window>Swatch Libraries>PANTONE solid coated to see what I mean. Keep in mind, however, the issue of color viewed on screen versus print. Pantone 107C (a vellow color) will look slightly different on your monitor (which contains varying brightness and contrast levels) than on the printed swatch. If you know your artwork will go to print, I suggest trusting more the color you see on the printed swatch versus on the screen.

Note: To get the color visually equivalent (or, as close as you can) while working in Illustrator, read up on Producing Consistent Color in the Illustrator Help files (Help>Illustrator Help).

In addition to process colors, another color type used in printing is *spot* colors. These are special colors made up of premixed inks that require their own printing plate other than the four used for four-color processing. You'll run into the process and spot color types as you work with colors in Illustrator, but don't worry about them so much at this time. Preparing an image for a professional print job can easily become an advanced topic beyond the scope of this book. However, some more information is covered in Chapter 10, Print Publishing. A good start is to know that if your Illustrator artwork is eventually going to go to print, you'll want to choose colors within the CMYK color model.

GETTING IN THE MODE

While you can select colors from various color models, ultimately you'll want to set up your Illustrator artwork (document) to a specific *color mode* depending on the artwork's intended purpose. A color mode determines how your artwork is output, either for display on screen (RGB) or for print (CMYK). When you create a new document in Illustrator you must specify the color mode (see

figure | 5-9 |

Setting the Color Mode for the document.

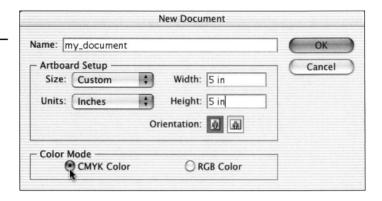

Figure 5–9). However, you can change the color mode at any time and without losing any information by choosing File>Document Color Mode on the menu bar. It's possible you'll want to change the color mode for a couple reasons—one, you'll want to use one of Illustrator's raster (bitmap based) filters or effects, which can only be applied when the document is in RGB mode, and two, you simply change your mind about where you want to output your artwork.

Why all this color mode business, you might be wondering? Well, remember, when it comes to color reproduction what you see is not necessarily what you're going to get from print to screen and screen to print, but it doesn't hurt to try every means possible to get it close. Setting the proper color mode is one of those means.

APPLYING COLOR

When coloring vector-based illustrations you have two possible parts of the drawing in which you can apply the color—the stroke and the fill. The stroke is the path of an object and the fill is the area enclosed by the path. Already you've applied color to both of these parts in previous lessons. You can change the color of a selected stroke or fill in one of three areas of the program—the Color palette, the Color Picker (accessed by double clicking the Stroke or Fill box in the toolbox), or the Swatches palette. Also, for fills, you can create graduated blends of color using the Gradient tool or Gradient palette. Each of these color selection options is described below.

The Color Palette

The Color palette (see Figure 5–10) allows you to choose various color models in which to work in and to switch between choosing and adjusting colors on either a stroke or fill of a selected object.

The Color Picker

The Color Picker is a somewhat sophisticated version of the Color palette, offering the option to view, select, and adjust colors of all the available color models in one window. It can be a little overwhelming at first, so let me break it down for you—see Figures 5–11 through 5–14.

figure | 5-10 |

Select a color model to pick colors from in the Color palette.

figure | 5-11 |

A full view of the Color Picker.

figure | 5-12 |

In this area of the Color Picker you choose your colors.

figure | 5-13 |

This area of the Color Picker indicates the current color selection and the original color selection for an object.

figure | 5-14 |

In the Color Picker adjust colors in any of the four available color models.

In the area of the Color Picker indicated in Figure 5–12 you choose your colors. The spectrum bar on the right is where you pick the hue you would like, such as red, blue, green, whatever. The large box to the left allows you to adjust the hue's saturation (moving horizontally) and brightness (moving vertically).

In Figure 5–13 you see the colors you are selecting in the Color Picker. Your current color selections are updated automatically in the top area of the box, while the lower part indicates the original selected color on the object. Next to the color indicator are gamut warnings. Gamut warnings pop up when you've chosen a color that's outside either the Web Safe (the 3D box icon) or the CMYK (alert triangle icon) gamuts. When you click directly on the 3D box icon the color shifts to the closest Web Safe color. Similarly when you click directly on the alert triangle the color shifts to the closest CMYK (print) color. This is a really handy feature!

The last area of the Color Picker indicated in Figure 5–14 allows you to see and adjust colors in all four of the color models—HSB, RGB, CMYK, and Web Safe RGB.

The Swatches Palette

After spending long hours picking out your favorite colors, it's good to know you can save them in the Swatches palette (see Figure 5–15). You can apply your saved colors to selected objects by simply clicking on your saved swatches in the palette window. You can also make swatch libraries to reuse in other documents or use one of the many already provided for you. The Swatches palette not only saves solid color selections, but also gradients and patterns.

figure | 5-15 |

The Swatches palette.

The Gradient Palette and Gradient Tool

Gradients are graduated color blends. They are useful to create smooth transitions of color on an object or across multiple objects, and give them a more dimensional look. Gradients come in two types—linear and radial, both of which are explored in Lesson 2 (see Figure 5–16). Gradients are created using the Gradient palette and their starting and end points modified using the Gradient tool (see Figure 5–17 and Figure 5–18). You can also save your favorite gradient blends in the Swatches palette.

figure | 5-16 |

Examples of linear and radial gradients.

figure | 5-17 |

The Gradient palette is used to create gradient color blends.

figure | 5-18 |

Modify gradients with the Gradient tool.

Lesson 1: Vegas Lady, Part I

Now's your chance to apply solid colors to the strokes and fills of a predrawn image. You will choose colors from the Color Picker and Swatches palette. Also you'll create and save your own colors.

Setting Up the File

- **1.** In Illustrator open **chap5L1.ai** in the **chap5_lessons** folder.
- **2.** Choose Shift_Tab to hide any open palettes.
- **3.** Select View>Fit In Window to see the original photo used as the drawing template.
- **4.** Choose Window>Layers.
- **5.** In the Layers palette unhide the **coloring layer** to view the drawing in grayscale. See Figure 5–19.
- **6.** Choose View>Outline to see how the image is constructed with numerous paths and shapes.
- **7.** Choose View>Overprint Preview to view the fills and strokes.
- **8.** Save this file in your lessons folder with the name **chap5L1_yourname.ai**.

figure 5-19

Unhide the coloring laver.

Applying Color to Fills

- **1.** In the Layers palette, expand the **coloring layer.** To do this, click on the arrow to the left of the layer name. Each of the paths and shapes that make up the image are organized in separate layer directories. See Figure 5–20.
- **2.** Expand the **head_dress** layer to see the individual paths.
- **3.** Click in the selection column of the **head_top** layer to select the object in the document. See Figure 5–21. The selection column of the Layers palette is located along the scroll bar side of the Layers palette; when an object is selected a colored selection box appears in this column.
- **4.** Using the Color Picker, let's choose a new color for the top part of the headdress. Double click on the Fill box in the toolbox to open the Color Picker.

Note: The Color palette window also opens up. You can use the Color palette to select colors too.

5. Select a deep red color by choosing a red hue and adjusting the saturation and brightness levels of the color. Alternatively, you can type in the following for the RGB: R = 152, B = 15, G = 8. Select Tab on the keyboard after each numeric entry. See Figure 5–22.

The expanded layer.

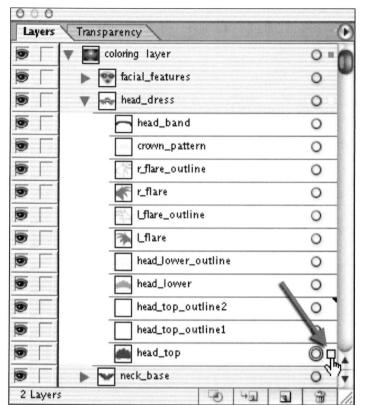

R: 152

G: 15

B: 8

980F08

figure | 5-21 |

Select an object from the selection column in the Layers palette.

figure | 5–22 | Enter the RGB color.

- **6.** Let's select the same color for the base of the Vegas lady drawing. With the Selection tool click on the curved base object to select it. See Figure 5–23.
- **7.** Now, choose the Eyedropper tool in the toolbox. See Figure 5–24.
- **8.** Move the Eyedropper tool over the red headdress and click to take a sample of the red color. The selected base will update with the sampled color. See Figure 5–25.

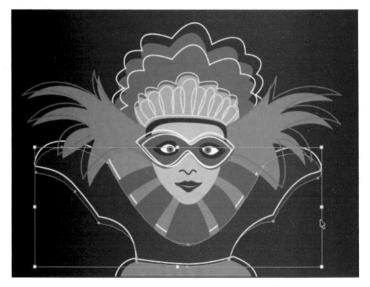

figure | 5-23 |

Select the curved base.

figure | 5-24 |

figure | 5-25 |

9. Now, choose a color using the Swatches palette. Choose Window>Swatches to open the Swatches palette.

Note: If the Swatches palette is docked with other palettes, select the title tab of the Swatches palette and drag it away from the docked group to release it. Close the other, unneeded palettes.

- **10.** With the Selection tool select one of the flares (feathers) of the Vegas lady drawing (Figure 5–26). Click on the ocean blue colored swatch in the Swatches palette to apply the color.
- **11.** Apply the same blue color to the other flare (feather).
- **12.** Save your file.

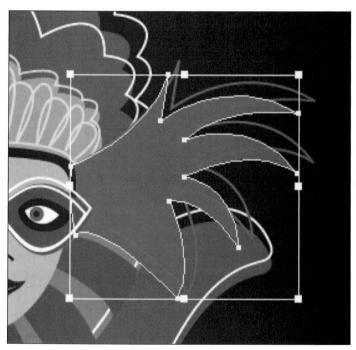

figure | 5-26 |

Select a flare on the ladv.

Applying Color to Strokes

- 1. In the Layers palette select the **r_flare_outline** object in the **head_dress** layers directory. Once again, to do this, click in the selection column of the layer located along the scroll bar side of the Layers palette. See Figure 5–27. Notice in the toolbox that the Stroke box is highlighted and the Fill box is indicated as "none." It's ready for you to add a new color to the stroke (Figure 5–28).
- **2.** In the Swatches palette, choose the magenta colored swatch for the stroke color.
- **3.** Select the **l_flare_outline** and apply the same magenta color.
- **4.** Practice applying color to other strokes and fills on the document. Apply color to all the gray areas.
- **5.** Save your file.

figure 5-27

Select an object from the Layers palette.

figure | 5-28 |

Stroke box is current, fill indicates "no fill."

Saving Colors

- 1. Once you've decided on some colors for the image you can save the colors to use over and over again. Be sure the Swatches palette is open (Window>Swatches).
- **2.** Select the **headdress** object again. Notice that the color of the **headdress** is indicated in the Fill box in the toolbox—this is the current color.

- **3.** In the Swatches palette click on the New Swatch icon in the lower right of the palette window (next to the trash can) to add the current color. See Figure 5–29.
- **4.** Double click on the new swatch you just added. A dialog box comes up that allows you to enter a name for your new swatch (Figure 5–30). Go for it . . . enter a descriptive name. Notice here you can also completely change the color mode and color of the saved swatch. Select OK.
- **5.** There's another way to make a new swatch. Select one of the flares (feathers) on the Vegas lady. Click on the arrow in the upper right corner of the Swatches palette and from the dropdown menu select New Swatch (Figure 5–31). Enter a name for the swatch and select OK.

figure | 5-29 |

Add a new swatch.

	Swatch Options	
Swatch Name:	my cool swatch	ОК
Color Type:	Process Color 💠	Cancel
	Global	
Color Mode:	RGB 🕏	✓ Preview
R	152	
G	15	
B	£	

figure | 5-30 |

Name the swatch in the Swatch Options.

figure | 5-31 |

Create a new swatch from the Swatches dropdown menu.

Note: To delete a swatch, select the swatch and click on the trash can icon in the Swatches palette.

- **6.** Select each of the other colored areas in your image and save the colors in the Swatches palette.
- 7. Let's save your collected swatches into a library to use in another document. Click on the arrow in the upper right corner of the Swatches palette and from the drop-down menu choose Save Swatch Library. Name your library vegas_colors.ai and save it in your lessons folder.
- **8.** To open your swatches library click again on the arrow in the upper right corner of the Swatches palette to open the Swatch Options—choose Open>Swatch>Library and select Other Library (at the bottom of the list).
- **9.** Find your saved swatches library—**vegas_colors.ai**—in your lessons folder. Select Open, and the library will appear as a palette in the program.
- **10.** Save your file—you're done with this version of the Vegas ladv.

Lesson 2: Vegas Lady, Part 2

Using the predrawn image from Lesson 1, you will create gradients of color for the fill areas of the image.

Setting Up the File

- 1. In Illustrator open the file chap5L2.ai in the chap5_lessons folder.
- **2.** Choose Shift-Tab to hide unneeded palettes.
- **3.** Choose View>Fit in Window.

4. Choose Window>Gradient.

Note: If the Gradient palette is docked with other palettes, select the title tab of the Gradient palette and drag it away from the docked group to release it. Close the other, unneeded palettes.

- **5.** Click on the arrow in the upper right corner of the palette and choose Show Options to open the options for the Gradient palette. See Figure 5–32.
- **6.** Save this file in your lessons folder with the name chap5L2_yourname.ai.

figure | 5-32 |

Open the Gradient palette options.

Applying a Linear Gradient

- 1. Select the red, top headdress of the Vegas lady.
- **2.** In the Gradient palette click on the gradient fill box in the upper left—this places a default gradient on the selected object.
- **3.** Let's change the colors of this default gradient. Choose Window>Color. Undock the palette if it's docked with others and choose Show Options from the Color palette drop-down menu. Keep things clean—close all palettes except for the Color palette and the Gradient palette.
- **4.** In the Gradient palette, be sure Type: Linear is selected.
- **5.** Notice the color ramp at the bottom of the Gradient palette. It has two colors, one on each side blending together. The markers under the ramp are called *color stops*. Click on the leftmost color stop to highlight it (see Figure 5–33).
- **6.** Notice that the Color palette changes to reflect the current selection. From the Color palette drop-down menu choose the RGB model for color selection.

figure | 5-33 |

Select a color stop.

figure | 5-34 |

Select a color in the Color palette.

7. Drag the Eyedropper tool along the RGB spectrum ramp at the bottom of the Color palette to select a new color for the gradient color stop. Pick any color you'd like. See Figure 5–34.

Note: As you move the Eyedropper tool along the spectrum ramp, notice the gamut warning signs popping up. As discussed previously, you can click on either the web or print gamut warnings to snap to an equivalent color within the gamut.

- **8.** In the Gradient palette, click to select the rightmost color stop.
- **9.** In the Color palette, choose the RGB color model, and assign this color stop a new color.
- **10.** Rotate the angle of the gradient by typing 90 in the angle box of the Gradient palette.
- **11.** Adjust the blend of the gradient by moving the gradient slider (the diamond shape above the gradient ramp) to the right or left.

- **12.** For fun, let's add another color to the ramp. Click under the ramp to create another color stop (see Figure 5–35).
- **13.** Create a new color for the color stop in the Color palette.

Note: To delete a color stop, select it and drag it down and away from the Gradient palette.

- **14.** Save your gradient by choosing Window>Swatches. From the swatches drop-down menu, select New Swatch. Enter a name for your new swatch and select OK.
- **15.** The new gradient appears in the Swatches palette.

Note: If you don't see it, be sure Show All Swatches is selected in the lower part of the Swatches palette (Figure 5–36).

16. Save your file.

figure | 5-35 |

Make another color stop.

figure | 5-36 |

Select the Show All Swatches option.

Applying a Radial Gradient

- 1. Select the Zoom tool and magnify the Vegas lady's lips.
- **2.** Let's apply a radial gradient to both the upper and lower lips. Shift-select with the Selection tool to select both parts.
- **3.** Click on the Gradient fill box in the Gradient palette to apply the last created gradient on the lips.
- **4.** In the gradient box choose Type: Radial.
- **5.** Click the rightmost color stop and in the Color palette select a red color to apply to the gradient.

Note: Alternatively to selecting colors in the Color palette, you can also drag a color swatch from the Swatches palette over the selected color stop.

- **6.** Apply a lighter red color or white to the leftmost color stop.
- **7.** Let's modify where the radial center starts on the gradient. To do this, click on the Gradient tool in the toolbox (Figure 5–37).
- **8.** Click and drag the tool vertically from the lower lip to the top part of the lip and notice how the gradient direction changes (see Figure 5–38). Try dragging the tool shorter or longer distances over the lips to readjust the gradient direction to your liking.

figure | 5-37 |

Select the gradient tool.

figure | 5-38 |

Use the Gradient tool to adjust the radial gradient.

- **9.** Save this gradient in the Swatches palette.
- **10.** Using the methods you just learned, create other gradient combinations on the various shapes of the image. For example, use a radial gradient on the lady's eyeballs to give them more three-dimensionality.
- **11.** Save your final file.

COLOR IN DESIGN

So many colors, so little time—this becomes the case very quickly when you find yourself hours later still trying to decide what colors to use for your favorite masterpiece. This is why knowing something about how colors work together can really speed things up. In Illustrator you have several ways and color models in which to pick color, but how do you know what colors look good together? There is actually a whole art and science to creating a visually appealing palette of hues; and, of course, numerous theories to back the information up. In general these theories are based on an understanding of the color spectrum and usually in the form of a color wheel (see Figure 4 in the color section).

As a starting point for picking colors, think in terms of color chords, combinations of colors that work well together. Six basic color chords are described below (there are others). For colorful examples of these color chords, see figures in the color section, or open the chords1.jpg and chords2.jpg in the chap5_lessons/samples folder.

- **Monochromatic** Uses one hue (color) plus the addition of black, white and/or grays.
- Analogous Uses two to three hues, which are adjacent to each other on a standard color wheel (e.g., red, red orange, orange), plus the addition of black, white and/or grays.
- Achromatic Uses a combination of black, white, and/or grays. No hues.
- Dyad (complement or opposite) Uses hues that are opposite each other on the color wheel or color spectrum (e.g., orange and blue), plus the addition of black, white, and/or grays.

Note: There's a quick way to find dyad colors in Illustrator. In the program, create an object and fill it with color. Be sure the object is selected. Open the Color palette and from its Options drop-down menu choose Complement.

- Warm Hues Color hues that give the viewer the sense of warmth, such as reds, yellows, and oranges.
- **Cool Hues** Color hues that give the viewer the sense of coolness, such as blues and greens.

To practice making your own color chord combinations see the Exploring On Your Own section.

SUMMARY

This chapter introduced you to some important concepts about color, including color models, modes, and gamuts. You applied color to strokes and fills using Illustrator's Color Picker, and Color and Swatches palettes. Using color effectively in your artwork is more than just applying it to strokes and fills, however. It's also about picking colors that are visually enticing and preparing the colors correctly for the artworks final, anticipated purpose.

in review

- 1. Describe color gamut.
- 2. How do different color gamuts affect what colors look like in Illustrator?
- 3. What's a color model? How is it different than a color mode?
- 4. What color model represents the primary colors of light?
- 5. What's hexadecimal?
- 6. Briefly describe hue, saturation, and brightness.
- 7. Four-color processing uses what kind of color model?
- **8.** What's a gamut warning in Illustrator?
- 9. What tool can take a sample of color in an image?
- 10. Describe complementary colors.

★ EXPLORING ON YOUR OWN

- 1. Access the Help>Illustrator Help menu option. Under Contents read up on the topic Applying Color, Fills and Strokes. For more advanced information on working with color in Illustrator see also the topic, Producing Consistent Color.
- Practice your color chords with the color theory lesson. Examples of the completed lesson are provided in the color insert, Figures 7 and 8, or in the chap5_lessons/samples folder, chords1.jpg, and chords2.jpg.

Instructions:

- In Illustrator open the file colortheory.ai in the chap5_lessons/samples folder.
- In the box for each labeled color chord use the following tools to create a motif (design) for each chord:
 - a. Dyad: Ellipse tool
 - b. Monochromatic: Rectangle tool
 - C. Achromatic: Star tool

- d. Analogous: Polygon tool
- e. Warm Hues: any tool
- f. Cool Hues: any tool
- Color each motif design with the appropriate characteristics for each chord.

Note: Review the characteristics of each chord in the Color in Design section.

3. I've learned a lot about color theory and design by surfing the Internet. Do a search for "color theory" or "color design" and plenty of information is bound to pop up. For more information on color in design, see also Adventures in Design: The Moods of Color in this book.

Adventures in Design

ADVENTURES IN DESIGN

THE MOODS OF COLOR

Certain colors and the way they come together can produce a visceral response from a viewer. Colors can be representative of a thought or idea, or evoke an emotion. Green brings visions of nature or money. Blue is calming or corporate. Yellow is happy, bright, illuminating. Advertisers know this fact all too well—a set of golden yellow arches, for example, reminds most of french fries, shakes, and Happy Meals.

As you've learned, there are guidelines for choosing appropriate color combinations—color modes, color chords, the color wheel. Moreover, colors chosen for a particular piece of artwork or layout directly relates to a design's look and feel. This is a deeper and more subjective aspect to the color picking process—it involves the sense of "mood."

What is the mood you want to convey in the artwork? Or, that your client would like to convey? Is it to appear, for example, classic and professional, warm and inviting, or playful and light? What color combinations will work best to achieve each mood? By identifying a mood for your design, the sometimes nightmarish experience of picking colors can be more easily identified. Let me introduce to you a scenario of choosing colors with mood in mind and then it's your turn to give it a try.

Professional Project Example

In Chapter 1 you recreated from a sketch a logo for an actual real estate broker company called Stratton Buyer Brokerage (SBB) in Vermont (see Figure A1-1). The company's owner, Andrea, also requested a color version of the logo that can be used for both print and the web. To avoid the endless decision process that can occur when choosing colors, it was important to try and hone in on some colors Andrea envisioned for the logo. First, Andrea used adjectives to describe what her company represents, providing a better idea of where to begin when selecting colors for her logo. It was learned that SBB is a small company; they are professional in a friendly, personalized way. With this in mind, certain color combinations could easily be eliminated—bright or neon colors

四月

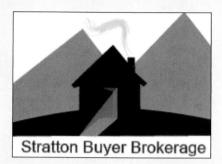

Figure A-1 The black and white version of the SBB logo.

were out—not professional looking enough. So were bold colors like navy blue and red (too corporate). It was decided that subtle, warmer colors were better—more inviting and homey. After several versions of the logo with different color combinations were created, a logo with deep greens and purples was the eventual choice. The black and white version is shown in Figure A–1. (See the aid1_example.ai in the aid_examples folder to view the sample color variations or view Figure 9 in the book's color insert.)

Your Turn

Now it's your turn to play with different color combinations on Andrea's logo. It's important to remember the identity of the company—personalized, professional, based in rural Vermont. Just as important, use what you learned about color in design in Chapter 5 to more easily blend combinations of colors together. A sample file with four black and white duplicates of the SBB logo is provided in aid_examples/aid1.ai. Use the duplicates to explore different stroke and fill color combinations on the logo shapes.

Color Mood Project Guidelines

- Assume the logo will eventually go to print, so be sure the aid1.ai document is saved in the CMYK color mode.
- 2. To more easily and independently adjust different hues, saturation, and brightness levels when determining your color combinations, use the HSB Color palette (see Figure A–2).

Figure A-2 The HSB Color palette.

Adventures in Design

For example, select one part of the logo, adjust the hue slider of the HSB palette to a color you like. Begin to adjust the S and B sliders to modify the color in saturation and brightness to what might seem appropriate to Andrea's description of the company's look and feel. (Here's where some subjective decision

3. Then, select another item on the logo and take a sample of the color you just created to fill the selected shape. Leaving the S and B sliders in the HSB Color palette the same, adjust only the H slider to another color of your liking. By adjusting just one and the same component of the HSB color model for each color—in our example just the H (hue)

making comes in.)

- component—you can quickly create colors that have a similar tone, making for more compatible color combinations.
- 4. Try this method on another of the logo duplicates, using perhaps a lighter or darker set of colors on each logo shape.
- 5. For one of the other logo examples, use another technique for quickly choosing like colors with the Complement or Invert commands available in Illustrator (see Figure A–3). These options offer variations on a color, based on the complement (opposite) or inversion of the color in a standard color wheel. First, fill a logo shape with a color. Take a sample of that color to fill in another selected shape on the logo. Then, from the Color palette

Figure A-3 Select the Complement command in Illustrator.

- options menu, choose Invert or Complement.
- 6. Check and be sure the colors you have chosen are within the CMYK color gamut. This means selecting a color that does not bring up the print gamut warning (the triangle icon in the color palette). If the warning does come up, click on the triangle icon to adjust the color to its nearest CMYK equivalent (see Figure A–4).
- 7. Save your color selections in the Swatches palette.
- 8. Do a color test by printing your logos off a color printer. Compare how the color looks printed versus on the screen. As you have learned, color can vary depending on the device in which the color is viewed.

Things to Consider

Here are some tips to consider when working with color on the SBB logo and in general.

- As a starting point for picking colors, use color chords as described in Chapter 5, Color in Design section.
- If available, pick colors from a swatch book—a book of printable color examples that's usually available for viewing at your local printing bureau. Swatch books will also give you a sense of how colors might look printed on various types of paper.
- Limit the number of colors used on a logo design or document. Work with only about two to four colors at a time.
- With colored pencils, sketch out various color combinations on paper, then attempt to tackle the colors in Illustrator.
- Remember the moods of color and how these moods reflect on your overall design objectives.

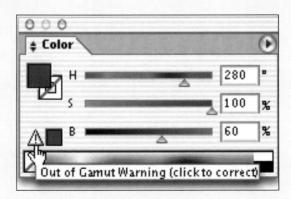

Figure A-4 The CMYK warning icon.

value and texture

charting your course

What brings life to an illustration is the use of value and texture, the last two components in our study of the fundamental building blocks of visual art. (For a review of these principles, see Chapter 3). This chapter defines value and texture in art and introduces you to value and texture on strokes and fills, including brushes, patterns, filters, effects, and graphic styles. You'll learn that the strokes and fills that make up an Illustrator graphic can be further modified to take what is initially a flat colored illustration and transform it into one that appears to have more tactile characteristics.

goals

In this chapter you will:

- Differentiate between the use of value and texture in illustrative art.
- Get a handle on the various attributes of strokes and fills.
- Master the use and modification of Illustrator brush types and the Paintbrush tool.
- Explore the differences and uses of filters, effects, and graphic styles.
- Understand the steps for creating and applying patterns.

IMPLYING SURFACE

Take a look at the row of flower images on the first page of this chapter. Flower number 1 is the original image—a print of a drawing I did when I was a young child, which now hangs in my office. Can you see, maybe even feel, the roughness of the paper it was printed on? Is the tablecloth smooth or rough? Is the flower's pot old or new? Now, look at flower number 2. This is a trace of the print done in Illustrator using only solid, flat colors. The image has a completely different look and feel, very one-dimensional. Finally, check out number 3. This is the same Illustrator image, but with value and texture added. It looks a lot more like the original print with varied paint strokes and implied surface characteristics, but completely digitized and easily altered. Note: A colored version of these flowers is also available in the color insert of this book (Figure 10).

What are value and texture in art? What does it mean to add value and texture to a digitized image? Value is the relationship of light and dark parts within an image, sometimes referred to as tone, shade, or brightness. You've already experienced the use of value in the last chapter when working with varying fill colors and in particular with gradients, which are simply blended values of color. There is also value in line—a stroke in Illustrator has different weights (thicknesses), as do brushes. Value in line is what you learn mostly about in this chapter. Value can also imply a sense of space, which you encounter later in Chapter 9. A good example, however, is the illusion that appears when you put a lighter copy of an object below its original, resulting in a shadow effect. See Figure 6–1.

Texture implies surface—how an object might feel if we were to touch it. It informs us of our surroundings, tells us about the nature of objects—smooth, rough, soft, hard. Textures in our

figure | 6-1 |

The shadow of the word "shadow" is created by changing the value of the text to a lighter gray and adding a slightly blurry texture.

environment are represented by how light hits a surface—depths of lights and darks. In Illustrator, the textures you create are simulated, meaning the texture is flat by touch but it tricks the eye into thinking that it's not. A filter or effect in Illustrator can produce simulated textures, also brushes and patterns—all of which are coming up in this chapter.

STROKE AND FILL ATTRIBUTES

By now, you're probably pretty clear on the difference between a stroke and a fill; a stroke is the defined outline or path of an object, and a fill is the area enclosed by the path. In the previous chapter, you applied the attribute of color to both strokes and fills. Lucky for us, strokes and fills have other attributes and appearance effects besides color. See Figure 6–2 and Figure 6–3.

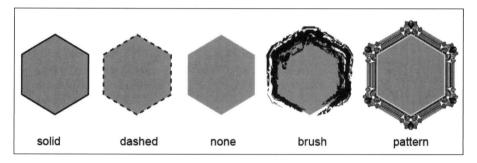

figure 6-2

Stroke variations.

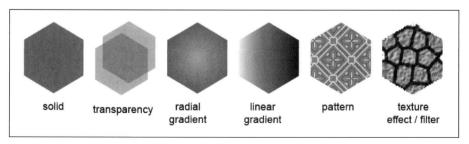

figure 6-3

Fill variations.

Stroke Variations

Stroke variations include: color, weight (line thickness), solid or dashed lines, line caps and joins, and brush styles. To review from the last chapter, you can change the color of a selected stroke (or fill) in one of three areas in the program—the Color Picker (accessed by double clicking the stroke [or fill] box in the toolbox), the Color palette, or the Swatches palette. To change the attributes of a selected stroke, such as the weight, line type, or line caps and joins, you go to Window>Stroke and open the stroke properties. To access brush types you choose Window>Brushes and/or Window>Brush Libraries.

About Stroke Attributes

Stroke attributes for a selected object are located in the Stroke palette (Window>Stroke). See Figure 6–4. In the Stroke palette you can alter a stroke's weight, capping, joining, and miter limit. You can also create varied dashed lines. By default, a stroke's weight is measured in points (pts). If you want a really thin line you might put in a weight of .05 points, a thicker line might be 20 points. See the examples of stroke weights in Figure 6–5.

figure | 6-4 |

Go to Window>Stroke to open the Stroke palette.

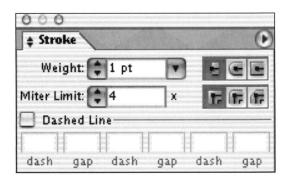

figure | 6-5 |

Example stroke weights, measured in points.

Note: If you prefer, you can change the unit measurement of a stroke (to inches, picas, or pixels for example) by going to Illustrator> Preferences>Units & Display Performance (Mac) or Edit>Preferences> Units & Display Performance (Windows).

You can also add different caps to the ends of your strokes. Yes, "cap" seems like such a funny name, but it really makes sense—just like you might put a cap on your head for a stylish effect, you can do the same thing with strokes. To choose different caps you select one of three options in the stroke palette. See Figure 6–6.

- **Butt Cap** Stroked line with square ends.
- Round Cap Stroked line with rounded ends.
- Projecting Cap Stroked lines with squared ends that takes the weight of the line and extends it equally in all directions around the line.

Another stylish effect is the line join options. Joins determine the look of a stroke at its corner angles. There are three types of joins. See Figure 6–7.

• Miter Join Creates stroke lines with pointed corners. The miter limit controls when the program switches from a mitered join (pointed) to a beveled (squared-off) join. See Figure 6–8.

figure	
rigure	ן ס—ס ן

1. Butt Cap, 2. Round Cap, 3. Projecting Cap.

figure 6-7

- 1. Miter Join.
- 2. Round Join,
- 3. Bevel Join.

figure | 6-8 |

Miter of a stroke set at 4x and at 1x.

figure | 6-9 |

1. Dash pattern: 12 pt dash; 2. Dash pattern: 2 pt dash, 12 pt gap, 2 pt dash, 3 pt gap; 3. Dash pattern: 2 pt dash, 12 pt gap, 16 pt dash, 3 pt gap.

- Round Join Creates stroked lines with rounded corners.
- Bevel Join Creates stroked lines with squared corners.

From the Stroke palette, you can also create custom dashed lines. To do this, you select a stroke and specify a sequence of dashes and gaps between them. See Figure 6–9 for an example. You can also combine caps styles with different dash patterns, resulting in either rounded or squared dash ends.

About Brushes

Another, and very popular, stroke variation is the use of brushes. With Illustrator brushes you can really mess around with the texture and value of your drawn paths, and not have to wash the brushes when you're done. You can apply Illustrator brush types to selected strokes and paint new strokes with the Paintbrush tool. The four basic brush types are (and see Figure 6–10):

- **Calligraphic** Calligraphic brush strokes resemble the angled strokes produced from a calligraphic pen.
- Art brushes resemble sketched or painterly strokes such as those created with chalk and watercolors. They also include objects, such as arrows, that when drawn stretch evenly along the length of the path.

figure | 6-10 |

The four brush types: 1. Calligraphic; 2. Art;

3. Scatter; 4. Pattern.

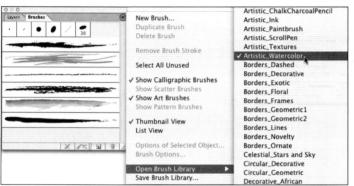

figure 6-11

There are lots of brush libraries to choose from.

- **Scatter** Scatter brushes randomly disperse objects along a path.
- **Pattern** Pattern brushes produce a repeated pattern—derived from individual tiles—that repeat evenly along a path.

To find these brush types you choose Window>Brushes to open the Brushes palette. By default, some calligraphic and art brushes are provided, but you can find many more by choosing Window>Brush Libraries from the main menu or Open Brush Library from the Brushes palette options menu (see Figure 6–11). You can also create and modify your own brush styles and libraries—and, how wonderful is that?

For when you want to draw a path and create a brush stroke at the same time, you use the Paintbrush tool located in the toolbox (see Figure 6–12). Painting with the Paintbrush tool can sometimes bring unwanted results, unless you adjust the tool's settings in its preferences box. To open the Paintbrush tool's preferences, you double click on the tool in the toolbox (see Figure 6–13).

figure | 6-12 |

The Paintbrush tool.

figure | 6-13 |

Double click on a tool in the toolbox to get to its options or preference settings.

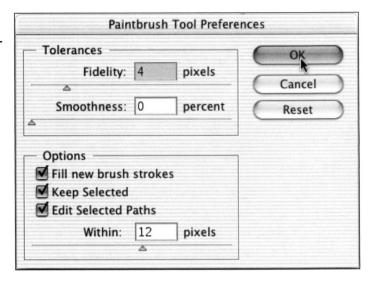

figure | 6-14 |

Adjust the transparency slider.

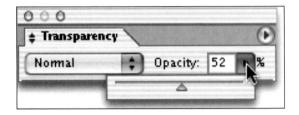

Note: By the way, this "double click" thing to bring up a tool's options or preferences applies to any tool in the toolbox. You might be surprised by the many options lurking under those tools.

You'll experience painting with brushes and adjusting brush preferences in Lesson 1.

Fill Variations

Demonstrated in Figure 6–3, fills also have attributes other than just solid colors. Linear and radial gradients were introduced in the last chapter. You can also apply transparency to any fill. Simply select the filled object, choose Window>Transparency and in the Transparency palette adjust the opacity setting from 100 (no transparency) to 0 (full transparency). See Figure 6–14.

Note: In order to see the transparency effect on an object, it helps to put another object behind it.

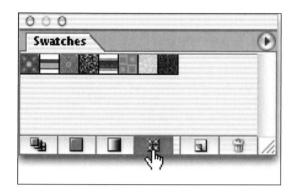

figure | 6-15 |

Select to view patterns saved in the Swatches palette.

Patterns are also a great way to have fun with fills. You can apply, create, and transform patterns—and, save patterns in the Swatches palette (see Figure 6–15). Patterns are useful if you want a repeated tile effect or mosaic. Take a look at the clothing patterns designed by students in the color insert of the book (Figures 12 to 14). You'll get to play with patterns in Lesson 2.

Another way to create fills with varied textures is to use the filters and effects available in the program. At first glance it seems that the Filter and Effect menus are the same. For instance, from the menu bar if you choose Filter>Sketch you will get the same list of options as if you choose Effect>Sketch. What's up with that?

An effect (versus a filter) is a live overlay. When you apply an effect to an object it's as if you're laying a cover or covers over the object. It only changes the appearance of an object, but not its original path. When you reshape the original path of the object the effects applied will readjust accordingly. The Appearance palette (described in the next section) lists your effect(s) and enables you to modify, expand, duplicate, delete, or save it as a graphic style.

A graphic style is a named set of appearance attributes (what makes up an effect) that can be stored in a Graphic Styles palette or library. Illustrator comes with many premade graphics styles (Window>Graphic Style Libraries), but, of course, you can also create your own. You can apply graphic styles not just to individual fills, but also to individual strokes, grouped objects, and layers. See Figure 6–16.

Filters, on the other hand, directly change an underlying object, and the change cannot be modified or removed after the filter is

figure | 6-16 |

The Scribble Effects graphic styles library.

applied. If you ever used filters in Photoshop, the filters in Illustrator work in much the same way. In fact, Photoshop compatible filters can be applied to objects that have been rasterized (Object> Rasterize) in Illustrator.

Note: To access Photoshop filters, copy the filters from the Photoshop filters folder to the Illustrator plug-ins folder and relaunch the program.

An initially perplexing thing about filters and effects is to understand what filters and effects apply to what types of objects. In the filters menu, the items at the top of the list can be used on vector-based graphics (those you draw in Illustrator), while filters primarily used for bitmap (or rasterized) objects are grouped in the bottom portion of the menu. Effects can be applied to any kind of object, even text.

As well, some filters and effects, like those in the Artistic menu, are available only for documents in RGB mode. A quick way to identify what filter or effect works on what type of image, is to select the image, choose the Filter or Effect menus, and any filters or effects that are highlighted in black (versus gray) can be applied to that particular image, or in that particular document mode.

You'll have the opportunity to be hands-on with filters, effects, and graphic styles, and their many quirks in Lesson 1.

Using the Appearance Palette

Once you start applying multiple brushes, patterns, and effects to strokes and fills it can get difficult to remember and modify all the

figure | 6-17 |

Filled object with the Fude art brush outline.

figure 6-18

The Appearance palette.

variations. The Appearance palette comes to the rescue; it's your guide to what fill and stroke variations you have applied to a particular object(s). Let's say you applied a brush called Fude (yes, there's actually a brush style by that name) and a solid fill to an object. It would look like Figure 6–17. When you open the Appearance palette (Window>Appearance), it will list the stroke and fill attributes of the selected object, as in Figure 6–18. Furthermore, when you double click on, say, the word Fude in the Appearance palette, the options for that particular brush stroke will appear. See Figure 6–19.

If you have a somewhat more complicated effect or graphic style assigned to an object, such as the Tissue Paper Collage in

figure | 6-19 |

Using the Appearance palette to alter brush stroke options.

figure | 6-20 |

A complicated effect.

Figure 6–20, the Appearance palette shows a breakdown of the ingredients (per se) that make up the object's "look," which you can then modify individual parts of. For example, see Figure 6–21 for a list of ingredients that produce the Tissue Paper Collage effect.

Another great thing I really like about the Appearance palette is that in its options box (see Figure 6–22) you can do some crazy things like add a new fill or stroke, reduce the object to its basic appearance (theoretically, peel off its covers), or, when things get really messy, clear its appearance all together.

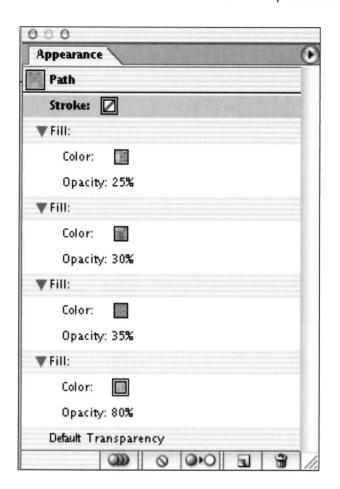

figure | 6-21 |

Viewing the parts of an object's effects in the Appearance palette.

figure | 6-22 |

The Appearance palette's options.

Lesson 1: The Fish Painting

Once you learn how to apply brush styles on drawn paths, paint directly with the Paintbrush tool, and use graphic styles and effects—all good things covered in this lesson—there's no turning back on your inner artist. See Figure 6–23.

figure | 6-23 |

The finished Lesson 1 file.

Setting Up the File

- 1. In Illustrator open chap6L1.ai in the chap6_lessons folder.
- **2.** Choose Shift_Tab to hide any open palettes.
- **3.** Choose View>Fit In Window.
- **4.** Select Window>Swatch Libraries>Other Library (located at the bottom of the list).
- **5.** Browse for the custom library called **fish_colors.ai** in the **chap6_lessons/assets** folder. Choose Open to open the swatches in the document.

Applying Brush Styles

- 1. Select the body outline of the fish. For easier reference, all the paths of the fish are labeled in the Layers palette. Open the Layers palette, then expand the layer called "fish" and select the desired path name. See Figure 6–24.
- **2.** Click on the orange swatch in the **fish_colors** Swatches palette to apply the color to the fish's body.

figure | 6-24 |

Select a named path from the Layers palette.

figure 6-25

Select the bubble swatch. When you roll over a swatch, the swatch name will appear.

- **3.** Change the stroke color of the body outline to None.
- **4.** Select the bubbles of the fish (they are grouped, so you can select them all at once). In the custom Swatch palette choose the swatch called **bubble.** See Figure 6–25.
- **5.** Change the stroke color of the bubbles to None.

- **6.** Select the **top_fin_lines** of the fish. See Figure 6–26.
- **7.** Let's apply an art brush to the lines. Open Window>Brushes. Choose the Thick Pencil art brush. See Figure 6–27. The brush stroke is applied to the selected paths.
- **8.** Select the grouped lines of the fish's tail (tail_lines), and, once again apply the Thick Pencil art brush.
- **9.** Also, select the **gil**, **lower_fin_lines**, **back_fin_lines**, and **center_fin_lines** and apply the same Thick Pencil brush.
- **10.** Save your work so far, and name it **chap6L1_yourname.ai** in your lessons folder.
- **11.** Now, select the **eye_outline** and choose the Rough Charcoal art brush (first one in the horizontal brush list). Notice that the width of the Rough Charcoal brush is bit thick for the eye outline. We need to fix this.

figure | 6-26 |

Select the **top_fin_lines** of the fish.

figure 6-27

Choose the Thick Pencil art brush in the Brushes palette.

- **12.** Double click on the Rough Charcoal brush style in the Brushes palette—this brings up the Art Brush Options for that particular brush. See Figure 6–28.
- **13.** Be sure the Preview option is selected to see your changes updated on the object before closing the options box.
- **14.** Change the width setting to 20%, and click the Tab key to update the change on the object. Ahh, much better.
- **15.** Click OK to exit the options box. A dialog box will pop up asking if you would like to apply the new change to the currently selected brush strokes. Select Apply to Strokes. See Figure 6–29.

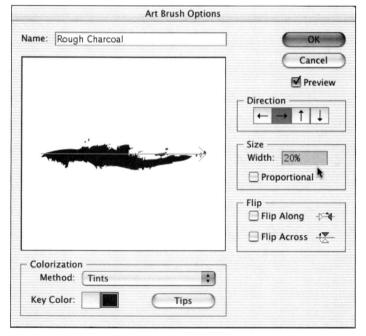

figure | 6-28 |

Change the brush style settings.

figure | 6-29 |

Select Apply to Strokes.

- **16.** Now, select just the **eye** object and from the **fish_colors** Swatches palette choose the Predator Eye pattern.
- 17. Save your file again.

Applying Graphic Styles

- **1.** Select the **center_fin** of the fish (the outer line, not the lines inside).
- **2.** Choose Window>Graphic Style to open the Graphic Styles palette.
- **3.** Some graphic styles are provided, but let's find some more. From the options drop menu in the upper right of the Graphics Style palette choose Open Graphic Style Library>Image Effects.
- **4.** Select the effect called Chiseled in the Image Effects palette to apply it to the object. See Figure 6–30. (Okay, now I know you're itching to try the other graphic styles—because they are so cool looking I say "go for it," but save your file beforehand and when you're done doodling please come back to the next step . . .)

figure | 6-30 |

Select the Chiseled graphic style.

- **5.** Assign the Chiseled effect to the **back_fin** and **lower_fin**, as well.
- **6.** Let's check out this graphic style in the Appearance palette—select one of the fins and choose Window>Appearance. Notice the many stroke and fill variations that make up this effect. See Figure 6–31.
- **7.** You can change parts of the effect in the Appearance palette. Move the scroll bar of the Appearance palette all the way down to find the Fill attributes of the effect. See Figure 6–32. Double click on the Fill line to bring the Color palette forward. Select a new color in the Color palette for the Fill. Notice the color updates right away on the selected fin.

figure 6-31

Holy Mackerel! What a list of ingredients for just one effect.

figure | 6-32 |

Double click on an effect attribute to edit it.

- **8.** Notice also that there is a drop shadow and opacity setting for the Fill of the effect. Double click on the Drop Shadow line to open its options. Click the Preview option box and choose 4 pts for the Y offset. Hit Tab to see the change on the fish fin without closing the options box. Hit OK.
- **9.** Now, double click on the Opacity setting for the Fill. The Transparency palette will come forward. (Note: The Transparency palette is probably attached to the bottom of the Color and Graphic Styles palettes—look carefully). Move the opacity setting in the Transparency palette to 100% to darken the fin effect color.
- **10.** Okay, let's assume you're the indecisive type like me, and you don't like the effect changes you've just made. From the Appearance palette drop-down menu choose Clear>Appearance to completely remove the appearance effect. See Figure 6–33.

Note: You can also choose Reduce to Basic Appearance to reduce the Fill and Stroke colors of the effect to their most basic colors. Or, you can add to the effect by choosing Add New Stroke and/or Add New Fill. So many choices, so little time.

- **11.** So, you've cleared the effect completely off the selected fin. In the Graphic Style palette reapply the original, unmodified effect called Chiseled to the object.
- **12.** Now would be a good time to save your file.

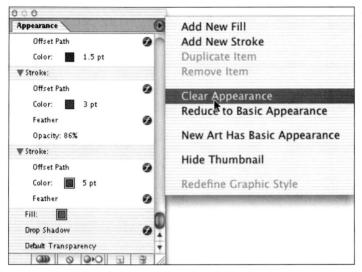

figure | 6-33 |

Clear the effect on a selected object.

Applying an Effect

- 1. Select the fish's body outline (entitled "body" within the Layer called "fish").
- **2.** Choose Effect>Document Raster Effects Settings (see Figure 6–34). Indicate the following settings:
 - Resolution: Screen (72ppi)
 - Background: Transparent

Hit OK to apply.

Note: When you apply a raster effect to a vectored object (what you will be doing in the next step) it's important to set up the specifications for this conversion in the Document Raster Effects Settings box. If you recall from Chapter 3, raster images, otherwise know as bitmap images, are dependent on resolution, which is one of the settings you need to determine in this settings box. Also, whether the background of the final object will be filled with white or remain transparent.

3. Choose Effect>Artistic>Rough Pastels. Oops, the effect type is unavailable. Why? In order to use Artistic effects in Illustrator your file must be in RGB mode.

figure | 6-34 |

Choose Effect>Document Raster Effects Setting.

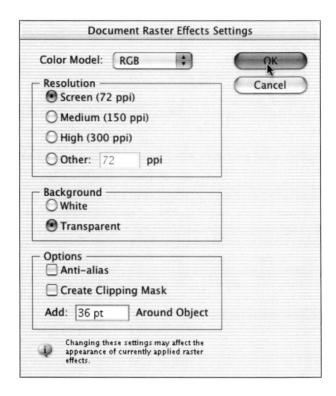

4. From the main menu choose File>Document Color Mode>RGB Mode.

Note: if you don't quite understand this "mode" stuff, go to Chapter 5, section "Getting in the Mode."

- **5.** Now, choose Effect>Artistic>Rough Pastels (see Figure 6–35). Enter in the following settings (or, try out some of your own):
 - Stroke Length: 29
 - Stroke Detail: 4
 - Texture: Canvas
 - Scaling: 90%
 - Relief: 28
 - Light Dir: Top Right

Hit OK to apply the effect.

Note: If you want to edit the effect at any time, select the object with the effect, and in the Appearance palette double click

figure | 6-35 |

Choose Settings in Rough Pastels.

on the effect name (in this example, "Rough Pastels") to bring up its options box again.

Note: Currently you are working in RGB mode, because, as required, in order to access the Artistic Effects your document needed to be in RGB mode. But, what if you want to eventually output this document in a print format, which is best saved in CMYK mode? If you convert back to CMYK mode right now (File>Document Color Mode) you'll lose the effect you just applied. In order to preserve the effect and convert to CMYK mode, an extra step needs to be taken—on the object with the effect, choose Object>Rasterize to permanently apply the effect (once you've rasterized an object it is no longer editable in the Appearance palette). Now, choose File> Document Color Mode>CMYK Mode.

Applying a Scatter Brush

- 1. Choose View>Actual Size to see the whole document.
- **2.** Choose Select>Deselect to deselect any objects in the document.
- **3.** Default the Fill and Stroke colors (see Figure 6–36).
- **4.** From the main menu choose Window>Brush Libraries> Foilage_Leaves.
- **5.** Select the Green Grass scatter brush (third in top row).
- **6.** Now, double click on the Paintbrush tool in the toolbox to bring up its preferences. In the Options, be sure the following is deselected:
 - Fill new brush strokes
 - Keep selected
 - Edit Selected path

Hit OK.

Note: By default these options are selected. However, personally, I like them deselected, especially Edit Selected path, which automatically edits the shape of your paths as you draw over them. On your own, try drawing with and without these options selected to see the varying results.

- **7.** With the Paintbrush tool, paint a single stroke of grass across the lower part of the document (see Figure 6–37).
- **8.** Click on the grass to select it and go to the Appearance palette. Double click on the Stroke variation called Green Grass to open the Green Grass scatter brush options (see Figure 6–38).

figure | 6-36 |

Change the Fill and Stroke to the default colors.

- **9.** In the options window set the following:
 - Size: 500% to 110%, Random
 - Spacing: 75%, Fixed
 - Scatter: 6%, Fixed
 - Rotation: 0%, Fixed
 - Rotation relative to: Page
 - Colorization: None

Hit OK to apply the changes.

10. Select the grass, and move it up so that it appears as if the fish is hiding in the grass. Save your file.

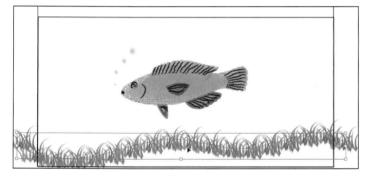

figure | 6-37 |

Paint with the Green Grass scatter brush.

		Stroke Options	(Scatter Bru	sh)			armae ni
Size:	500%	110%	Random	+	6	ΟĶ)
	- 4				6	Connel	5
Spacing:	75%	75%	Fixed	+	<	Cancel	ノ
	Δ Ι						
Scatter:	6%	6%	Fixed	1			
Rotation:	0°	0°	Fixed	+			
CONTRACTOR STORT OF THE CONTRACTOR OF T	Δ						
	Rotat	ion relative to:	Page	+			
	ation						
None	ation	:) (Tine				
None		•	Tips	2			

figure | 6-38 |

Modify the scatter brush options.

Making Water and Waves

- 1. Choose View>Actual Size and select the large, unfilled rectangle object that is around the fish (it's the layer called waves).
- **2.** Locate the **fish_colors** swatches that you opened at the beginning of this lesson.

(Window>Swatch Library>Other Libraries>chap6_lessons> assets>fish_colors.ai)

- **3.** Select the swatch called **water** (a blue gradient).
- **4.** Let's adjust the linear direction of the gradient. Select the Gradient tool in the toolbox.
- **5.** Position the cursor of the Gradient tool at the top part of the gradient-filled rectangle. Click and drag down to the bottom of the rectangle. The direction of the gradient is altered with the dark blue color on the bottom and the light blue color on the top.
- **6.** Choose Window>Transparency (if not already available) and set the opacity of the gradient anywhere between 50% and 80% depending on how clear or muddy you want the water to appear.
- **7.** Select None for the stroke color of the gradient-filled rectangle.
- **8.** Double click the Paintbrush tool to open its preferences and select the Fill new brush strokes option. Hit OK.
- **9.** Select Window>Brush Libraries>Artistic Watercolor.
- **10.** Choose the LightWash_Thick art brush (the first one in the row).
- **11.** At the top of the water you just created, paint some foamy waves (see Figure 6–39).
- **12.** Save your file.

figure | 6-39 |

Paint waves using a watercolor art brush.

Lesson 2: Playing with Custom Brush Styles and Patterns

Creating custom brush styles and patterns in Illustrator requires a special lesson. In the first part of the lesson, you learn how to design your own brushes and patterns and save them in libraries. Then, like a fashion designer, in the second part of the lesson you apply and transform your custom patterns on clothing illustrations. Once you get the hang of designing and modifying brush styles and patterns, you'll find them quite versatile in the quest to create more tactile looking imagery.

Setting Up the File

- 1. Open the file chap6L2a.ai in the chap6_lessons folder.
- **2.** Choose Shift_Tab to hide any open palettes.
- **3.** Select View>Fit In Window. This will be your working document for creating new brushes and patterns.

Creating a Custom Brush

1. Let's create a simple object, a smiley face, as your first custom brush stroke. In the first drawing area of the template, draw a smiley face. See Figure 6–40 for an example. Keep your smiley

figure | 6-40 |

My smiley-face pattern.

face simple—you cannot use gradients, blends, other brush strokes, mesh objects, bitmap images, graphs, placed files, or masks. Also, art brushes and pattern brushes cannot include type. However, there is a way around that, which you'll learn about in the next chapter on type.

- **2.** Select all parts of your drawing and choose Window>Brushes to open the Brushes palette (if the palette is docked to other palettes click on its title tab and drag it out of the group, then close the other palettes).
- **3.** Click on the arrow in the upper right corner of the Brushes palette to open its options drop-down menu. Choose New Brush. (Or, alternatively, choose the New Brush icon at the bottom of the Brushes palette—see Figure 6–41.)
- **4.** For brush type select New Scatter Brush and hit OK.
- **5.** In the Scatter Brush options box, enter a name for your brush (I called mine smiley_face). You can determine your own settings for how the scatter brush will work, or try my settings see Figure 6–42. Once you've determined your settings hit OK. Notice your new brush is available in the Brushes palette (see Figure 6–43).
- **6.** Select your new scatter brush in the Brushes palette.
- **7.** Now, select the Paintbrush tool and in the second drawing area of the template create some smiley-face paint strokes (see Figure 6–44).

figure | 6-41 |

Select the New Brush icon.

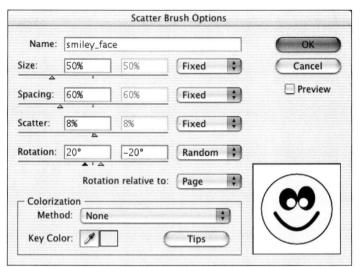

figure | 6-42 |

My settings for the scatter brush.

figure | 6-43 |

The new brush is made available in the Brushes palette.

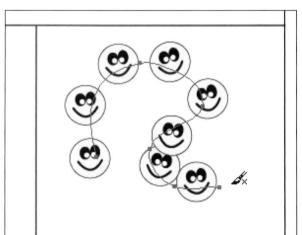

figure | 6-44 |

Adjust the settings for the paintbrush.

Note: Once again, to adjust the settings for your paintbrush, double click on the Paintbrush tool to open its preferences. I turned off Fill new brush strokes in my example.

- **8.** To modify your new smiley-face strokes, select a stroke and double click on the brush in the Brushes palette. The options for that brush pop up again. Adjust the settings to your liking and hit OK.
- **9.** Save your brush stroke by choosing Save Brush Library, from the Brushes palette drop-down options menu.
- **10.** Give your new brush library a descriptive name and save it in your lessons folder.
- **11.** Feel free to use the above steps to create other custom brushes to put in your custom brush library.
- **12.** Save the document as **chap6L2a_yourname.ai**.

Defining a Regular Pattern

- 1. On the template, notice there are four boxes in the My Custom Pattern Fills area. These boxes are the required boundary areas for the patterns you create; they determine the bounding edges for where patterns begin to tile. A bounding area is simply a rectangle with the stroke and fill set to None. For visual purposes the stroke and fill of the boxes are now set to the default colors—this will change when you go to save your patterns in later steps. Let's create a simple pattern in the first box. Select the Rectangle tool.
- **2.** Draw a series of overlapping, colored rectangles within the box (see Figure 6–45).

Note: To align the rectangles perfectly, select all the rectangles, choose Window>Align, and in the Align palette select Vertical Align Center (see Figure 6–46).

- **3.** Select all the parts of your pattern. From the menu bar choose Edit>Define Pattern. Name the pattern **rectangles1** and hit OK (see Figure 6–47). Open the Swatches palette to see your new pattern in the palette window. Feel free to test out your new pattern—create a new object and apply your pattern to it. However, we will also apply these patterns in the next part of the lesson.
- **4.** Save your file.

figure | 6-45 |

Create a pattern of overlapping rectangles.

figure 6-46

Align the rectangles using the Align palette.

New Swatch				
Swatch Name: rectangles 1			OK	
Color Type:	Process Color Global		*)	Cancel
Color Mode:			*)-	
Гс		0	%	
M		0	%	
Y		0	%	
K		0	%	

figure | 6-47 |

Define the pattern.

figure | 6-48 |

Start the creation of an irregular pattern.

Creating an Irregular Pattern

- 1. Creating an irregular pattern takes a little finesse. Select the Ellipse tool (hidden under the Rectangle tool in the toolbox) and draw a colorful circle that overlaps the top part of the second bounding box in the template (see Figure 6–48).
- **2.** Now, choose View>Snap to Point (if not already selected).
- **3.** Select both the circle object and the bounding box.
- **4.** Drag the rectangle down; then press Option+Shift (Mac) or Alt+Shift (Windows) to create a copy and constrain the move. When the top of the duplicate rectangle snaps to the bottom of the first rectangle, release the mouse button, then release the keys. See Figure 6–49.

Note: don't worry if you find it challenging at first to drag, copy, constrain, and snap objects all in one fell swoop. Usually I have to Edit>Undo a few times before I get it just right.

- **5.** Click outside the rectangle to deselect it.
- **6.** Select the bottom rectangle (leave the duplicate circle) and delete it.
- **7.** Create another set of colorful circles on the left side the bounding box.
- **8.** Select these side circles and the bounding box (but not the top and bottom circles) and follow the technique in step #4 to drag, copy, constrain, and snap the objects to the right side of the bounding box. See Figure 6–50.

figure | 6-49 |

Drag, copy, constrain, and snap objects of the pattern.

figure | 6-50 |

Finish the side portions of the pattern.

- **9.** Click outside the rectangle to deselect all.
- **10.** Select the right side rectangle (leave the duplicated circles) and delete it.
- **11.** Draw a couple more circles in the center of the rectangle area. Your final pattern will look something like Figure 6–51.

figure | 6-51 |

An example of the final pattern.

figure | 6-52 |

Select all parts of the pattern.

- **12.** Select the bounding rectangle and choose None for both its fill and stroke. This is a required step to get the pattern to work!
- **13.** Select all the parts of the new pattern, including the now invisible bounding area (see Figure 6–52), and choose Edit> Define Pattern. Name it **polka_dots** and hit OK. The new pattern appears in the Swatches palette.
- **14.** Save your file.
- **15.** Using what you've learned in this last section, create two more patterns in the other bounding boxes provided. Define them in the Swatches palette.

- **16.** Once you have all your patterns created and defined in the Swatches palette, choose Save Swatch Library from the Swatch palettes drop-down menu.
- **17.** Call your new Swatch Library **my_patterns.ai** and save it in your lessons folder.
- **18.** Save and close this file.

Applying and Transforming Patterns

- 1. Open chap6L2b.ai in the chap6_lessons folder.
- **2.** Choose View>Fit In Window to see the clothing illustrations.
- **3.** Choose Shift_Tab to hide unneeded palettes.
- **4.** Choose Window>Swatch Libraries>Other Library (at the end of the list). Browse for and open the custom library you created in the last section called **my_patterns.ai** (alternatively, you can find my version in the **chap6_lessons/assets** folder).
- **5.** Select one of the lapels of the tuxedo illustration. Then, select one of your patterns in your custom library to apply it to the lapel. See Figure 6–53.

figure | 6-53 |

Applying the polka dot pattern.

figure | 6-54 |

Select the Scale tool in the toolbox.

figure | 6-55 |

Adjust the scaling of just the pattern.

- **6.** Let's transform this pattern; scale the pattern smaller. Select the Scale tool in the toolbox (see Figure 6–54).
- **7.** To scale only the pattern and not the selected object itself, hold down the tilde key (~) on the keyboard, place your cursor over the pattern and drag your cursor down and/or across to scale the pattern. A yellow bounding box appears as you scale in this mode. See Figure 6–55.

Note: You can also use the Transform palette to transform only a pattern. Choose Window>Transform. From the Transform palette's drop-down menu select Transform Pattern Only. Enter in new values for the selected pattern. If you choose this option you must remember to change the settings back when you choose to transform only the object, and not the pattern.

figure | 6-56 |

An example of the completed lesson.

8. Select other parts of the tuxedo and sports jacket, and apply and transform patterns.

Note: To copy modified patterns to various parts of the clothing (such as from one sleeve to the other) select the object without the pattern, and with the Eyedropper tool take a sample of the modified pattern you want to copy. Or, Shift_ select all the clothing parts you want to apply a pattern to and apply and transform them as a selected group.

9. Save this file in your lessons folder. See Figure 6–56 for an example of the completed lesson.

SUMMARY

Let me guess, after this chapter you're hooked on painting in Illustrator—so many brushes, patterns, and effects to fool around with, so little time and digital screen space. As you learned with every stroke and fill, your drawing can suddenly come to life with variations on value and texture. These variations can be modified again and again with the Appearance palette, and used over and over in custom libraries.

in review

- 1. Define value in drawing and painting.
- 2. Define texture in drawing and painting.
- 3. What are "caps" and "joins"?
- 4. What are the four brush types and their characteristics?
- 5. What's the main difference between an effect and a filter in Illustrator?
- 6. How can the Appearance palette enhance your workflow?
- 7. What are the steps to edit brush styles applied to a particular stroke?
- 8. What's opacity?
- 9. To use the Artistic filters and effects, what color mode must a document be in?
- 10. What's so important about a bounding box when creating custom fill patterns? How do you make a bounding box?

≠ EXPLORING ON YOUR OWN

- Access the Help>Illustrator Help menu option. Under Contents read up on the following topics:
 - Applying Color, Fills and Strokes (section, "Changing stroke attributes")
 - Using Transparency, Gradients, and Patterns (sections "About transparency," "Working with transparency," "Working with gradient fills," and "Creating and working with patterns").
 - Enhancing the Appearance of Objects (sections "About enhancing the appearance of objects," "Working with appearance attributes," "Using filters and effects," "Using Stylize filters and effects," and "Using graphic styles").
 - Advanced Drawing (sections "Using brushes" and "Creating and editing brushes").

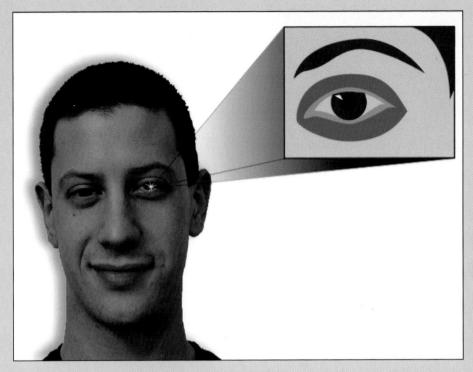

Figure 1 Illustrations start with simple lines and shapes, as demonstrated in an illustrative version of Adam's eye.

Figure 2 The visual (human eye), screen, and print color gamut areas.

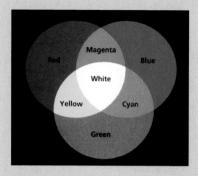

Figure 3 The RGB color model. RGB light combined creates white. When R, G, or B overlaps each other, they create cyan, magenta and yellow.

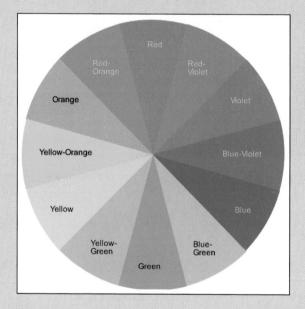

Figure 4 A standard color wheel.

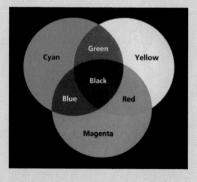

Figure 5 The CMYK color model. When CMY ink colors are mixed together, they create black (K). When the colors overlap, they produce red, green, and blue.

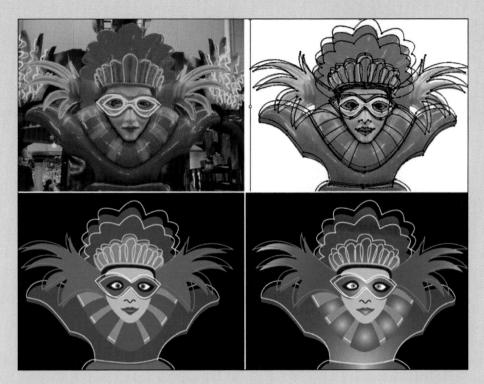

Figure 6 The different stages of the Las Vegas Lady lesson from Chapter 5.

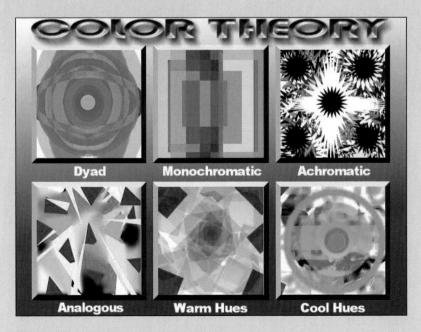

Figure 7 Combinations using color chords.

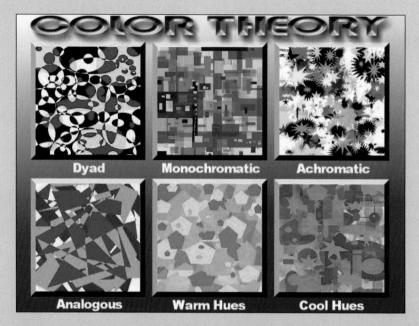

Figure 8 More color combinations using color chords.

Figure 9 Colored versions of the Stratton Buyer Brokerage logo.

Figure 10 Three variations of an illustration—the traditional print, a version drawn in Illustrator with flat shading, and a version drawn in Illustrator with value and texture added.

Figure 11 The Completed Fish Painting created in Chapter 6.

Figure 12 Runway Pattern Project by student, Phillip Morphis (Modesto Junior College Illustrator class).

Figure 13 Runway Pattern Project by student, Sandra Madrigal (Modesto Junior College Illustrator class).

Figure 14 Runway Pattern Project by student, Sandra Madrigal (Modesto Junior College Illustrator class).

Figure 15 Pathfinder Palette Shape mode examples.

Figure 16 Pathfinder Palette pathfinder filter examples (1).

Figure 17 Pathfinder Palette pathfinder filter examples (2).

Figure 18 Example of the Web Page Design lesson in Chapter 8.

Figure 19 Design of a playing card box by student, Denise Gillit (Modesto Junior College Illustrator class).

Figure 20 Playing card designs by student, Denise Gillit (Modesto Junior College Illustrator class).

Figure 21 Self portrait, Gregory Sinclair (Modesto Junior College Illustrator class). Created using the Pen tool and filling the shapes with gray tones.

Figure 22 Complex blends of color, as in these balloons, are created using Illustrator's gradient meshes.

Figure 23 Three-dimensional effects, as in this wine glass, can be produced in Illustrator CS.

Figure 24 This wine label was created using a combination of Illustrator and Photoshop by the artists at Gallo Winery, Modesto, California. (Used with permission of E & J Gallo Winery)

Figure 25 Finished business card design—ready to go to print—for Stratton Buyer Brokerage in South Londonderry, Vermont. (Compliments of Andrea Linkin-Butler and Stratton Buyer Brokerage)

 $\begin{tabular}{ll} \textbf{Figure 26} & Logo illustration for Optometrist. (Copyright @ 2002 STAUDESIGN. All rights reserved.) \end{tabular}$

Figure 27 Illustration for Hair Stylist, specializing in hair color décor in tropical theme. (Copyright © 2002 STAUDESIGN. All rights reserved.)

Figure 28 Food Pyramid by Dave Joly/picturedance.com

Figure 29 Generator by Dave Joly/picturedance.com

Figure 30 Ling by Dave Joly/picturedance.com

Figure 31 Ring Toss by Dave Joly/picturedance.com

Figure 32 Blankets by Annie Gusman/picturedance.com

Figure 33 Destiny by Annie Gusman/picturedance.com

Figure 34 House Arrows by Annie Gusman/picturedance.com

Figure 35 Peaceful Sleep by Annie Gusman/picturedance.com

Figure 36 Hippo. Illustration by Laurie McAdam. (The Modesto Bee)

Figure 37 Oliver Kringle, book cover illustration. Author, Justin Matott, Illustration/Designer, Laurie McAdam. The entire Oliver Kringle children's Christmas book was illustrated, designed, and produced by Laurie McAdam in Adobe Illustrator.

Figure 38 Chef. Illustration by Laurie McAdam. (The Modesto Bee)

Figure 39 American Idol contestant, Clay Aiken. Illustration by Laurie McAdam. (The Modesto Bee)

Figure 40 Hot Door CADtools 3 is a CAD plugin for Adobe Illustrator, adding a full set of 2D and isometric precision drawing tools for technical illustration. Trial versions of the plugins are available on the book's CD-ROM. (Compliments of Hot Door, www.hotdoor.com)

Figure 41 An illustration using Hot Door CADtool plugins for Adobe Illustrator. Trial versions of the plugins are available on the book's CD-ROM. (Compliments of Hot Door, www.hotdoor.com)

Figure 42 Illustration by graphic artist Wai Har Lee.

Figure 43 Illustration by graphic artist Wai Har Lee.

Figure 44 Illustration by graphic artist Wai Har Lee.

Figure 45 A company logo drawn from a concept sketch then redrawn in Illustrator. (Compliments of artist Allen Passalaqua)

Figure 46 Label design by artist Kathy Landess. Portrait artist, Rick Priest. (Compliments of Mike Hutchinson and Mike Nuts Home Brews)

Figure 47 Randall is a vector sketch using the Pencil tool and layers. (Compliments of artist Allen Passalaqua)

- Practice applying value and texture variations on my flower illustration. Open chap6_lessons/samples/flower.ai. Or, make your own flower image, starting with a flat colored version, then adding value and texture to the strokes and fills. An example of my original, digitized flower can be viewed in the color insert of this book (Figure 10).
- 3. Runway Pattern Project—similar to Lesson 2, develop your own patterned blouse, shirt, coat, dress, pants, or a whole outfit that can be complemented with a patterned accessory, such as a tie, ascot, scarf, sash, belt, or purse. See the student examples in the color insert (Figures 12 to 14).

First, draw your clothing fashions using the Pen tool with a basic, black stroke color and no fills. Next, using the techniques learned in this chapter, design a variety of patterns (geometric, regular, irregular for both brushes and fills). Save them in a custom library (brushes in a Brush Library, fills in a Swatch Library). Then, apply your patterns and transform, if necessary, on your fashion drawings.

Green Goddess Dressing

To achieve a beautiful green color, use very fresh green parsley and scal-

lions, and puree the dressing for one to two minutes.

1- 10.5 oz package of silken tofu

1/3 cup, packed Italian parsley, minced

1/4 cup, packed scallions, minced 1 garlic glove, minced

1/4 cup lemon juice (1 lemon)

2 tablespoons apply cider vinegar

1 tablespoon umeboshi vinegar

1 tablespoon sea salt

Pepper to taste

Soymilk or water, as necessary

Puree all the ingredients in a food processor or blender for 1-2 minutes, with enough liquid to achieve a creamy, smooth consistency. Adjust the seasonings to taste. Serve immediately or chill 1-3 hours to let the flavors marry and intensify.

VARIATION: Green Goddess Dip Reduce the soymilk or water for thicker consistency. Add basil, chives, cilantro, dill, fennel, parsley, or marjoram.

working with type

charting your course

For the novice graphic designer, picking fonts, and working with type are often neglected—an afterthought to the overall image or layout. But type can become a design in itself and provides a vital role in communicating your illustrative message from business cards, to logos, to party invitations. The skill and talent of designing with type, or simply working with the appearance of printed characters, is called typography. This chapter is an opportunity to put on your typographer's hat, introducing you to the methods for creating, formatting, exporting, and importing type in Illustrator. Also provided are basic design techniques for making appealing and readable type layouts, turning you into a type guru or font aficionado in no time.

In this chapter you will:

- Practice the three methods of creating type in Illustrator—type at a point, type in an area, type along a path.
- Discover the quirks of fonts, font families, and font formats.
- Format type with ease.
- Get an overview of what to know when importing, exporting, installing, and embedding fonts.
- Learn some basic design techniques when choosing and working with fonts and type layouts.
- Get familiar with typography terminology.

CREATING TYPE IN ILLUSTRATOR

Creating type in Illustrator is pretty straightforward. There are three methods for doing so:

- Type at a point
- Type in an area
- Type on a path

Typing at a Point

Not unlike typing in any basic word processing program, to type at a point you simply click down on your document with the Type tool and starting typing. The Type tool, located on the toolbar, has a big T on it (no chance of missing that!). When you expand the Type tool you get several more tools, which we will investigate soon enough. In general, the first three tools in the list create horizontal type, the last three create vertical type. See Figure 7–1 and Figure 7–2.

figure **| 7**–1 **|**

The Type tool and its expanded options.

figure | 7-2 |

An example of horizontal and vertical text.

To type at a point follow these steps:

- 1. Select the Type tool in the toolbox. Your cursor changes to what's called an I-beam—this is your starting mark. The small horizontal line toward the bottom of the I-beam determines where the text rests, called the baseline.
- **2.** Click down anywhere on your document, and start typing. See Figure 7–3.

CLICK DOWN WITH THE I-BEAM AND START TYPING.
TO TYPE A NEW LINE YOU HIT RETURN OR ENTER.
NOTICE THE LITTLE BLINKING CURSOR, INDICATING
WHERE YOU ARE LOCATED IN THE TEXT LINE. | I

figure | 7-3 |

Some text typed at a point. Notice the I-beam at the end of the paragraph.

Be careful not to click down on an existing object with the Type tool. Otherwise that object converts to area type or assumes you want to type along its path—we're not quite there yet. To be on the safe side, hide or lock any objects that might get in your way.

- **3.** Hit Return or Enter to start a new line. To insert a letter, word, or line within the existing text block, click between any two letters and start typing at that point.
- **4.** To select the block of text use the Selection tool. Or, alternatively, Ctrl-click (Windows), or Command-click (Mac OS) the text.

Note: When you choose View>Show Bounding Box and select the text block, notice that transform handles appear around it—this makes it easy to move, scale, and rotate your text. See Figure 7–4.

- **5.** There are actually several methods to select and modify individual characters, words, sentences, or paragraphs. I encourage you to find which of the following methods works best for you.
 - If the text block or path is already selected, just double click on the text to switch to the Type tool and get the

figure | 7-4 |

Transform a text

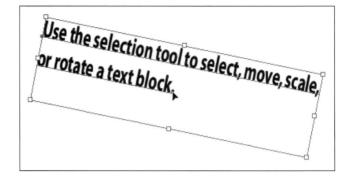

I-beam cursor. With the I-beam, click in front of and then drag over the text you want to modify.

- Or, select the Type tool in the toolbox, and with the I-beam, click in front of and then drag over the text you want to modify.
- If you want to select a single word quickly, place your I-beam anywhere within the word and then double click. If you're really quick with your clicks, position the I-beam, then click 3 times fast to select a whole line (no, I'm not pulling your leg here, or your sequined, red shoes—it really does work).

Typing in an Area

Most often it's useful to type in a defined area. There are two ways to do this. To define a rectangular area you drag with the horizontal or vertical type tool (see Figure 7–5), and then start typing within the area. To type within another kind of shape, you click with the horizontal or vertical type tool or horizontal or vertical area type tool (second and fifth options when you expand the Type tool list) on any object's outline, which converts it to a container for the text (see Figure 7–6).

When you've typed more than can fit in the defined area, a little red box with a plus sign shows up at the bottom of the text block, indicating that the text is flowing outside of the space (see Figure 7–7). You can fix this problem, of course, in several ways. You can use a smaller point size for the font (see section on formatting type), or scale the text area larger. To scale, choose View>Show Bounding Box, then select the area and adjust the transform handles. Notice that when you scale a defined area, the area size changes but not

figure 7-5

Drag with the Type tool to define an area.

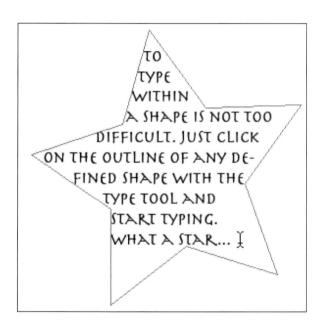

figure | 7-6 |

Create a text container out of an object.

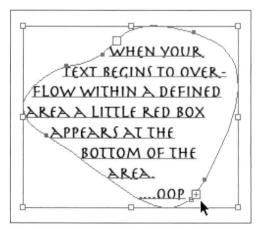

figure 7-7

The little box with the plus sign in the corner of the text block indicates an overflow of text.

figure | 7-8 |

You can scale a text block larger to include overflow text.

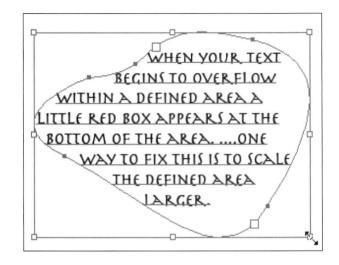

figure | 7-9 |

Scaling text at a point distorts the text.

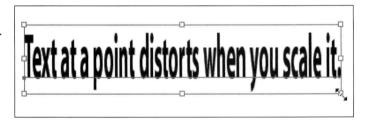

the text itself. This is different than scaling text at a point, which actually distorts the text. See Figure 7–8 and Figure 7–9.

So you know, there is also an Area Type Options box (see Figure 7–10), which includes options to numerically change the width and height of a text area, create rows and columns, and adjust offset and text flow. To get to the options box, select some area type on the document, and choose either Type>Area Type Options from the menu bar, or double click the Type tool in the toolbox.

Using area type, you can also thread (or flow) type from one object to the next. On any selected type area there are two little boxes, called ports, on each side of the box. To attach two blocks of text together you click on the end port of one text block and the beginning port of the next object to initiate the thread (see Figure 7–11, then Figure 7–12). Whenever you want to release threaded text, select one of the linked boxes, and choose Type>Threaded Text>Release (or Remove) selection.

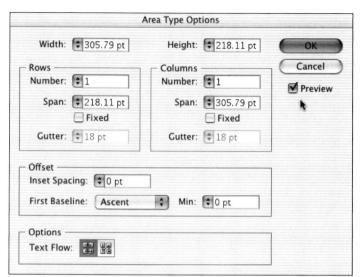

figure | 7-10 |

The Area Type Options box.

You click on a little box, called a "port", on either end of a block of area text to initiate the threaded text option.

figure | 7-11 |

Click on an end port of a text area to initiate the threaded text option.

You click on a little box, called a "port", on either end of a block of area text to initiate the threaded text option. Theri, click
again on another
object to flow the
text from one
object to the
next

figure | 7-12 |

Then, click on another object to continue the text thread.

Typing on a Path

Okay, here's where things get a little more interesting. In Illustrator you can also create text that flows along an open or closed path. To do this, use the Horizontal Type or Type on a Path tool (third type tool option). Or, Vertical Type or Type on a Path tool (sixth type tool option), depending on your preference. Click on any defined path and start typing. Check out Figure 7–13.

Chances are you'll want to move your text along its path and adjust its orientation, especially if you're trying to attempt the often-requested "text bending around an ellipse" trick. To move text along a path, first select the path. A bracket appears at the beginning, middle, and end of the path. Place your cursor over the middle bracket until a little icon that looks like an upside-down T appears. Click and drag on the middle bracket to move the path. See Figure 7–14 and Figure 7–15. The brackets on each end of the type line adjust the distance between the beginning and end of the typed line. See Figure 7–16 and Figure 7–17.

Note: As you adjust the path using the brackets, avoid clicking on the little boxes, or ports, at each end of the line. This initiates the threaded area type option discussed in the previous section.

figure | 7-13 |

Create horizontal and vertical text on a path.

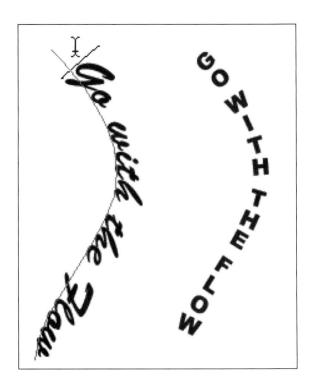

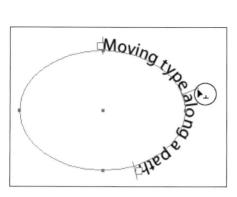

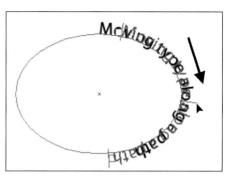

figure 7-14 and 7-15

Select, then move, the middle bracket to adjust the text on a path.

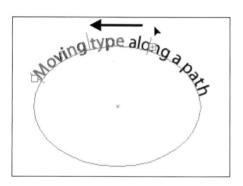

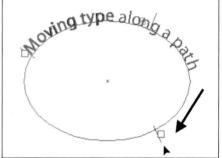

figure 7-16 and 7-17

Select the end bracket and adjust the distance between the beginning and end of the text line.

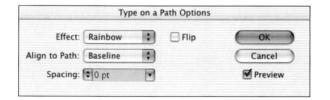

figure | 7-18 |

The Type on a Path options box.

Of course, there are more goodies to tinker with in the Type on a Path options box. Select some type on a path and choose Type>Type on a Path>Type on a Path Option, or double click the Type tool in the toolbox (see Figure 7–18). I highly recommend selecting Preview in this options box and exploring the different options available.

figure | 7-19 |

If you use the Type tool on an open path you get option #1; if you use the Area Type tool on the open path you get option #2.

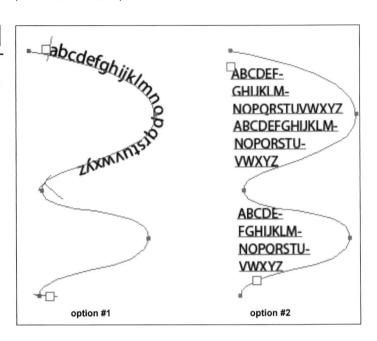

Some Type Tips

Before moving on, there are a couple miscellaneous things you ought to know about creating type. When I was first learning how to create type in Illustrator, it seemed that I could use either the Type tool or Area Type tool to create area type. Similarly, I could use either the Type tool or Type on a Path tool to create type on a path. Why have two tools for the same task? Well, come to find out it depends on whether you are using an open or closed path for each method. In the case of creating area type, I discovered that if the object to be used as the area is an open path, you must use the area type tool to define the bounding area. If you use the type tool, it creates type on a path. In contrast, when creating type on a path, if the object to be used as the path is a closed path you must use the type on a path tool. If you use the type tool, it creates area type. Confused? See Figure 7-19 and Figure 7-20 to help you out, or try the above scenario in Illustrator and you'll quickly get what I mean.

Another, somewhat annoying, thing about creating type is that often (and usually inadvertently) empty type paths are created when you click the Type tool in the artwork area and then decide to choose another tool. To quickly clean up these stray type markings and containers, choose Object>Path>Clean Up and select the Empty Text Paths option.

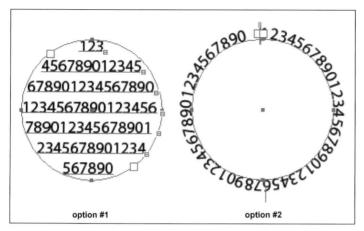

figure | 7-20 |

If you use the Type tool on a closed path you get option #1; if you use the Type on a Path tool you get option #2.

FORMATTING TYPE

You've probably formatted plenty of text in word processing programs—selected font styles and sizes, used the bold and underline options, copied, pasted, and justified paragraphs, and maybe even worked with letter and line spacing. All of these familiar formatting options are also available in Illustrator (how convenient!).

To format specific characters, such as font style and size, leading, tracking and kerning, you choose Window>Type>Character to bring up the Character palette. To modify familiar paragraph options, such as paragraph justification and indentation, you use the Paragraph palette, which is usually grouped with the Character palette (see Figure 7–21 and Figure 7–22). Definitions for some of the formatting options that might be new to you, such as tracking, leading, and kerning are provided in the Designing with Type section of this chapter.

Another kind of formatting that's somewhat specific to Illustrator is changing the appearance of type. You can change the basic fill color or stroke of type easy enough, by selecting the text and changing the color, as you would any object. With this same method you can also change transparency, effects, and graphic styles (see Figure 7–23 and Figure 7–24).

There might also come a time when you want to apply a gradient to some text. Because of the nature of fonts, you must convert the text to outlines (the underlying path structure and shape of each letter) before assigning a gradient color to it. To do this, select the text path and choose Type>Create Outlines, then apply the gradient

figure | 7-21 |

The Character palette used to format type.

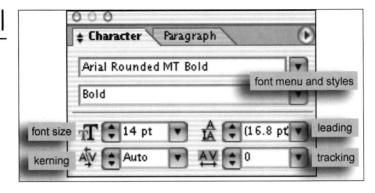

figure | 7-22 |

The Paragraph palette used to format type.

figure | 7-23 |

Select the text and change its fill and stroke color.

figure 7-24

Play with graphic styles and transparency on text.

figure | 7-25 |

The top line indicates text when normally selected. Below is the text selected after converting it to outlines, then applying a gradient; notice that the points that make up the path of each letter shape are now visible and editable.

blend (see Figure 7–25). Creating outlines is also a necessary step if you want to manipulate the individual anchor points of a letter form, or need to use text in a custom-made art or pattern brush. However, be aware that once you've converted type to outlines, character and paragraph options for the type are no longer available. More on the characteristics of fonts and font formats is discussed in the next section.

THE STORY OF FONTS

Fonts are funky. If you've worked with type at all on a computer, there's no doubt you have experienced the quirks (or, rather, the "wrath") of fonts. Suppose, for example, a time you found the perfect font, called "Groovalicious," and used it extensively in your document. You send your document to a friend who opens it on his computer and a warning comes up indicating that "Groovalicious" is nowhere to be found. Furthermore, unless otherwise specified the missing font will be substituted with Times New Roman (or something like that), and . . . so much for design. This unfortunate predicament occurs when one computer has a particular font installed and the other doesn't. Because of this, designers often send their font files along with their documents, or, if the option is available, embed (save) the fonts within the document.

Before I continue further with this rather in-depth story about fonts, what exactly is a font, or font face, anyway? A very textbook definition of fonts is "a full set of printing type or of printed or screen characters of the same design and size" (taken from the figure | 7-26 |

Part of the Helvetica font family.

Helvetica Medium Helvetica Bold

Helvetica Neue Thin Italic

Helvetica Neue Condensed Black

dictionary supplied in my MS Word program). Most often fonts come in font families—a group of similarly designed font sets. For a particular font within a font family, you can choose a font style, such as bold, italic, or medium. In Illustrator, you can select fonts using the Character menu (Window>Type>Character) or the Type menu (Type>Font). Each font family, appropriately, has a family name, usually derived from the artist who first created the font design. For example, Figure 7–26 shows some of the Helvetica font family.

Font Copyright

Unless you use license free fonts (freeware)—and, there are a lot out there—fonts and font families are protected by copyright law. Just as when you use another artist's image or photograph in your work, when you use someone else's font creations you need to get permission. It's a curious fact that even though you have the ability in Illustrator to embed (save a font's outlines for viewing in other applications), select, and format any font installed in your computer system's font folder, that doesn't necessarily mean you have the rights to showcase it in your Illustrator creations (especially your work designed for commercial means). A reminder of this fact occurs when you go to save your document and a font embedding notification pops up (see Figure 7–27). Play it safe, and contact the creator of the font to determine whether a given font can legally be embedded and used in your document. Most often, you can find the font creator's information in the Read Me files or in documentation that accompanies the font before installation. You can also select the font's file name, and Ctrl-click>Get Info on a Mac, or right-click>Properties on Windows for more information on that particular font.

figure 7-27

Depending on their license agreements, fonts used in your artwork might prompt the font embedding notification when you go to save the document.

Font Formats

Just as there are different ways in which a device, such as a computer or printer, renders a digital image (i.e., as bitmapped pixels or vectored outlines), so it is for fonts. A font's format, generally speaking, provides the instructions for how a digitized font is either printed on paper, presented on screen, or both. As is the nature of technology, font formats have evolved quickly over time, and it behooves us to have some understanding of the current font technologies.

Interestingly, back in the 1980s it was Adobe Systems that made the most significant advancements in how computers handle text. It started out with something called Postscript, a page description language that stores objects or glyphs (character shapes on a page or screen) not as fixed resolution bitmaps, but rather as programmatically defined outlines or shapes. The nice thing about Postscript-derived glyphs is that they can be reliably recreated at the resolution of whatever Postscript-compatible device you output it on. In other words, it doesn't matter if you choose 12-point type or 72-point type, it will always look crisp and clean when you print it off.

Note: Adobe PostScript® is still the worldwide printing and imaging standard. If you save your documents in Adobe's Portable Document Format, commonly known as PDF, you are using a form of the PostScript language.

To some extent, each of the three most common font formats use Postscript. These include Type 1, TrueType, and OpenType.

- Type 1 is a resolution-independent digital font type that can translate a font from the screen to a high-quality font in print. Adobe is the original designer and manufacturer of Type 1 and maintains its standards; however, many other companies have designed and released their fonts using the Type 1 format. Type 1 fonts are commonly used by graphic designers whose work specifically goes to print.
- TrueType is the standard for digital type fonts, which was first developed by Apple Computer Incorporation then subsequently licensed to Microsoft Corporation. Each company has made independent extensions to this format, some of which can be used on either or both the Windows and Macintosh operating systems. Within a single font format, TrueType has the ability to translate fonts for print and screen, avoiding the bitmapped look when size and resolution quality are changed. TrueType fonts are great for graphic designers who create work for both print and screen (e.g., CD-ROM and web).
- OpenType, developed jointly by Adobe and Microsoft, is currently the most sophisticated form of font technology, an extension of the TrueType font.

Note: With Illustrator CS, more advanced support for OpenType has been provided.

OpenType formatted fonts have several benefits over previous font types. One, they are cross-platform compatible, meaning you can use a single font file for both Macintosh and Windows computers—no more font substitution issues. Also, it has the ability to support expanded character sets and languages, by containing more variations of glyphs in a single font set, including nonstandard ones like old-style figures and fractions.

OpenType, literally, is opening new doors for typographers, providing better control over type layout and design. Illustrator CS now has the expanded ability to support OpenType layout features on OpenType formatted fonts. A single character in the OpenType format can have several glyph (shape and symbol) variations to

broaden its linguistic and typographic options. For example, variations on the number "2" in the font Myriad Pro (an OpenType font) could be alternated as you see in Figure 7–28, using the OpenType options box (Window>Type>OpenType).

You can also view and choose glyphs for any currently selected font format by choosing Type > Glyphs. See Figure 7–29 for the glyphs available for the font Myriad Bold (a Type 1 formatted font) and Myriad Pro Bold (an OpenType formatted font). The OpenType version has many more glyph variations.

 2 = numerator

2 = denominator

 $\frac{1}{2}$ = fractions

figure 7-28

Example glyphs of the number "2" within the Myriad Pro OpenType font.

Glys	bs V						00000							-		and the	Glyp															
hoe	- 9	tire For	11	-11600	TO U	+003f											Par	-	tire Fo	nt		1 P	+0041									
ë	è	í	î	ï	1	ń	ó	ô	ö	ò	ô	š	ú	û	ü	r		!	11	#	\$	%	&	,	1)		+	,		Γ.	1
ù	ý	ÿ	ž	\$	()	0	1	2	3	4	5	6	7	8		0	1	2	3	4	5	6	7	8	9	:	;	<	=	>	?
9	,	٠	٤	ff	ffi	ffl		,			0	4	5	6	7		@	A	В	c	D	E	F	G	н	1	J	K	L	M	N	0
8	9	0.	1	2	3 .	4	5	6	7	8	9	c	5		,		P	Q	R	s	T	U	٧	w	X	Υ	Z	1	1	1	٨	_
	Ă	Ā	Ą	Æ	Ć	Č	Ĉ	Ċ	Ď	Đ	Ě	Ě	Ė	Ē	Ŋ		'	a	b	c	d	e	f	g	h	i	j	k	ı	m	n	0
Ę	Ğ	Ĝ	Ģ	Ġ	Ħ	Ĥ	Ĭ	IJ	Ĭ	1	Ĩ	ĵ	Ķ	Ĺ	Ľ	i.	р	q	r	s	t	u	v	w	х	у	z	{	ī	}	~	i
Ļ	Ŀ	Ń	Ň	Ņ	Ŏ	Ő	Ō	Ø	Ŕ	Ř	Ŗ	Ś	Ş	Ŝ	Ş		¢	£	1	¥	f	5	п	1	"	«	(>	fi	fl	-	+
Ŧ	Ť	Ţ	Ŭ	Ű	Û	Ų	Ů	Ũ	Ŵ	Ŵ	Ŵ	ŵ	Ŷ	Ý	Ź		‡		1		,	"	11	»		‰	į	,	,	^	~	-
Ż	İ	ă	ā	ą	æ	ć	č	ĉ	ć	ď	đ	ě	ě	ė	ē		~	•		0	,	"	,	*	_	Æ	a	Ł	ø	Œ	0	æ
ŋ	ę	ğ	ĝ	ģ	ġ	ħ	ĥ	ĭ	ij	î	į	î	ĵ	ķ	ſ		1	ł	ø	œ	ß	1	Ò	Ç	×	Ñ	Ö	μ	Ó	þ	ð	ì
ľ	1	ŀ	ń	ň	ņ	ŏ	ő	ō	ó	ŕ	ř	r	Ś	ş	ŝ		ô	É	Ë	Á	Ž	ç	٦	Ã	þ	1/4	Â	ö	3/4	Û	Ù	Ü
ş	ŧ	ť	ţ	ŭ	ű	û	ų	ů	ű	ŵ	ŵ	ŵ	ŵ	ŷ	ý		ĺ	À	٥	1/2		Ý	2	Ú	(9)	©	Ê	TM	±	Đ	Ä	Å
ź	ż	K	'n	•	-	Α	В	Γ	Δ	E	Z	н	Θ	1	K	*	Ÿ	÷	1	3	È	ï	Š	Î	á	â	ä	à	å	ã	é	ê
ria	Pro									-	1	Beld	-	-	43	1	διδητία	đ	-			-							ole	- 15	-	44

figure | 7-29 |

Part of the glyphs list for Myriad Bold (Type 1) and Myriad Pro Bold (OpenType).

figure | 7-30 |

_____ Type 1 It's easy to identify a font's format, whether Type 1 (Figure 7–30), TrueType (Figure 7–31), or OpenType (Figure 7–32), when you go to select a font by choosing Type>Font, or Window>Type> Character. To the left of each font name you happen to have installed on your computer is a small icon indicating the font type (see also Figure 7–33).

Font Compatibility

figure | 7-31 |

TrueType

As you encountered in the "Groovalicious" situation previously mentioned, document fonts are not always where you want them to be. Fonts go a-missing when they are used in a document, but are unavailable on a computer system. For easy identification, Illustrator automatically highlights missing fonts for you. You can then use the Find Font command (Type>Find Font) to replace the missing fonts with installed ones or identify the missing fonts so you can install them. You can also choose to highlight the substituted fonts or glyphs, as well as choose other global Type options under File>Document Setup. See Figure 7–34.

figure | 7-32 |

OpenType

One other thing to mention here, particular to Illustrator CS, is the issue of legacy text. The term legacy in Illustrator refers to earlier versions of an Illustrator file format. So, legacy text refers to text used in early versions of the program. Because Illustrator CS has a new and more efficient way of dealing with text composition, called the Adobe Text Engine, legacy text must be updated before you can edit it. When you import an earlier version of an Illustrator file, a dialog box comes up asking if you would like to update any legacy text in the document. If you choose to update, slight variations in the text layout might occur; however, you can then

figure | 7-33 |

Here's an example of part of the font list installed on my computer. Notice the icons next to the font names indicating the font's format.

figure | 7-34 |

The Type options in File>Document Setup.

edit the text. If you choose not to update, the legacy text will be preserved (indicated by an "X" in its bounding box when selected) and can be viewed, moved, and printed, but not edited.

Lesson: Recipe Card

Hands-on in this lesson, you experience creating type and applying formatting options, while constructing a graphically pleasing recipe card. Figure 7–35 is a visual reference of the completed file.

figure | 7-35 |

The completed Recipe Card lesson.

Setting up the file

- 1. In Illustrator open chap7L1.ai in the chap7 lessons folder.
- **2.** Choose Shift_Tab to hide any open palettes.
- **3.** Choose View>Fit in Window.
- **4.** Choose Window>Layers. Be sure the **type on path** layer is selected. Notice the other layers are locked (indicated by the lock icon to the left of the layer name), so that you cannot accidentally select items in those layers.

Creating Type on a Path

- 1. Let's create some type on a path that looks like the result in Figure 7–36. With the Zoom tool, zoom in closer to the tomato logo in the upper left corner of the document.
- **2.** Select the Ellipse tool in the toolbox. Click down over the logo to bring up the Ellipse tool options box. Type in Width = 2.3 inches and Height = 1.7 inches and hit OK (Figure 7–37). The ellipse shape will be created on the document.

figure | 7-36 |

Karen's Kitchen logo is an example of type on a path.

figure | 7-37 |

Specify an exact size for the ellipse.

- **3.** Choose None for the fill color of the ellipse, then position the ellipse object so that it fits over the tomato logo, as in Figure 7–38.
- **4.** Let's cut this ellipse shape into two sections—a top section to create one line of curved text and a bottom section for another line of curved text. Be sure your ellipse is selected, then select the Scissors tool in the toolbox (see Figure 7–39).
- **5.** Position the cursor directly over the anchor point on the left side of the ellipse shape and click down to cut the anchor point. Do the same thing on the anchor point on the right side of the ellipse, breaking the shape into two halves (see Figure 7–40).

figure | 7-38 |

Fit the ellipse shape over the logo.

figure | 7-39 |

The Scissors tool used to cut paths.

figure | 7-40 |

Cut the ellipse in half using the Scissors tool.

Note: When attempting to click over an anchor point to cut it with the Scissors tool a warning box might come up as follows: "Please use the Scissors tool on a segment or an anchor point (but not an endpoint) of a path." This warning comes up when you have not directly clicked on a segment or anchor point on the selected path. Exit out of this warning box and try cutting the anchor point again.

6. Choose Window>Type>Character to open the character options. For Font type and style choose Arial Bold. For font size choose 24 points (Figure 7–41).

Note: If Arial Bold is unavailable on your computer, choose another font type to play with such as Helvetica or Verdana.

7. Now you're ready to type some text on the defined paths. Select the Type on a Path tool in the toolbox (hidden under the Type tool; see Figure 7–42). Then, click down on the top line segment of the ellipse you just cut in half to convert the path into a text path. A blinking cursor will appear on the path line.

figure 7-41

Format the type in the Character palette.

figure | 7-42 |

Select the Type on a Path tool.

- **8.** Type in the word KAREN'S in all capital letters.
- **9.** Let's adjust the alignment of the text. Select the Selection tool in the toolbox and select the text path. Click and drag on the middle bracket to the right or left until the text line is centered along the path. See Figure 7–43.
- **10.** Now, choose Type>Type on a Path>Type on a Path Options. In the options choose Preview to view changes directly on the document. Why not take a moment here to explore the Type on a Path Options? What does the 3D Ribbon Effect do? How about Align to Path, Descender? How about Spacing? Once explored, set the type to the following, then exit the options box:
 - Effect: Rainbow
 - Align to Path: Center
 - Spacing: 0 pt
- **11.** Now, with the Type on a Path tool, click on the lower segment of the ellipse you cut in half.
- **12.** Type in the words KITCHEN in all caps along the path.

Adjust the text alignment and type options of this lower segment of text similarly to what was done with the top segment of text. Refer to Figure 7–36 again for an example of the final result.

Note: You might need to use the Flip option in the Type on a Path Options box to fit the text upright on this lower path.

13. Save the document; call it **chap7L1_yourname.ai.**

figure | 7-43 |

Center the text line on the path.

Creating Type in an Area

- 1. Choose View>Actual Size to see the whole document.
- **2.** Choose Window>Layers to open the Layers palette.
- **3.** Lock the **type on path** layer. To do this, click on the blank box to the left of the layer's name and a lock icon will appear.
- **4.** Unlock the **logo** layer. To do this, click on the lock icon to the left of the layer's name.
- **5.** Now, select the **logo** layer. You are going to build a text block in the **logo** layer. The reason for doing this, rather than creating a new layer, is for preparation of a later step. Eventually you will wrap your text block around the logo image, and to do this you must have both objects on the same layer.
- **6.** Select the regular Type tool in the toolbox.
- **7.** Click and drag on the center of the document to create a text block.
- **8.** Choose Window>Transform to open the Transform options.
- **9.** For Width type in 515 px (or 7.153 in), and for Height type in 300 px (or 4.167 in). Be sure to hit Enter after each entry.
- **10.** Now, let's put some text in the text block (don't worry if it's off center, you fix that in a later step). Be sure there's a blinking cursor indicated at the top of the text block. If not, choose the Type tool again and click on the little white box in the upper left corner of the text block to initiate the blinking cursor.
- 11. Choose File>Place from the menu bar. Look for chap7_lessons/assets and select the recipe.rtf text file. Select Place, and leave the Microsoft Word options at their default. Hit OK. The text should fill the defined area (see Figure 7–44).

Note: RTF stands for Rich Text Format, a cross-compatible text format available in any popular word processing program. Illustrator will also import text in Microsoft Word formats (.doc) and plain text, ASCII, or .txt formats.

12. Select the text box, then choose Type>Area Type Options. Enter Columns, Number = 2, and hit OK. See Figure 7–45.

figure | 7-44 |

Imported text filling a defined area.

figure 7-45

Create 2 columns in the Area Type Options.

- **13.** Position the text block in the center, lower part of the white space within the black border. See Figure 7–46. The text will overlap the logo image. This is fixed in the next section.
- **14.** Save your file.

figure | 7-46 |

Position the text block.

Wrapping Text around an Object

- 1. The first thing to know about wrapping text around an object is that the object and the text to be wrapped must be on the same layer. We anticipated this requirement in a previous step, so both the logo and the text block are located in the logo layer of the document. An additional issue, however, is that the parts that make up the object must be stacked above the text that will wrap around it. We need to fix this. Open Window>Layers. Expand the logo layer. Select the layer with the text "To achieve a beautiful green color . .," and click and drag it to the bottom of the list of logo layers. See Figure 7–47.
- **2.** Select the logo image on the document (or, alternatively select the layer labeled **Compound Shape** in the **logo** layer list).
- **3.** Choose Object>Text Wrap>Make Text Wrap from the menu bar. For the Text Wrap Options choose Offset: 3 pts. Hit OK.

Note: With all good luck, the text should wrap around the image. If not, select the logo again, choose Object>Text Wrap>Release Text Wrap, then follow the previous two steps again. See Figure 7–48.

4. Save your file.

figure | 7-47 |

Move the Text layer below the layers that make up the logo graphic.

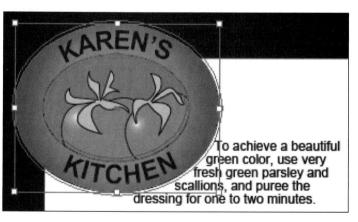

figure | 7-48 |

The text block wraps around the edge of the logo graphic.

Formatting the Text

- **1.** Select the 2-column text block. Then, with the Type tool, select all the recipe text in the text block.
- **2.** Choose Window>Type>Character. For Font Type and Style choose Arial, Regular. For Size, choose 12 pt.

Note: You might be wondering why we are using such an unexciting (yet, versatile and easily readable) font family such as Arial in this document. It's mainly for compatibility purposes when working through this lesson. I'm fairly certain that whether you are working on a Mac or PC, you'll have the ever-so-common Arial font installed on your computer. If by chance you don't have Arial on your computer or prefer to use a different font for this lesson, that's perfectly legit. Just be aware that different font styles will vary in size and shape and might affect the text layout of this particular lesson. And, you know what, that's ok, because for right now, it's all about exploring the tools anyway.

- **3.** Let's vary slightly the different paragraphs of text in the text block. Select the text block, and then with the Type tool, select the first sentence of the text.
- **4.** In the Type>Characters palette enter Arial, Italic, 16 pt. Be sure Auto is selected in the kerning and leading options. Tracking leave at 0.
- **5.** Let's change the color of this selected sentence. Choose Window>Swatches and click on any red colored swatch (I chose Crimson, dark red, if that's available to you), or create or select your own red from the Color palette or Color Picker.
- **6.** Finally, choose Window>Type>Paragraph (if not already open) and modify this first sentence, so that it's justified with last line aligned left. See Figure 7–49.
- **7.** Now, with the Type tool select the list of ingredients—from 1–10 oz. package of silken tofu to soymilk or water, as necessary.
- **8.** In the Characters palette enter Arial, Regular, 12 pt. Set the kerning to Auto, and leading to 16 pt. Tracking leave at 0.

figure | 7-49 |

Justify the text paragraph using the Paragraph palette.

figure 7-50

Choose the All Caps option.

- **9.** Select the last section of the recipe (located in the second column) and in the Characters palette choose Arial, Regular, 14 pt. Set kerning and leading to Auto. Tracking leave at 0.
- **10.** Now, select just the word Variation: and in the Character palette choose Arial, Bold. Then, open the Character options (arrow in the upper right corner of the palette) and choose All Caps (Figure 7–50).
- 11. Save your file.

Adding a Headline

- 1. Choose Select>Deselect to deselect any items on the document.
- **2.** Select the Type tool, and click the I-beam just above and to the left of the 2-column text block. Type in the recipe name: Green Goddess Dressing.

Note: Refer to figure 7–35 for a visual.

3. Select the recipe name and in the Characters palette enter Arial, Bold, 22 pt. Leave kerning and leading to Auto. Tracking set to 200.

- **4.** Now, select the recipe name with the Selection tool. Go to Window>Swatches and select any solid color to fill the text. No problem.
- **5.** Now, choose a gradient swatch, such as Rainbow or Midday Sky. Interestingly, it does not apply to the text. Let's remedy this . . .
- **6.** Choose Type>Create Outlines (or Effect>Path>Outline Object) to convert the text to compound paths and shapes.
- **7.** Select the gradient swatch called Green Leaf. Then, deselect the headline. The text should be filled with the gradient color.

Note: Once you convert type to outlines, it loses its instructions for character and paragraph adjustments. Therefore, it's advisable to set the formatting options for your type before converting to outlines.

8. Save your file again.

Adding the Final Look

- 1. Choose Window>Layers and unlock the border layer.
- **2.** Select the white rectangle on the document (the background for the 2-column text block).
- **3.** Choose Window>Brush Libraries>Food_Fruits and Vegetables.
- **4.** Select the Chili Pepper Color brush (roll over each brush to bring up a text-equivalent name for the brush).
- **5.** Choose Select>Deselect.
- **6.** Select the Paintbrush tool in the toolbox.
- **7.** From the Food brush library select the Mushroom Color scatter brush (at the top of the palette).
- **8.** For fun, paint a couple strokes of mushrooms in the lower, right area of the recipe card.
- **9.** Save your file—your recipe card is complete.

DESIGNING WITH TYPE

Like color, type evokes a look and feel. And, also like color, designing with type is an endless adventure into the creative depths of the subjective consciousness. Since I'm not one to be fooling around with an artist's inclination, let me just offer some common, general guidelines for honing your typography skills. When given a visual comparison of what works "well enough" and what works "really well" in typography design, it's easy to see the difference between an amateur and professional-looking document. Check out Figure 7–51 and Figure 7–52 to get an idea of what I mean. Making a few, simple font style and formatting changes makes all the difference in the world. Before reading on, take a moment to identify your own typography likes and dislikes between the two business card versions. What works for you? What doesn't?

When working with type take into account the text's readability and visual impact, specifically the formatting and flow of the type for readability, and the use of type contrast and appropriate font selections for visual impact. Below is a modified list of typography tips to achieve readability and visual impact. Compare and contrast these suggestions with the two visuals of the Stratton Buyer Brokerage business cards (Figure 7–51 and Figure 7–52).

Andrea Linkin-Butler, Principal Broker STRATTON BUYER BROKERAGE, LTD.

Exclusive Buyer Representative 802-824-4421 (800) 808-5917 www.strattonbroker.com

email: andrea@strattonbroker.com P.O. Box 2036, S. Londonderry, VT 05155 figure | 7-51 |

A business card design that works "well enough," but could use some typographic improvement.

figure | 7-52 |

A business card design that works better—is more visually appealing and readable— when simple typographic design principles are applied.

Spacing and Alignment

Line Length

Long lines of text are no fun to read, and short lines of text can break up the text flow, so it's good to find just the right balance. A general rule is that a line should have 55 to 60 characters, or approximately 9 to 10 words, for optimal readability. Of course, this suggestion applies to the creation of documents or layouts containing large blocks of text, and not so much for logo or stationery designs.

Leading or Line Spacing

Leading refers to the air, the distance of space, between lines of type, and is measured in points. Depending on the font type used, leading can vary for optimal readability (Figure 7–53).

Leading is the distance between lines of type. If the line distance is too close, it's difficult to read.

figure | 7-53 |

If it's too far.

it's also difficult to read.

Adjust leading in the Characters palette to find just the right spacing.

Examples of leading or line spacing.

Space — too much space Space — too little space Space — just right for this font.

figure | 7-54 |

Tracking is the process of adjusting the space between selected characters.

Word and Letter Spacing

- **Tracking** The spacing between individual words and letters is a subtle thing, but can really improve text legibility. Most typefaces available today are designed with correct spacing between characters, however on occasion you might find yourself wanting to adjust these defaults. For example working with ALL CAPS. Tracking is the process of adjusting the space between selected characters or entire blocks of text (Figure 7–54).
- **Kerning** An even subtler variation of character spacing, kerning refers to how space appears between certain types of letters. For most letters, kerning is relatively uniform, but in some cases, such as with A–V, kerning must be adjusted so spacing looks consistent and more readable (see Figure 7–55).

Note: Most often, setting the kerning in the Characters palette to Auto will work just fine; however, you might consider seeing what your text selection looks like using the Optical option. Optical kerning automatically adjusts the spacing between selected characters based on their shapes.

figure | 7-55 |

Kerning is the process of adjusting the space between certain letter forms.

AVE - this text is not kerned. Note that there is more space between the A and the V.

AVE - this text is auto kerned. Note the reduced space between the A and the V.

Justification

Justification is the alignment of lines of text or text blocks. Documentation with lots of text is usually formatted with a left justification—aligned to the left margin (flush left) and ragged on the other end. You can also choose to align text to the right margin (flush right) with the left side ragged, but it's really not as easy to read. For a more formal look all lines might be justified on both the right and left sides (no ragged edges), such as this book. Often newspaper or magazine articles also have this type of look. Centered justification works well with small amounts of copy.

Font Selection and Size

Proportional vs. Fixed Pitch

Fonts are distinguishable not just by their style, but in the way in which their individual letters and characters are spaced. Spacing of a font can either be fixed pitch or proportional. A fixed-pitch font is usually what is defined as a typewriter font, where each character takes up the same amount of space, and is representative of how old-style typewriters used to reproduce letter forms. Modern digital type and printable text is now generally designed using proportional spacing, where each letter is given just the amount of space it needs to look visually appealing and legible. Proportional fonts can be formatted better on a page and actually improve readability over fixed-pitch fonts. See Figure 7–56.

Courier is a fixed-pitch font, often called a typewriter font.

Arial is a proportional font,

so is Adobe Garamond Pro.

figure | 7-56 |

Examples of fixedpitch and proportionally spaced fonts.

Times is a serif font – it contains serifs (tails) on the ends of each letter.

Arial is a sans-serif font, a font without tails. Other common sansserif fonts are Verdana and Helvetica.

figure | 7-57 |

Serif vs. Sans Serif

It's important to know the difference between serif and sans-serif fonts, because both types play a vital role in the readability of either print or web-based documents. Serif fonts are letter forms with tails or cross lines at the ends of each letter stroke. Sans-serif fonts don't have these tails—evolutionally speaking they've been removed. Serif fonts usually have a more formal look, whereas sans-serif fonts often look more bold and modern. See Figure 7–57 for examples.

For printed documents containing lots of text, serif fonts, such as Times New Roman, are easier on the eyes to read. This is why newspapers traditionally use serif fonts for their copy. For screen-based text, like on a web site, sans-serif fonts are recommended, such as Arial, Helvetica, or Verdana. This is especially true when working with type sizes that are less than 12 points (the little tails of certain serif fonts get lost when the text is viewed on a lighted

Examples of serif and sans-serif font faces.

screen). Usually I like to use a combination of serif and sans-serif fonts in my designs, and stick with just two or three font families or font faces (any more gets distracting). For web page designs, for example, I might use a serif font family for my topic headings and a sans-serif font family for the body copy (main text areas). On the other hand, in the business card (Figure 7–52) example, which will be printed, notice that there is a sans-serif font (Berthold Imago) for the business title and a serif font (Georgia) used for the address and contact information.

Contrast

To really put some "oomph" in your type design, the principle of contrast is a must-know. A contrast is something that is different compared to something else and is commonly used in design to heighten visual impact. Here are six characteristics of type that can be manipulated to create contrast (notice how these characteristics are used or not used to produce contrast in our two business card examples):

- **Size** Big size versus small size type offers contrast, such as a 20-point headline above 10-point body text.
- Weight Most font families and font formatting options come in varying weights just for the purpose of providing contrast, such as medium, light italic, bold, or condensed versions. See Figure 7–58 for an example.

figure | 7-58 |

Provide contrast with variations of font weight.

COPPERPLATE REGULAR
COPPERPLATE BOLD
COPPERPLATE BOLD CONDENSED

- **Structure** Within a layout, a combination of serif and sans-serif fonts offers contrast.
- **Form** Form implies a font's shape. For example, a good contrast of form would be an uppercase type set against lowercase type.
- Color The color of type can make a huge impact on a design, especially how it might contrast with a colored background or other colored objects. Be sure there is sufficient enough contrast when working with colored copy, such as white text on a black background or dark blue text on a white background, but not yellow text on a white background, or dark blue text on a black background.
- Direction As you experienced in the recipe card lesson, you can change the direction of text to provide contrast—put text on a curved path for example, slant it, or send it vertically down a page.

SUMMARY

After reading this chapter, it becomes obvious that one of Illustrator's great strengths is its ability to work with type, offering you ample flexibility and versatility for creating, formatting, and managing type. With such control over these typography issues, you can better focus on the often-overlooked subtleties of type design, and watch your illustrative work transcend from amateur to professional.

in review

- 1. What tool do you use to type at a point? To type in an area? To type on a path?
- 2. What does the command Type>Create Outlines do? When would you use it?
- 3. Name three font formats and describe their characteristics.
- 4. What has happened when your document is missing a font?
- 5. What's legacy text?
- **6.** When wrapping text around an object, the object and text must be on the same layer. Does the text need to be below or above the object in the layer stack?
- 7. What's an RTF file?
- 8. Describe leading, kerning, and tracking.
- 9. Name at least four general design tips when working with type.
- 10. What should you do when you use someone else's font in your commercial artwork?

★ EXPLORING ON YOUR OWN

- Access the Help>Illustrator Help Menu option. Under Contents read up on Adding Type to Artwork and Formatting Type.
- 2. Illustrator CS comes with an array of premade templates that you can use for basic layout designs, such as cards and postcards, business sets, and stationery. In Illustrator, choose File>New From Template and explore the various templates provided. Some of them have premade designs, others are blank templates with common layout sizes that you can build from. I used the Business Card 2_Blank.ait (ait is the file format for Illustrator template files) found in the Blank Templates folder to create the Stratton Buyer Brokerage business card shown in this chapter. Using your newfound typography skills, create your own logo design (or other layout design) using one of these templates.

Note: You can also save your own layout designs for repeated use by choosing File>Save As Template. You will work more with layout design in the next chapter on composition.

- Adobe is a forerunner in digital type technologies, and provides a wealth of information on type, such as type design, terminology, and typeface licensing and copyright FAQs, on its web site—www.adobe.com/type.
- 4. There are plenty of places online where you can buy fonts and font symbols (image glyphs such as Dingbats) in just about any style you can image. However, there are also many places that offer fonts for free use, usually with only a minimum requirement of crediting the font creator. Do a search for "free fonts" on the web. One of my favorite freeware font sites is www.abstractfonts.com—when you get there do a search for the TrueType font "Groovalicious Tweak" from Font-a-licious Fonts (www.fontalicious.com).
- 5. Explore the topic of "typography" and "typography design" online.
- 6. Open up a magazine or a web browser and put on your typographer's hat. Critique the text that you see—not only its design and visual impact, but its legibility. What simple things would you do to improve text that is difficult to read or perhaps even "boring" to read—adjust the leading (line spacing), change the font, change the color, make its size bigger or smaller? Become your own type critic.

Overview: What are online courses?

Welcome to ATW Online

what are online courses :

Is taking an online course for me?

How do I participate?

Online courses use the Web as the central environment for learning. At ATW Online we use a customized course management system that facilitates your class experience. As an online student you are no longer required to travel to campus to participate in a course or restricted to scheduling conflicts.

ATW Online offers:

- Over 500 course offerings, both credit and non-credit
- Online instructor office hours for personal support
- Flexible course scheduling for working professionals
- 24-hour technical help
- Asynchronous and synchronous discussion options

object composition

charting your course

So, you've learned about the basic components of drawing in Illustrator, which include creating lines and shapes from scratch using the Pen tool, and then enhancing objects using value, texture, color, and type. The next step is to combine, group, and organize objects to produce more complex and complete illustrations or graphic layouts. This is the process of composition. In this chapter you explore features for combining paths and shapes, such as grouping, the Pathfinder palette, and clipping masks. Also included are process steps for creating a design layout, introducing you to the organization elements of composition in design, with more on layers and layout tools, such as rulers, guides, and grids, and extensive information on importing content. Then you venture further and build a layout for a web site home page.

In this chapter you will:

- Get a handle on grouping objects.
- Create compound paths and shapes using the Pathfinder.
- Reveal artwork through clipping masks.
- Understand design composition.
- Learn workflow and organizational techniques for developing your compositions and layouts.
- Know what works when importing content.
- Gain further practical experience working with layers.
- Practice working with rulers and guides.

COMBINING PATHS AND SHAPES

Before moving into an explanation of the larger concept of composition in design (next section), I'd like to share more specifically the combining (or compounding) of paths and shapes. So far, you've been drawing simple paths and shapes, but now you learn how to go more complex with your object construction. This is something that Illustrator does very well with grouping, the Pathfinder palette, and clipping masks.

Grouping

Grouping objects is easy enough and something you might be familiar with from other programs. Grouping is a common way to consolidate objects into a single unit, so you can move, scale, or rotate them without affecting their attributes or relative positions. To create a group, you select the intended objects and choose Object>Group (Figure 8–1). To release a group, you select the grouped object with the Selection tool and choose Object>Ungroup.

If you create a group from a series of objects each on a different layer, when you choose Object>Group all the objects are combined into a single layer called <Group>. When you open the grouped layer, each individual item is stacked in sublayers (see Figure 8–2). This is really great because within the layers palette it allows you to select either the whole group layer, or individual sublayers. You can also select and modify individual objects within a group by choosing the Group Selection tool in the toolbox. See Figure 8–3 and Figure 8–4. To modify the stacking order of a

figure 8-1

Create a group.

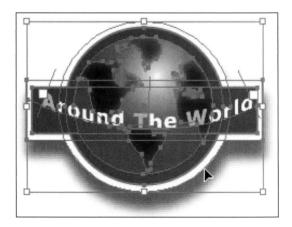

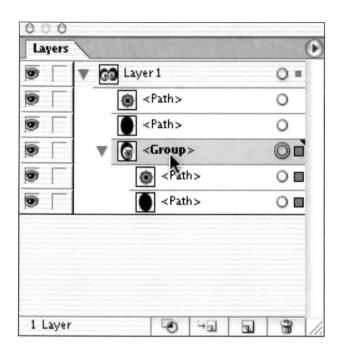

figure | 8-2 |

The individual parts of a grouped object are available in sublayers.

figure | 8-3 |

The Group Selection tool selects individual parts of a group.

figure | 8-4 |

Select and arrange objects in a group forward or back of each other.

group—send objects forward or back of each other—you select an individual object using the Group Selection tool, and choose Object>Arrange. (Of course, you can also arrange the stacking order of objects that are not grouped, but they must be on the same layer).

If you are really into keeping things organized, especially when you get lots of objects overlapping each other, you can also group grouped objects (called nesting). For example, let's say you draw a face. First, you group the two eyes together, so you can move them around easily. Then you choose the head, nose, and mouth, plus the previously grouped eyes and make them into a larger group that can also be selected as a whole. To practice this idea, do Lesson 1: Creating Groups.

Compound Paths, Shapes, and the Pathfinder Palette

The more you begin to draw in Illustrator, the more you realize that using the geometric shape tools and creating simple paths with the Pen tool are not going to cut it when constructing more complex objects. You need to be able to compound these simple paths and shapes into new and different objects. There are various ways to do this in Illustrator, which can get somewhat confusing. In fact, when I construct more complex shapes, I often don't get the result I want on the first try—it usually takes some experimentation with the available tools in Illustrator to get it just right.

As a point of reference, it's important to understand the difference between a simple path or shape in Illustrator versus compound paths and shapes. See Figure 8–5.

figure 8-5

Identify simple paths and shapes versus compound paths and shapes.

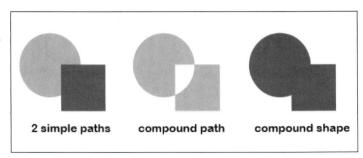

Simple paths and shapes are what you've been working with up until now in this book; they are a single path or shape, either open or closed

A compound path is created when you take two or more simple paths and intercept them in some way to create a new kind of path. To create a compound path you select two or more simple paths and choose Object>Compound Path>Make (to release the paths, you choose Object>Compound>Path>Release).

A compound shape is made up of two or more paths, compound paths, groups, blends, text, or other compound shapes that intercept one another to create new and editable shapes. To create a compound shape you select the desired paths, choose Window> Pathfinder, and in the Pathfinder options (see Figure 8–6) choose Make Compound Shape (to release, choose Release Compound Shape).

Admittedly, things can get a little cloudy in understanding the difference between compound paths and compound shapes. Here's what I can tell you—compound shapes are more editable. Although you can select parts of a compound path or compound shape with the Direct or Group Selection tools, only with compound shapes can you change appearance attributes or graphics styles on individual components, or manipulate them individually in the Layers palette. This difference becomes clearer when looking in the Layers palette. Objects merged into a compound path create a single layer. Objects of a compound shape are contained in a single layer, but each part is editable in sublayers. See Figure 8–7.

Commands to combine compound paths and shapes into various ways are available in the Pathfinder palette (Window>Pathfinder) or in Effects>Pathfinder.

The Pathfinder palette contains two sections of commands— Shape Modes and Pathfinders. Shape Modes allow you to add,

figure 8-6

Make a compound shape.

figure | 8-7 |

View a compound path and compound shape in the Layers palette.

figure | 8-8 |

The Pathfinder palette.

figure 8-9

Create a compound shape using the subtract option in the Pathfinder.

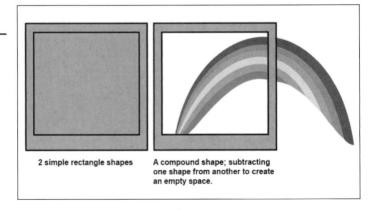

subtract, intersect, and exclude objects. Pathfinders allow you to divide, trim, merge, crop, outline, and minus back objects. See Figure 8–8 and Figure 8–9, and also the Pathfinder examples in the color insert (Figures 15 to 17). The Expand option in the Pathfinder palette converts a compound shape into a path or compound path. Generally, expanding is useful when you have created an object that is native to Illustrator and need to import it to a dif-

ferent program or if you are finding that the attributes assigned to the object (transparency, gradients, blends . . .) are having difficulty printing. For more details on each of the Pathfinder combinations, see Help>Illustrator Help, go to Index and look for information on Pathfinder/palette. You also get to use the Pathfinder exclusively in Lesson 2.

The Pathfinders in the Pathfinder's palette are filters, which, if you recall from chapter 6, do not allow editing in the Appearance palette. However, pathfinder effects in the Effects menu do. To use the Pathfinder effects, first convert your selected paths or shapes into a compound shape—choose Make Compound Shape from the Pathfinder palettes options menu, then choose Effect> Pathfinder and then whatever effect you would like to try.

Clipping Masks

Masking is a universal concept in graphic design. A mask is an object that hides or reveals other objects. A mask in Illustrator is referred to as a clipping mask, which can be a vector object or group, whose shape becomes like a window that reveals other objects or artwork through it. Figure 8–10 and Figure 8–11 provide an example, and you make masks in Lesson 3. Here are a few things to know about clipping masks:

 Only vector objects can be masking objects. However, they can mask any type of artwork, such as photographs.

figure | 8-10 |

Before Object>Clipping Mask>Make is applied.

figure | 8-11 |

After
Object>Clipping
Mask>Make is
applied. The flower
photo is visible only
through the text
mask.

- Objects to be masked must reside in the same layer as the mask object.
- When an object is converted to a clipping mask, it loses all its previous attributes and is assigned no fill or stroke.
- When using more than one vector object as a mask, the objects must first be converted into a single, compound path.

Lesson 1: Creating Groups

To familiarize you with grouping and how grouped objects are indicated in the Layers palette, here's a simple lesson. Your completed file will look like Figure 8–12.

Setting Up the File

- 1. Open chap8L1.ai in the chap8_lessons folder.
- **2.** Choose Shift_Tab to hide any open palettes.
- **3.** Select the Zoom tool and magnify the funny face graphic.

Grouping Face Parts

1. With the Selection tool, Shift_select both parts of the mouth. Be sure you don't accidentally select the head. See Figure 8–13.

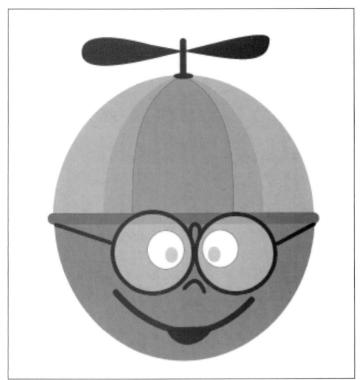

figure | 8-12 |

The completed lesson file on creating groups.

figure | 8-13 |

Select both parts of the mouth.

2. Choose Object>Group to group the two pieces.

Note: To test if the objects are grouped move the mouth section around and see if both pieces move as one.

- **3.** Deselect all by clicking on a blank area of the artboard.
- **4.** Shift_select all the parts of the two eyes (there are four parts—outer eyes, right and left, and eyeballs, right and left).
- **5.** Choose Object>Group to group the parts together.

Note: If you made a mistake in your grouping you can always choose Object>Ungroup to release the grouped state.

- **6.** Now, select all the parts of the face, including the mouth group, eye group, nose, and head.
- **7.** Choose Object>Group to consolidate all the objects and groups into one, larger group. (This becomes a "nested group," or "groups within a group"—an even more nitpicky way to organize your file!)

Note: The shortcut key command to group is Command-G (Mac) or Ctrl-G (Windows).

- **8.** Deselect all again by clicking on a blank area of the artboard.
- **9.** To maintain the "groupness" of the objects and yet select individual parts for modification or adjustment, choose the Group Selection tool (hidden under the Direct Selection tool). See Figure 8–14.
- **10.** With the Group Selection tool, practice selecting individual parts of the face.
- 11. Save the funny face; call it chap8L1_yourlstname.ai.

figure | 8-14 |

Choose the Group Selection tool.

Examining Groups in the Layers Palette

- 1. Choose Window>Layers.
- **2.** Open the Layer called **face**, and then expand the sublayer called **Group>**. Notice the groups within groups. See Figure 8–15.
- **3.** Double click on the topmost group title within the face layer (<Group>), and rename the whole group **face.**
- **4.** Within the **face** group rename the group containing the eye parts—**eyes**, and the mouth parts—**mouth.** See Figure 8–16.
- **5.** Close the subcategories of the **face** layer.

Creating a Beanie Cap

- 1. Choose View>Fit in Window.
- **2.** Unhide the layer called **beanie**.
- **3.** Zoom in close to the half-completed beanie cap drawing.

figure | 8-15 |

Groups within groups in the Layers palette.

figure | 8-16 |

Name the layers.

figure | 8-17 |

Select the colored sections of the beanie cap.

figure | 8-18 |

The Reflect tool in the toolbox.

- **4.** Select the three colored sections of the beanie cap (red, blue, yellow). Don't select the black propeller or the green rim. See Figure 8–17.
- **5.** Choose Object>Group.
- **6.** Let's make a duplicate for the other side of the hat, and flip it in one step. Select the Reflect tool hidden under the Rotate tool in the toolbox (yes, a new tool to play with!). See Figure 8–18.
- **7.** Double click on the Reflect tool icon in the toolbox to open its options.
- **8.** In the Reflect options box choose Vertical and click the Copy button (Figure 8–19). A flipped copy of the half beanie is created.
- **9.** With the Selection tool, position the new copy to the left of the first half. See Figure 8–20.

R	eflect	
Axis ————————————————————————————————————		ОК
Vertical		Cancel
Angle: 90	·	Серу
Options —		Preview

figure 8-19

Create a flipped copy of an object using the Reflect tool.

figure | 8-20 |

Use the Selection tool to position the new copy to the left of the first half.

Note: If necessary, you can move the new copy into place incrementally by clicking the right/left or up/down arrow keys on your keyboard. To adjust the increment distance, go to Illustrator>Preferences>General and enter an amount in the Keyboard Increment option.

- **10.** Select both halves, and choose Object>Group, or Command-G (Mac) or Ctrl-G (Windows).
- **11.** Now, select the grouped halves, the propeller, and the green rim, and choose Object>Group to create one larger group.

Finishing the Character

- **1.** Choose View>Fit in Window and position the beanie cap above the funny face.
- **2.** To complete the character, in the Layers palette unhide the layer called **glasses**.
- **3.** Let's quickly group all the parts of the glasses. Expand the **glasses** layer to see the parts.
- **4.** In the Layers palette, Shift_select each of the target icons of each of the layers (right-hand side) that make up the glasses. Notice that each of the objects is also selected in the document. See Figure 8–21.
- **5.** Choose Object>Group to consolidate the pieces.
- **6.** Save your file.

Lesson 2: Hands-on with Pathfinder

The best way to get a handle on what the options are for constructing compound paths and shapes is to try each of the shape mode and pathfinder variations in the Pathfinder palette; here's your chance in this lesson. For an example of this lesson, see the Pathfinder palette variations in the color insert (Figures 15 to 17).

Setting Up the File

1. Open chap8L2.ai in the chap8_lessons folder.

figure | 8-21 |

Select the target icons in the Layers palette to select the objects in the document.

- **2.** Choose Shift_Tab to hide any open palettes.
- **3.** Zoom in close to the first set of moth creatures under the Shape Modes heading. See Figure 8–22.

Exploring the Shape Modes

- 1. Select all the parts of the moth creature above the Add label.
- **2.** Choose Window>Pathfinder and in the Pathfinders palette, choose the Add option. See Figure 8–23.
- **3.** The moth parts merge together. The Add variation joins the outer edges of selected objects into one compound path

figure | 8-22 |

Zoom in close to the first set of moth creatures.

figure | 8-23 |

The Pathfinder palette options.

- object. The paint attributes (stroke and fill) from the front-most object (the bug's head) are applied to the new object.
- **4.** Scroll down the document, and select the moth parts above the Subtract label.
- **5.** Choose the Subtract option in the Pathfinder palette. The Subtract option subtracts the frontmost objects from the backmost object. Use this command if you want to delete areas of an illustration. Frontmost objects' paint attributes are applied to the new object.
- **6.** Continue down the document, and then select all the parts of the moth above the Intersect label.
- **7.** Choose the Intersect option in the Pathfinder palette. Intersect deletes any nonoverlapping areas from overlapping, selected objects. Frontmost objects' paint attributes are applied to the new object.
- **8.** Continue down the document, and then select all the parts of the moth, above the Exclude label.
- **9.** Choose the Exclude option in the Pathfinder palette. With Exclude, areas where an even number of selected objects overlap become transparent; areas where an odd number of objects overlap are filled. Frontmost objects' paint attributes are applied to the new object.

Exploring the Pathfinders

- **1.** Choose View>Fit In Window.
- **2.** Zoom in close to the top, right-hand side of the document to see the first moth creatures under the Pathfinders (pathfinder filters) heading.
- **3.** Select all the parts of the moth above the Divide label.
- **4.** Choose the Divide option in the Pathfinder palette (first option, second row). The divide option divides overlapping areas of selected paths into separate, nonoverlapping closed paths or lines. The new objects will maintain their original fill and stroke attributes. To get a better idea of how the division works, it helps to select and pull apart the divided sections with the Group Selection tool.

- **5.** Scroll down and select all the moth parts above the Trim label.
- **6.** Choose Trim in the Pathfinder palette. With Trim the frontmost object is preserved, whereas parts of the object(s) behind it and overlapping it are deleted. Objects retain their original fill attributes, but stroke colors are deleted. Once again, pull the trimmed areas apart to see the effect.
- **7.** Moving on . . . scroll down and select all the moth parts above the Merge label.
- **8.** Choose Merge in the Pathfinder palette. With Merge the frontmost object is preserved, whereas adjacent or overlapping objects of the same color or shade are combined (unlike Trim, where they are separate). Objects retain their original fill attributes, but stroke colors are deleted. Pull the merged areas apart to see the effect.
- **9.** Select all the areas of the moth above the Crop label.
- 10. Choose Crop in the Pathfinder. With Crop the frontmost object trims away areas of selected objects that extend beyond the borders. The frontmost object is removed. Remaining nonoverlapping objects retain their fill colors; strokes are removed.
- **11.** Select the two moths above the Outline label.
- **12.** Choose Outline in the Pathfinder. Nothing tricky here—objects turn into stroke lines. The fill colors of the original objects become stroke colors, and the fills are removed.

Note: If you cannot see the stroke lines, it's possible the stroke weight needs to be readjusted in the Stroke palette (Window>Stroke).

- **13.** Last one—select the moth and blue marker above the Minus Back label.
- **14.** Choose Minus Back in the Pathfinder. Minus Back subtracts the backmost selected objects from the frontmost object. Parts of objects that overlap the frontmost objects are deleted. Frontmost objects' paint attributes are applied to the new object. The selected objects must partially overlap for this command to create an effect.

15. Save your file in your lessons folder for future reference when working with the Pathfinder palette.

Lesson 3: Clipping Masks

Clipping masks are commonly used and easy to create, as you'll realize in this lesson.

Setting Up the File

- 1. Open chap8L3a.ai in the chap8_lessons folder.
- **2.** Choose View>Actual Size.
- **3**. Open the Layers palette.

Creating the Mask Effect

- 1. Expand Layer 1. Notice there are two sublayers—the THINK PINK Group and flower photo.
- 2. Further expand the THINK PINK Group layer. Each letterform is in its own layer and recognized as compound paths, rather than type. Note: To turn type into compound paths, like this example, you select the type and choose Type>Create Outlines. Creating compound paths out of type can be useful when you want to work with the type like an image, need it to be compatible with certain printers, or don't want to worry about whether the proper font is installed to render the type correctly. Be aware, however, that once you convert type to outlines, you can no longer use the type formatting options, such as font size, style, and spacing. It's not necessary to convert type to outlines when working with clipping masks; I just did it in this lesson in case you didn't have the correct font on your computer.
- **3.** Select the THINK PINK text on the document.
- **4.** Choose Object>Compound Path to convert the letter forms into one compound path. This is necessary when you are using more than one object in a mask (e.g., each of the letters).
- **5.** Select both the THINK PINK text (now invisible) and the flower photo. To do this, either marquee with the Selection

figure | 8-24 |

Both parts of the clipping mask are grouped under one layer.

tool around the flower photo, or Shift_select each layer's target icons in the Layers palette.

- **6.** Choose Object>Clipping Mask>Make. The flower photo is revealed through the letters.
- **7.** Notice in the Layers palette that both pieces are now in a clipping group layer. See Figure 8–24.
- **8.** Select the flower photo by clicking on its target icon in the Layers palette.
- **9.** With the Selection tool practice moving the flower photo on the document. Notice it stays behind the text mask.
- **10.** Save this file in your lessons folder, and then close it.

Creating Another Clipping Mask

- 1. Open the file chap8L3b.ai in the chap8_lessons folder.
- 2. Choose View>Actual Size.
- **3.** Select the Spiral tool (hidden under the Line Segment tool) in the toolbox (Figure 8–25).
- **4.** Be sure the default fill and stroke options are selected in the toolbox (white for fill, black for stroke).
- **5.** Click and drag over the boy's face in the photo, creating a spiral shape that covers his face.
- **6.** Create two more spirals anywhere else over the photo. See Figure 8–26.

figure | 8-25 |

The Spiral tool.

figure | 8-26 |

Create spirals.

figure | 8-27 |

Click and drag right on a path edge with the Group Selection tool to move the individual spiral.

- **7.** Shift_select all three spirals, and choose Object>Compound Path>Path to combine the three shapes into a compound group.
- **8.** Select the compound group (the spirals) and the photograph, and choose Object>Clipping Mask>Make.

Note: If you want to release the mask choose Object>Clipping Mask>Release.

9. Select the Group Selection tool (hidden under the Direct Selection tool) and practice adjusting individual parts (spirals) of the mask or the photo underneath.

Note: Selecting the spirals can be tricky, since there is no fill or stroke associated with them. You must click directly on a path edge to get it (See Figure 8–27).

10. Save the file in your lessons folder—keep it as reference for future mask making.

ABOUT COMPOSITION

Author Otto G. Ocvirk and contributors describe composition best in their book *Art Fundamentals*, *Theory and Practice*: "an arrangement and/or structure of all the elements, as organized by principles, that achieves a unified whole. Often used interchangeably with the term 'design.'" Reflect for a moment on things in your life that seem compositionally complete—the car parked in your driveway, the house you live in, the flower in the vase sitting on your table, the television commercial you remember, your

figure | 8-28 |

Composition is everywhere—in the design of a temple, a fuel-efficient car, a mosaic of ceramic tiles.

favorite song. Each of these things came to being through the combination of some predefined principles of design. See Figure 8–28.

For us, as graphic or multimedia designers, the principles derived are from those in visual art, and they are what we have studied explicitly through the use of Illustrator—line, shape, value, texture, and color. How these principles are organized is what brings about the sense of completeness of a drawing or layout. In traditional art study, these organization elements include concepts such as harmony, variety, proportion, dominance, movement, and economy. The study of these concepts and their effective interaction with each other is more than we can get into in a book about Illustrator, but not to be overlooked in your own study of visual art and graphic design. In this section, I introduce a general process in which to organize and produce a compositionally sound design layout, and also share with you some of the tools available in Illustrator for organization and workflow.

The Layout Process

The creative process comes to fruition in many ways. When I design a web page or print layout, my process is pretty well mapped out. There are no big secrets. It's mostly stuff that I learned from experience and quickly adopted to streamline production and reach a compositionally whole design. Generally, my process

figure | 8-29 |

Before and after of the Vella logo design for Gallo Winery. It starts with a sketch.

breakdown is: start with an idea, make an initial mock-up, gather content, assemble content, and fine-tune.

Starting with an Idea

As with the making of anything, a design always starts with a vision or idea. In your mind sometimes the idea is perfectly realized, and it's simply a matter of getting it into a tangible form. Other times, the idea is further fleshed out as you go through the design process. Either way, you have to start with an idea—something that drives you to make it "real."

Making a Mock-up

Once you've got the idea, the next step is to put it into some tangible form or mock-up. Often it starts out as a cursory sketch, then is reproduced into a more detailed drawing. Many artists will sketch the idea on paper first, scan it, then use the sketch as a template for constructing the digital version. See Figure 8–29. Others, who feel more comfortable drawing on the computer, construct the whole vision digitally, utilizing the flexibility of undo and redo.

When it comes to page layout design, setting up what I call "content zones" within a grid structure works quite successfully. Content zones are designated, blocked-out areas where information will be placed, such as images, copy, logo treatments, etc. Using the grid mapping idea, an initial mock-up for a web page might

figure | 8-30 |

Each content zone is assigned within a grid.

look something like Figure 8–30, with each content zone labeled for easy reference.

If you are creating multiple pages of a similar look, it's a good idea to keep the positioning of content zones consistent from page to page. For example, in the creation of a web page design—something you will practice in Lesson 4—it's important that the positioning of text to images to navigational (button) elements is not only visually appealing, but also consistently easy to use as you click from page to page. After all, a web page is not just a static design; it's an interactive experience.

After identifying content areas, I begin the often tedious, but most creative and interesting part of the process—applying design principles to get the "look and feel" that I want. Usually all of this is done in a very malleable fashion, knowing that the final version of the work will be completed once there is client approval of the design idea (if that's the case), and the final content pieces are gathered. Figure 8–31 and Figure 8–32 are two design layouts that I created for a client; the second one you will build in Lesson 4.

Gathering Content

Once you have your initial mock-up or sketch, you now have a better idea of what kind of content you need to fill each content zone area. Gathering content for your layout can be the most time-consuming and challenging part of the whole process. Possibly you are in the situation where you must create all the content—images and copy—yourself, or procure the content from other sources, such as your client or an outside resource, such as another artist or

figure 8-31

Web page design #1.

figure | 8-32 |

Web page design #2.

writer, image, or font repository. Here are where issues of copyright come into play—if you create all your own content or use copyright-free material there's no need to worry about the permission process. On the other hand, many resources out there that you might like to use, such as another company's logo or a photo of a famous person, could take a little investigative work to get the correct permissions for using the materials in your work.

Another aspect of content gathering is getting the content into the right format for your use. For example, if Illustrator is to be used as the medium for integrating all your content (see next section), you want to be sure that the content can be successfully imported into the program. Are the images and photos you want to use in the correct file format for Illustrator to read? Is the written copy translatable in the Illustrator environment? I'm not going to go into great detail about each of the importable file formats supported by Illustrator (you can review that info in the Illustrator

Help files), but here's a quick list: EPS, Adobe PDF, Photoshop, SVG, PICT, WMF/EMF, DXF/DWG, Freehand, CorelDraw, CGM, Raster formats (i.e., GIF 89a, JPEG, PNG, TIFF, BMP), and text formats, such as plain text/ASCII (.txt), MS RTF (.rtf), MS Word 97, 98, and 2000 (.doc).

Assembling Content

Once content is gathered, you assemble it in your layout program (i.e., Illustrator). There are two parts to integrating content into your final layout design—properly importing content from outside the program, and accurately positioning content into the intended composition using placement and organization tools.

Importing Once you have the content in an importable format (see previous section on gathering content), you bring it into Illustrator in one of several ways—using the Open, Place, or Paste commands, or, if available, dragging and dropping.

- Open (choose File>Open) opens artwork in a new Illustrator document. Vector artwork is converted to Illustrator paths, which you can conveniently modify with any Illustrator tool. Bitmap artwork can be modified with only some tools, such as transformation tools (scale, rotate, etc.) and image filters.
- Place (choose File>Place) places artwork into an existing Illustrator document. You can place the artwork in one of two ways: as a link or embedded. Linked artwork remains independent of the Illustrator document, which is good if you need to keep the document's file size down; however, if you move your Illustrator document to another spot on your desktop or a friend's desktop, the linked files must also come too, and possibly be relinked to the Illustrator document. This is very similar to how fonts are read by Illustrator—the fonts must be available in your font folder, in order for Illustrator to find them. The other option is to embed the artwork, which is when Illustrator makes a copy of the artwork into the Illustrator document, increasing the file size but keeping everything intact within the document. The option to link or embed a file happens when you choose File>Place—select the link option if you want to link the artwork, or unselect the option to embed it. See Figure 8-33. To identify and monitor linked and embedded files go to Window>Links. In the Link palette options box you can also change a linked file into an embedded file. See Figure 8–34.

figure | 8-33 |

To link or not to link, that is the question when you choose File>Place.

figure | 8-34 |

The Links palette lets you easily identify and modify your placed files.

You can't place a file within a locked layer. Be sure the layer is unlocked or create a new layer to place the file.

Paste (choose Edit>Paste) pastes copied artwork into the document. This method is particularly useful when transferring content from one Illustrator document to another. Before pasting artwork into Illustrator the copied artwork is saved on the Clipboard. You can think of a clipboard as a virtual holding place

for copied information. It sits in this temporary space until you are ready to paste it. When you close the Illustrator program, all content on the clipboard is cleared. To specify copy and paste preferences choose Illustrator>Preferences>File & Clipboard (Mac OS), or Edit>Preferences>Files & Clipboard (Windows).

 Dragging and dropping can also transfer artwork from one document to another, most commonly between Illustrator and Photoshop. If you are a Mac user, you can also drag a copy of Illustrator artwork to the desktop, which converts the artwork into PICT format.

One of the main issues I've had with trying to import some content into Illustrator, or other programs for that matter, is when I try to bring in, for example, a Macromedia Freehand file that is in a newer version than what the current Illustrator version can handle. If the file is in a vector format (which, if it's Freehand, it will be), it often helps to save the file in the EPS (Encapsulated Post-Script) format, rather than its native file format, then import it into Illustrator. EPS is a standard, cross-platform file format that recognizes both vector and bitmap information. Generally when importing native file formats—such as Photoshop (.psd), Freehand (.fh) or Flash (.fla)—from one program to another it's a hit or miss proposition. Sometimes the version of the program you are importing the file into will support it, sometimes not. Keeping files in more generic file formats-EPS for vector-based files, or TIFF for bitmap-based files—might prove a better solution, even if on occasion you lose some information in translation. Another importing issue is if you attempt to open a newer version of an Illustrator file into an older version (e.g., CS to version 10), you usually get a dialog box that says something like Figure 8–35. The conversion will probably work, but you might lose some information. One other thing, when you go to import artwork, and you can't access the file you want to import, this indicates that the file has been saved in a format Illustrator cannot read.

figure | 8-35 |

This is the screen you'll see if you attempt to import an Illustrator CS file into Illustrator 10.

Organizing Once you've imported your content into Illustrator, or created it directly in the program, you should organize it some way. I emphasis the word "should" here, because it's optional whether or not you want to organize your content, but I highly recommend it. I say this mostly to those of you who would rather close the door of a dirty bedroom than clean it up. You can't just leave all your content in one, unnamed layer and expect to find what you need quickly and without frustration later on.

As you've probably surmised from working through past lessons, the Layers palette is your organizational mecca. And, you're probably wondering why I've waited until Chapter 8 to impart this important bit of information. I figure the best way to learn how to use the Layers palette is to just practice using it, which by default you've had a chance to do in just about every document you've worked on in Illustrator, whether you wanted to or not. If you recall, you worked a lot with layers in the Adam's Eye lesson in Chapter 3. You'll also get to work more with layers in Lesson 4 of this chapter. For visual reference, Figures 8–36 through 8–40 show what the Layers palette can do for you.

For more details than you probably care to know about layers (at least for the moment), visit Help>Illustrator Help>Arranging and Combining Objects>Organizing objects into layers.

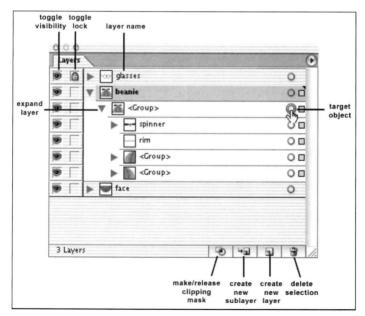

figure | 8-36 |

Basic layer options.

figure | 8-37 |

Click and drag a layer to a new location in the layer stack.

figure | 8-38 |

More layer options are available in the Layers palette drop-down menu.

figure | 8-39 |

From the Layers palette drop-down menu choose "Options for . . ." to open the specific options of a selected layer.

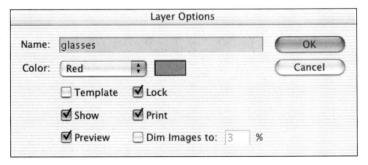

Other features that keep your work organized while integrating content in a document include the Align palette, Rulers, Grids, Guides, Smart Guides, and Snap to Grid or Point. The Align palette is located under Window>Align; all the other features you can find under the View Menu.

figure | 8-40 |

From the Layers palette drop-down menu choose Palette Options, to adjust how you view layers in the Layers palette.

‡ Alig	gn 🔪	Tribble			(P)
Align (Objects:				
	串		100	-D-	
Distrib	ute Ob	jects:			
프	-8-		Пр	04	

figure | 8-41 |

The Align Palette.

- The Align palette aligns selected objects horizontally right, left, or center or vertically top, bottom, or center. It also horizontally or vertically distributes selected objects evenly, using either the objects' edges or anchor points as the spatial reference. I use this tool a lot! See Figure 8–41 and Figure 8–42.
- Rulers, of course, are designed to accurately measure and place objects on the artboard. You must turn your rulers on by choosing View>Show Rulers (or off by choosing View>Hide Rulers). Both a horizontal and vertical ruler is made available along the edges of the document. You can change the rulers' measurement by Ctrl-clicking (Mac), or right-clicking (Windows) over a ruler and selecting a new measurement from the drop-down menu (see Figure 8–43). Alternatively, you can go to Illustrator>Preferences>

figure | 8-42 |

Before and after example of using the Align tool. The buttons and text on the right are horizontally centered, with a vertically centered distribution of space between each object.

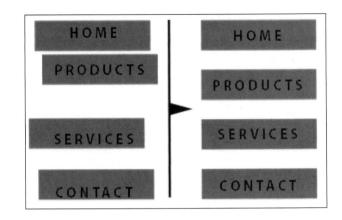

figure | 8-43 |

Set the rulers' measurement.

Units & Display Performance (Mac) or Edit>Preferences>Units & Display Performance (Windows). In the upper left corner of the document, where the vertical and horizontal rulers meet, you can also set what's called the Ruler Origin. Setting the ruler origin is useful when, for example, you are working on an object that's 2 by 3 inches on an 8-1/2-by-11-inch document. You can set the ruler origin at 0, 0 in the upper left corner of the 2-by-3 area, rather than the 8 1/2-by-11 area for more precise positioning. To set the ruler origin you move the cursor into the upper left corner of the document where the rulers intersect, then click and drag the crosshair to the new origin edge (Figure 8–44). To restore default settings, double click on the upper left corner where the rulers intersect.

The Grid in Illustrator is located under View>Show Grid. A grid
of lines or dots appears behind your artwork, and can be used to
symmetrically position objects. Grids do not print. You can
adjust Grid settings, such as color, style, and subdivisions,

figure 8-44

Click and drag the crosshair to the new origin edge.

figure | 8-45 |

Drag ruler guides from the horizontal and vertical rulers.

by choosing Illustrator>Preferences>Guides & Grid (Mac) or Edit>Preferences> Guides & Grid (Windows).

- Ruler Guides (see Figure 8–45) and Guide Objects are incredibly useful for aligning your work. You create ruler guides by choosing View>Rulers and dragging guidelines from the horizontal and vertical rulers on the sides of the document. Guide Objects, on the other hand, can be any vector object(s) that you decide to turn into a guide. To create a Guide Object, select the object and choose View>Guides>Make Guides. You can hide, lock, release, and clear guides by choosing View>Guides. Guides do not print. Adjust guide colors and style by choosing Illustrator>Preferences>Guides & Grid (Mac) or Edit>Preferences>Guides & Grid (Windows).
- Smart Guides (see Figure 8–46 and Figure 8–47) are something to get used to, but have their perks. The reason smart guides are

figure | 8-46 |

Use Smart Guides to snap to anchor points.

figure | 8-47 |

Use Smart Guides to align paths and shapes.

smart is they have a "snap-to" ability, which helps you create, align, edit, and transform objects relative to other objects. With Smart Guides turned on (View>Smart Guides) your cursor is like a magnet; it becomes an identifier for object edges, anchor points, and intersections.

 Snapping allows for even more precise positioning by snapping objects to the Grid (when visible) or anchor points. Choose View>Snap to Grid or Snap to Point.

Fine-tuning

The fine-tuning stage is where you fix the fine details of your layout—adjust colors, incrementally align items, play with subtle formatting of text, like line and character spacing—in short, make it look as perfect as possible. At this time, you also prepare your final work for its intended output, such as set the proper color mode and settings for either screen or print.

Lesson 4: Practicing the Process, Building a Web Page Design

Put the creative process into action. In this lesson, construct a web page from start to finish. (See Figure 8–48.)

figure 8-48

Completed web page design.

Setting Up the File

- 1. In Illustrator, choose File>New.
 - Name the file chap8L4_yourname.ai.
 - Size = Custom
 - Units = Points
 - Width = 760 pt, Height = 420 pt (standard dimensions for a web page layout).
 - Color mode; choose RGB Color, since this is eventually to be viewed on-screen.
- **2.** Choose File>Place and browse for the **page_template.jpg** in the **chap8_lessons/assets** folder. Be sure the link option is unchecked in the Place dialog box, then hit Place.

Note: By unchecking Link, you are choosing to embed the image into the document.

3. Choose View>Actual Size. This is a premade template based on a grid layout that I constructed for purposes of this lesson. I color-coded and labeled content zones for easy reference.

When you create your own layouts, you might consider doing something similar.

- **4.** Position the template precisely within the artboard area, if it's not already.
- **5.** Choose Window>Layers. In the Layer options drop down menu, choose Options for Layer 1.
- **6.** For Layer name, type in **page template.** Select the Template option, and dim the image to 40 percent. Hit OK. Notice in the Layers palette, in the visibility column, a Template layer is indicated by a series of geometric shapes, rather than an eye icon.
- **7.** Lock the Template layer.
- **8.** Save the file in your lessons folder.

Creating Guides

- **1.** Choose Create New Layer at the bottom of the Layers palette to create a new layer above the template layer.
- **2.** Double click on the new layer's title (Layer 2) to open the layer's options. Call the layer **guides.** Hit OK. See Figure 8–49.
- **3.** Choose View>Show Rulers.
- **4.** Ctrl-click (Mac) or Right-click (Windows) over the ruler at the top of the page and be sure Points is selected.
- **5.** Place your cursor over the top, horizontal ruler, and click and drag down to create a guide. Position the guide at the top edge of the document.
- **6.** Create another horizontal guide for the bottom edge.

Note: If you need to move guides, first be sure they are unlocked—go to View>Guides>Lock Guides to toggle the

Create and label a layer.

lock option off. Then, with the Selection tool, click and drag right over the guide you want to move.

7. Continue creating horizontal guides along the horizontal edges of each colored rectangle of the template. See Figure 8–50 for a visual.

Note: For precision placement of the guides, zoom in close to the document.

- **8.** Now, place your cursor over the left side ruler and click and drag to create a vertical guide. Place the guide on the leftmost edge of the template.
- **9.** Create another vertical guide for the rightmost edge.
- **10.** Place a third vertical guide between the side buttons and main copy areas. See Figure 8–51 for a final visual of the guide placement.

logo	header / top navigation	
	section title	
side buttons		
photo	main copy	

figure | 8-50 |

Use the template to accurately place horizontal guides.

logo	header / top navigation	
	section title	
side buttons		
	main copy	
photo		

figure 8-51

Final guide placement.

- **11.** Expand the guide layer in the Layers palette—notice that each of your guides is indicated in the Guides layer. Close and lock the Guides layer.
- **12.** Save your file.

Importing and Creating Content

- **1.** Choose Create New Layer at the bottom of the Layers palette, to create a new layer above the **guides** layer.
- **2.** Double click on the new layer's title (Layer 3) to open the layer's options. Call the layer **header and top navigation.**
- **3.** Choose File>Place and browse for the **header.jpg** in the **chap8_lessons/assets** folder. Be sure Link is unchecked, and then hit Place.
- **4.** Position the bitmap image into the upper area of the template labeled **header/top navigation**.
- **5.** Create a new layer and call it **section title.**
- **6.** Select the rectangle tool.
- **7.** For fill color, double-click on the Fill box in the toolbox. In the hexadecimal box of the Color Picker, type in the color **#D7E6DA** (a very light green), then hit Tab on the keyboard to update the color. Hit OK to exit the picker. See Figure 8–52.
- **8.** Type in **#999999** (gray) for the stroke color.
- **9.** Choose View>Smart Guides.

figure | 8-52 |

Enter a hexadecimal color in the Color Picker.

- **10.** Click and drag the Rectangle tool from the upper left corner of the purple section title area to the lower right corner.
- 11. Create another new layer and call it side buttons.
- **12.** Be sure the Rectangle tool is selected.
- **13.** For the fill color, enter in **#C3CFE6** (a very light blue) in the hexadecimal area of the Color Picker.
- **14.** Type in **#999999** for the stroke color.
- **15.** Zoom in close to the four side buttons to the left of the template.
- **16.** Create a rectangle shape for each of the blue side buttons. Look closely at the template, or the original web page design (Figure 8–48 or **chap8L4a_final.ai** in the lessons folder) to accurately place the buttons. Notice that the buttons do not bump up right next to each other, but have a horizontal space between each one.
- 17. Zoom back out.
- **18.** Create another layer and name it main copy.
- **19.** With the same color attributes as the side buttons, create another, large rectangle to cover the main copy area.
- **20.** Create another new layer, and name it **photo.**
- **21.** Choose File>Place and browse for the **typing.jpg** in the **chap8_lessons/assets** folder. Be sure you embed the file, not link it. Choose Place.
- **22.** Position the photo into the photo area of the template.
- **23.** Create another layer and name it **side_navigation_** background.
- **24.** Select the Rectangle tool. Type in **#E8E9EA** (a very light gray) for the fill color, no stroke.
- **25.** Create a rectangle that covers the remaining orange colored area to the left of the template—from the top of the side navigation buttons, over the photo, to the bottom of the page. See Figure 8–53.

figure | 8-53 |

Add a light gray rectangle to the left side of the template.

- **26.** So, you have a problem. The rectangle you just created is covering the buttons and the photo. Let's fix this by reordering the layer stacks . . . in the Layers palette, click and drag down on the **side_navigation_background** layer and place it below the **side_buttons** layer, but above the **section_title** (see Figure 8–54). Ahh, much better.
- **27.** Choose View>Guides>Hide Guides, and check out your work.
- **28.** Lock all your current layers.
- **29.** Save the file again.

figure | 8-54 |

Move a layer below another layer.

Adding the Text

- 1. Choose View>Guides>Show Guides to toggle the guides back on.
- **2.** Drag out a vertical guide from the left side ruler and place it so that it's between the R and the V of the word Overview in the header. This guide will be used to align your copy text.
- **3.** Create a new layer above the **photo** layer and name it **main_text.**
- Choose File>Place and open the overview.rtf in the chap8_ lessons/assets folder.
- **5.** If the Microsoft Word Options come up, deselect all the Include options and the Remove Text Formatting option.
- **6.** If you get a Conversion Warning, just hit OK.
- **7.** A text block is placed into the document. Move the text box so that it aligns along the guide you just created within the **main_copy** area. See Figure 8–48 for reference.
- **8.** Choose Window>Type>Character and change the text to Arial Regular, 12 pt. Set kerning to Auto, leading (line spacing) to 18 pt and tracking (character spacing) to 10 pt.
- **9.** Create another layer above the **main_text** layer and name it **title_text**.
- **10.** Select the Type tool in the toolbox and on the document click just above the **main_copy** in the light green area, and type the following: **Overview: What are online courses?**
- **11.** In the Character palette, choose Arial Bold Italic, 16 pt. For kerning and leading, choose Auto.

figure | 8-55 |

The web page with text added and aligned.

- **12.** Position the title along the same vertical guide as the main copy block.
- **13.** Choose View>Guides>Hide Guides, and check the alignment of your work. See Figure 8–55.
- **14.** Create a new layer above the **title_text** and name it **button_text.**
- **15.** Create a text line that says the following: **Welcome to ATW Online.**
- **16.** Set the characters of the text to Arial, Bold, 11 pt, and position it over the first blue side button on the left of the page.
- **17.** With the Selection tool, Option-Click (Mac), or Alt-click (Windows) and drag down to create a copy of the text line. Make two more copies, one below the other.
- **18.** Change the text on one of the copies to: What are online courses?
- 19. Change the text on another copy to: Is taking an online course for me?
- **20.** And the final text copy to: How do I participate?
- **21.** Position the **Welcome to ATW Online** text into the center of the first side button.
- **22.** Position the **How do I participate?** text into the center of the fourth (last) side button.

Welcome to ATW Online

What are online courses?

Is taking an online course for me?

How do I participate?

figure | 8-56 |

Before text alignment.

Welcome to ATW Online
What are online courses?
Is taking an online course for me?
How do I participate?

figure | 8-57 |

After using the Align palette.

- **23.** Roughly place the other two text lines in the second and third button areas.
- **24.** Shift-select the four text paths.
- **25.** Choose Window>Align to open the align tool. Choose the Horizontal Align Left option, and Vertical Distribute Center to align the text paths.
- **26.** Position the text paths so they fit properly over the side button area. See Figure 8–56 and Figure 8–57 for reference.
- **27.** Select the text **What are online courses?**, and in the Swatches palette choose the Moroccan Rust swatch (a dark red color).
- **28.** Save the file, but don't close it.

Adding the Logo

1. Okay, you're almost done (yes, layout design can be a tedious process!). Choose File>Open and open up the file

figure | 8-58 |

Select the Paste Remember Layers option before copying the logo.

chap8L4b_final.ai in the **chap8_lessons** folder. This is a completed logo file for ATW Online.

- **2.** Open the Layers palette and notice the compound shapes that were created. Also notice that the logo parts are grouped.
- **3.** Let's copy and paste this logo into the web page design. But first, go to the Layer palette option's drop-down menu and choose Paste Remember Layers, if not already checked (see Figure 8–58). This command ensures that when you paste the logo into the other document, the layers and their order will stay intact.
- **4.** Select the logo on the artboard.
- **5.** Choose Edit>Copy.
- **6.** Go to your web page design, **chap8L4_yourname.ai**. Create a new layer named **logo**.
- **7.** Choose Edit>Paste, and position the logo in the upper left corner of the document. See Figure 8–59.
- **8.** Whew! You're done with the layout design process.

figure | 8-59 |

Position the logo.

SUMMARY

After this massive chapter, hopefully your use of Illustrator has been bumped up to a whole new level. Constructing more complex shapes is no longer a mystery with the use of the Pathfinder palette, grouping, and clipping masks. And suddenly, the not-so-secret steps of producing compositionally complete layouts are within your grasp. Ideas that might have originally been lost can now be put into a tangible form with the importing, organizational, and workflow features of Illustrator.

in review

- What's an important difference between a compound path and a compound shape?
- 2. What does the Expand command do and why would you use it?
- 3. What's the difference between pathfinders in the Pathfinder palette versus the pathfinder effects (Effects>Pathfinder)?
- 4. Describe the steps for creating a clipping mask in Illustrator.
- 5. What tool do you use to select individual parts of a grouped object?
- 6. Describe the difference between linking and embedding artwork. Where would you go if you wanted to embed a linked file?
- 7. When you copy something, where does it go until you are ready to paste it?
- 8. Explain the EPS format and when it would be useful to use.
- 9. Name at least four features of the Layers palette.
- 10. How do you make ruler guides in Illustrator?
- 11. Where do you go to make a Template layer?
- 12. When would you use the Align palette?

★ EXPLORING ON YOUR OWN

- 1. Access the Help>Illustrator Help menu option. Under Contents read up on the topic "Arranging and Combining Objects."
- Practice your layout skills by deconstructing a premade layout design. Cut out
 a magazine advertisement or newspaper article, or print-off a web page and
 with pencil and ruler draw grid lines that partition out each section of the design. Label the sections as content zone areas, such as main copy, logo,
 header/title, photograph, artwork, etc.

3. Scan in a flattened drug box, bring it in as template in Illustrator, and reproduce its design or create your own. Keep in mind that since you are reproducing someone else's design, this project can only be used for educational purposes and should not be presented commercially in any way without prior permission from the designer. To protect copyright of the original designer, the example of student work in Figure 8–60 has been slightly altered.

figure | 8-60 |

An example design reproduced from a flattened drug box.

ADVENTURES IN DESIGN

MAKING A WINE LABEL

In the world of graphic design, Illustrator and Photoshop go hand in hand. When working with a project where many elements must come together into a compositionally complete design, often the illustrative or textual elements are created in Illustrator and the photographic elements or effects are created in Photoshop. These separate elements are then blended together—layered and

composited into a complete layout—in either Photoshop or Illustrator. As an example, I would like to share with you the development of a five-liter wine box label by Gallo Winery, Modesto, Calif. (art direction: Dave Garcez). (See Figure A–1 and the color version in the book's color insert.) Then you can apply your own skills to first envision a wine label design and then create parts of it within

Figure A-1 A five-liter wine box label was produced using Illustrator and Photoshop. (Used with permission of E & J Gallo Winery)

the Illustrator program. If you know Photoshop, use that program too to reach your envisioned label design.

Professional Project Example

A five-liter wine box label was created for Gallo Winery using a combination of both Photoshop and Illustrator. First, a photograph was taken of a wine glass, a basket, and some grapes

Figure A-2 Photographs were taken and layered together in Photoshop.

Figure A–3 The photographs composited together into a complete image.

(see Figure A–2), and then layered together using Photoshop (see Figure A–3). The logo was created in Illustrator. A hand-drawn sketch was scanned and placed as a template into Illustrator (see Figure A–4). Then

Figure A-4 A hand-drawn sketch of a logo.

outlines were created for each letter shape.

The Offset command under the objects menu (Object>Path>Offset Path) was used to create additional outlines around each letter to produce a beveled effect. Colored fill and stroke attributes were then added to the logo (see Figure A–5 and Figure A–6). The final logo design and photographic images were then composited together in Photoshop, and saved and imported back into Illustrator, where additional typographic

Adventures in Design

elements were added and the whole file was prepared for print (see Figure A–1 again).

Your Turn

As you can see from the description of the wine label project, starting with a sketched drawing or template to help you reconstruct an artistic vision (a logo) in the Illustrator program is a

Figure A-5 The stages of recreating the logo drawing using Illustrator.

common technique. In several of the lessons in this book you also used pre-made templates to aid you in your digital drawing. Now it's your turn to develop an illustrative element using this technique.

Wine Label Project Guidelines

- 1. With sketchbook in hand, take a stroll through the wine section of your local grocery store.
- 2. Take note of the wine labels that catch your eye—what is appealing about the label to you? Its color? Its graphics? Its use of fonts? Its dimensions, shape?
- 3. Begin to sketch your own wine label idea in your sketchbook. First determine the general size of the label. Make up your own name for your wine. Start blocking out content zone areas (where will the title, the main graphic element, the copyright, ingredients, and alcohol content instructions go?). How will the graphics you create for the label reflect the title for the wine you have chosen?

Figure A-6 $\,\,$ The final logo design with value and texture. (Used with permission of E & J Gallo Winery)

- 4. Create a final sketch of the wine label (you're still doing this on paper!). Be as precise as possible with your drawing—measure the label, use colored pencils to indicate the color scheme, draw to the best of your ability what you envision the label to look like.
- Scan a copy of your sketch into a digital format (a TIFF or JPEG image).
- 6. Import the image into Illustrator, and put it on a template layer.
- Begin to construct the label, using the tools you've learned in Illustrator.
- 8. Once you've read Chapter 10 on Print Publication you can then prepare the wine label for print.

Things to Consider

I'm going to assume that eventually you'll want to do some of these adventures in design and actually get paid for your work, or at least recognized with high praise. Here are some things to consider when making your wine label or any other professional-type project.

- A design is never finished. Leave time to do revisions of your work.
- Save often and back up your work. I suggest also saving different versions of your work, like "mylabel_v1," "mylabel_v2a," "mylabel_v2b," "mylabel_v3," and so on. You never know when you might want to refer back to an earlier version of your work.
- Get your document organized. In other words, use layers and name them intuitively.
- Show your wine label to a few trusted friends or colleagues. Ask them what they think... is the information clear, easily readable? Are the graphics visually appealing?
- Print your design from a desktop printer to get a good idea of the size of your label. Cut out your label and superimpose it over an actual wine bottle to see how it looks.
- If you "borrowed" from another's work, or used another's image as a template in the creation of your own wine label, keep copyright issues in mind.

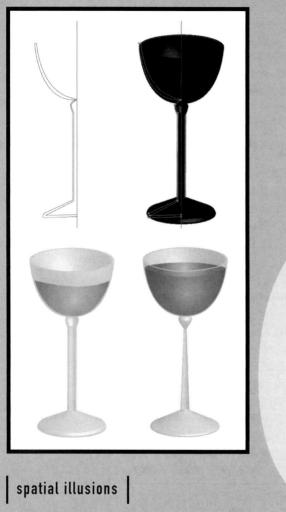

charting your course

Our world would be a pretty flat place indeed without a sense of space. And so would your two-dimensional artwork without the means of spatial illusion. In fact, the arrangement of objects into a whole—our definition of composition from the last chapter—is really only the surface part of what could be a more dimensional visual experience. With a little Illustrator magic you can create an illusion of dimensionality, organic form, and space in your drawing and design. Obviously, I can't show you all the methods for creating spatial illusions in your artwork, but this chapter covers some Illustrator tools and commands to help you get started. In this chapter, explore the use of the blend and mesh commands, the liquify reshaping tools, and 3D effects.

goals

In this chapter you will:

- Discover the use of blends for producing subtle transitions of color and dimensional impact.
- Distort and transform blended objects.
- Reshape and distort objects with the liquify tools.
- Use envelopes to mold objects.
- Precisely control the tonal detail of gradients with gradient meshes.
- Use 3D effects to construct objects in the x, y, and z dimensions, simulating a three-dimensional look.

MAKING SPACE

Establishing a sense of space in 2D artwork involves the skillful application of the fundamental elements of design—line, shape, value, texture, and color. The way in which these elements might be sized, rearranged, and positioned trick our eyes into seeing and mentally believing the illusionary effects of depth and dimension on flat surfaces. A simple example of this concept is one-point perspective drawing—the convergence of lines and shapes into a distant vanishing point.

Note: The one-point perspective example shown in Figure 9–1 is an easy and actually quite fun task to recreate and expand on further in Illustrator. Some suggestions: turn on View>Smart Guides to help you accurately snap your lines into place. To identify lines that are in the back of the box shape, use the dotted lines option in the Stroke palette.

Another example of spatial trickery is the use of light and dark shades of color (or value) to achieve dimensionality. In Figure 9–2, a graphic artist I know named Gregory took his photograph, then drew a realistic self-portrait by identifying the light and dark areas

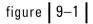

One-point
perspective—
placing lines and
shapes in such a
way that the feeling
of space is achieved.

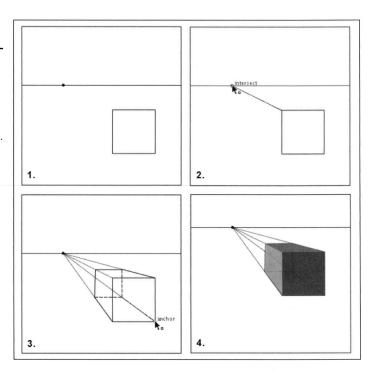

figure 9-2

The stages of Gregory's self-portrait.

in the photo and transposing them into filled light and dark colored shapes.

Since you're drawing digitally with a program such as Illustrator, mastering the art of spatial illusion can be a more manageable endeavor than doing it by hand. First, as you well know, you have the luxurious feature of undoing and redoing. Also, as covered in this chapter, you get to use some specific Illustrator tools and commands, such as blends, envelopes, liquify tools, gradient meshes, and 3D effects.

Blends

Blends are so cool. With the Blend tool or the Object>Blend> Make command you can create smooth transitions or

distributions of color or shapes between objects. It's a great way to make anything from simple borders to morphed, organic shapes. To use the Blend tool do the following (the sample file is provided in chap9 lessons/samples/shells blend.ai):

- **1.** Start with some shapes that you would like to blend together. If they have different fill colors, the colors will blend together too. See Figure 9–3.
- **2.** Go to Object>Blend>Blend Options. See Figure 9–4. You can choose Smooth Color to space the blended objects smoothly, like a continuous gradient; Specified Steps, which distributes a specified number of morphed objects between the start and end objects; or Specified Distance, which controls the distance of objects within a blend. When blends are first created the objects are blended along a straight path, which can be adjusted with Illustrator's editing tools. The Orientation option in the Blend options lets you control how the objects are oriented to the created path, either perpendicular to the *x*-axis of the page, or to the line itself. The best solution to getting to know these options is to try each one out and see what you

figure | 9-3 |

The different color starfish objects on the corner of each end of the artwork will be blended together to create a border.

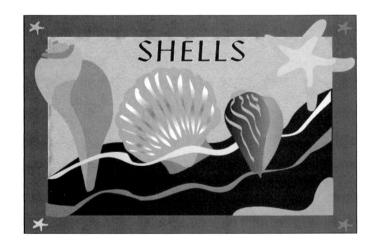

figure | 9-4 |

Set up the Blend options.

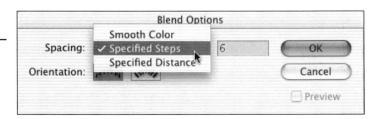

get. Click OK once you've set your Blend options. If you are using the sample file, choose Specified Steps = 6 and the Align to Page orientation options.

- **3.** Next, in the toolbox select the Blend tool. See Figure 9–5.
- **4.** Click with the Blend tool on one of the objects, then click again on the next object to create the blend. If you have more than one object you can continue clicking on each object to continue the blend.

Note: The order in which you select each object will affect the blending pattern. See Figure 9–6.

5. Select one of the objects in the blend to see how the blend is made. Notice that the blend objects interconnect by a path. With the Illustrator editing tools, you can adjust any of the original objects in the blend and the total blend will update. See Figure 9–7.

Note: To remove a blend between objects choose Object> Blend>Release. To create individual, editable objects out of each of the Blend objects choose Object>Blend>Expand.

figure | 9-5 |

Select the Blend tool.

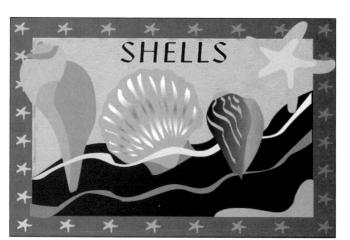

figure | 9-6 |

Click on each corner object to create the blend.

figure 9-7

Change the size of one of the original blending objects and it automatically adjust the size of the objects created from the blend.

figure | 9-8 |

This visual shows the before and after using the Smooth Color blend.

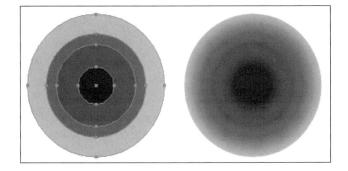

Alternatively to the Blend tool, the Make Blend command makes blends between multiple objects in one step. To practice using this command you can use the **circles_blend.ai** sample file, located in the **chap9_lessons/samples/** folder, or draw your own objects.

- 1. Select all the objects you want to blend.
- **2.** Set your blend preferences by choosing Object>Blend>Blend Options. To produce the blend shown in Figure 9–8, I chose Smooth Color, Align to Page.
- **3.** Select Object>Blend>Make to produce the blend.
- **4.** To modify or transform individual, blended parts, use the Group Selection tool (hidden under the Direct Selection tool in the toolbox). To modify individual anchor points of each

figure | 9-9 |

Each circle in the blend was pulled apart with the Group Selection tool. The blend readjusted automatically with the changes.

part, use the Direct Selection tool (see Figure 9–9). The blend readjusts automatically to your modifications.

For kicks, lets add some Distort & Transform effects to blended objects and see what we get. Use the **circles_blend.ai** to practice.

Note: Be aware that creating blends plus adding effects to them can get rather file-intensive. You might notice that the effect takes a while to render, or that it takes a couple extra seconds for items to redraw on the artboard. This is normal; your computer has to think a lot to execute more complex imagery. Save often when things get slow and, if necessary, use View>Preview to more quickly move around or select items in the document.

- 1. Select a blended object.
- **2.** Choose Effect>Distort & Transform and choose the Roughen effect. Choose the Preview option in the dialog box.

- **3.** Set the size, detail, and point specifications to your liking. In Figure 9–10, I chose 10 and 10 for both the size and detail. Click OK when you are satisfied with the settings.
- **4.** On your own, try other Distort & Transform effects on blended objects.

There's even more to blending . . . you can blend not only shapes, but also paths, as Figures 9–11 through 9–14 demonstrate.

Try the following steps with the sample file called **paths_blend.ai** located in **chap9_lessons/samples**, or make your own paths to blend.

1. Select all the paths you want to blend.

figure 9-10

Examples of the Roughen and Tweak effects on a blended object.

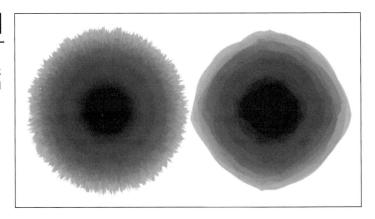

figure | 9-11 |

Start lines—an arc and a spiral.

figure | 9-12 |

Specify the blend options.

figure | 9-13 |

Create a blend between the two lines.

figure | 9-14 |

Modify the blend with the Direct Selection tool.

- **2.** Go to Object>Blend>Blend options to set your options. As seen in Figure 9–13, I chose Specified Distance, 4 pts, which created blend lines equally 4 points apart between the two master paths.
- **3.** Choose Object>Blend>Make to create the blend. If you want to release the blend for any reason, choose Object>Blend> Release.
- **4.** Modify individual anchor points of the blend by using the Direct Selection tool.

Liquify Tools

Located in the Illustrator toolbox are seven playful tools for reshaping and distorting objects (Figure 9–15). These are the Liquify tools, with fun names like warp, twirl, pucker, bloat, scallop, crystallize, and wrinkle.

To use a Liquify tool you simply select it from the toolbox then drag the tool over the object you want to reshape. If you double click on one of the Liquify tool icons in the toolbox, the options appear for that tool (Figure 9–16).

An example of what each of the Liquify tools do is provided in Figure 9–17. For you to experience hands-on, a practice version of this file is located in **chap9_lessons/samples/liquify.ai.**

- 1. Select an object you want to reshape or distort.
- **2.** Select a Liquify tool in the toolbox.
- **3.** Click or drag the tool over the selected object.

Note: Liquify tools cannot be used on linked files or objects containing text, graphs, or symbols.

figure | 9-15 |

The Liquify tools.

figure | 9-16 |

The options for the Pucker tool.

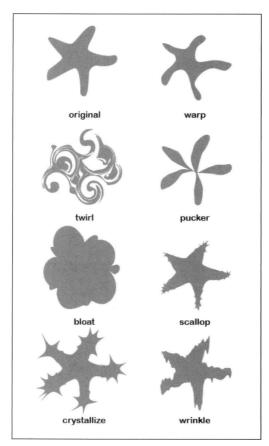

figure | 9-17 |

Examples of what each of the Liquify tools do.

- **4.** To modify the tool, double click on the tool's icon in the toolbox to bring up its options box.
- **5.** To interactively adjust the brush size of the Liquify tool, hold down the Option key (or Option_shift key) for Mac or Alt key (or Alt_shift key) for Windows as you click and drag with the tool.

Envelopes

Just like the Liquify tools, envelopes allow you to reshape and distort objects, but in a more global way. Think of envelopes as elasticized molds that wrap around objects, making them bendable and malleable. You can edit an envelope with Illustrator's editing tools, such as the Direct Selection tool, transform tools, and even the Liquify tools. Also, envelopes can be created from paths, compound paths, text, meshes, blends, and raster images, such as GIF, JPEG, and TIFF.

To make an envelope you choose Object>Envelope Distort and choose from one of three envelope types—warp shape, mesh grid, and with a different object. Let me show you the steps of how to create each kind, then you'll be ready to make your own.

Warp Shape

The Warp shape gives you a variety of choices for creating envelopes. See Figure 9–18.

- **1.** Select some text, or a raster or vector object.
- **2.** Choose Object>Envelope>Distort>Make with Warp.
- **3.** From the Warp options, select Preview.
- **4.** Choose a Style, Bend amount, and the level of horizontal and vertical distortion (see Figure 9–19).
- **5.** Click OK to apply the warp.
- **6.** Modify the scale of the warp using the Free Transform tool, or individual anchor points with the Direct Selection tool.

Note: Similar to blends, to remove an envelope choose Object>Envelope Distort>Release. To create individual, editable objects out of each of the blend objects, choose Object>Envelope Distort>Expand.

SPACE SPACE SPACE

figure | 9-18 |

Here are examples of the (clockwise from top left)
Squeeze, Arc, Bulge, and Flag Warp envelopes—there are many more.

	٧	Varp Option	5	
Style:	Squeeze	***************************************)	ОК
	Horizontal	O Vertical		Cancel
Bend:		50	%	✓ Preview
	I	Δ		
Distor	tion ———			
Horizo	ontal:	0	%	
	7			
Vertica	al:	0	%	
	Y		1	

figure | 9-19 |

The Warp options dialog box—so many warp styles to choose from!

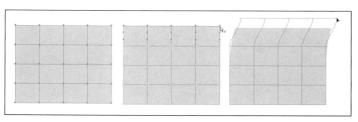

figure | 9-20 |

Here's an example of a 4-by-4 Mesh Grid on a simple rectangle, then modified with the Direct Selection tool.

Mesh Grid

The Mesh Grid, as you can see in Figure 9–20, looks like a grid on graph paper, but this one is stretchable.

- **1.** Select some text, a raster, or vector object.
- **2.** Choose Object>Envelope Distort>Make with Mesh.

3. In the Envelope Mesh dialog box, choose the number of rows and columns you would like in the mesh. Choose OK.

Note: Depending on the shape you are trying to create from the mesh, you might want to experiment with more or fewer rows and columns to get it just right. Keep in mind, more rows and columns produce more editable anchor points: however, computation time to redraw the mesh increases.

- **4.** Modify points on the mesh with the Direct Selection tool.
- **5.** Add more rows and columns to the mesh by clicking on the grid lines with the Mesh tool (see Figure 9–21).
- **6.** To delete a point, select a point with the Direct Selection tool or the Mesh tool and press Delete on the keyboard.

A Different Object

You can create an envelope of any shape, to surround and reshape an object or group by using the Envelope Distort Command. See Figure 9–22.

1. Select both the object you want to reshape and the object you want to use as an envelope. Very important—make sure that

figure | 9-21 |

The Mesh tool.

figure | 9-22 |

An object stacked above another object (e.g., the transparent circle above the text) can become an envelope for the object below it (e.g., the text).

the object to be used as the envelope is above the object you want to reshape.

- **2.** Choose Object>Envelope Distort>Make with Top Object. The two objects are grouped together into an envelope mold.
- **3.** Apply a fill or stroke to the selected envelope in the Appearance palette options (see Figure 9–23).
- **4.** Adjust the envelope by choosing Object>Envelope Distort>Edit Contents. Select the individual parts of the envelope with the Direction Selection or Group Selection tools, or in the Layers palette (see Figure 9–24).

Any envelope type can be selected and modified from the layers palette. Each envelope object is placed on its own layer (see Figure 9–25).

figure | 9-23 |

Change the fill color of the envelope object.

figure | 9-24 |

Adjust an individual section of the envelope.

figure | 9-25 |

Envelopes are indicated in the Layers palette.

Gradient Meshes

Gradient meshes allow you to subtly and precisely control the application, coloring, and tonal detail of gradient blends. See Figure 9–26. There are two ways to create mesh objects; choose the Gradient Mesh command (Object>Create Gradient Mesh) or use the Mesh tool. The Gradient Mesh command allows you to define a regular pattern of mesh lines and points. To create a customized mesh with a varied pattern of lines and points, use the Mesh tool. Here are some important things to know about mesh objects:

- Once a mesh object is created it cannot be converted to a path object. You can, however Edit>Undo a mesh if you notice you made a mistake.
- Meshes can be created on any simple path object or bitmap image, but not on text, compound paths, or linked EPS files.
- Complex mesh objects can affect your computer's performance and the speed in which the graphics refresh on the screen. Keep your mesh objects simple. Create a few small mesh objects rather than a single complex one.

Of course, as in any of the tools you've been using, the best way to understand how they perform is to try them out. Using the sample file called **balloons_mesh.ai** located in the **chap9_lessons/samples** folder or with your own artwork, practice your mesh making skills with the following steps:

- 1. Select a filled object.
- 2. Choose Object>Create Gradient Mesh.

figure | 9-26 |

Use gradient meshes to create tonal detail and smooth transitions of color. See a color version of the balloons in the book's color insert (Figure 22).

- **3.** In the Create Gradient Mesh dialog box, set your gradient options. Choose Preview to see how each option effects the object. Keep your rows and columns to a minimum. I suggest four rows and four columns to start out (see Figure 9–27). Select OK.
- **4.** Select the Mesh tool in the toolbox (see Figure 9–28) and click on a mesh patch, where an anchor point intersects a row and a column (see Figure 9–29).

figure | 9-27 |

The Gradient Mesh options box.

figure | 9-28 |

The Mesh tool.

figure | 9-29 |

Select an anchor point of a mesh patch.

- **5.** Open the Swatches palette.
- **6.** Choose a colored swatch to apply to the selected patch area.
- **7.** With the Mesh tool, select another anchor point and apply a color. Notice how the colors subtly blend together (see Figure 9–30).
- **8.** Modify the anchor points and how the colors blend by clicking and dragging on a mesh point or its tangent handles with the Mesh tool (see Figure 9–31).

figure | 9-30 |

Apply a colored swatch to a mesh patch.

figure | 9-31 |

Modify an anchor point of a mesh patch.

figure | 9-32 |

Add another column and row to the mesh using the Mesh tool.

- **9.** Add another mesh row or column by clicking between two anchor points on the mesh (see Figure 9–32).
- **10.** Delete an anchor point, if necessary, by selecting it and choosing Delete on the keyboard.

Note: Alternatively to choosing Object>Create Gradient Mesh, you can create a gradient mesh by selecting a filled object and then clicking directly on it with the Mesh tool—adding rows and columns as you like.

3D Effects

You easily get lost—in a good way—using the 3D Effects feature. Suddenly you are immersed into the third dimension, where paths and shapes can be extruded, rotated, and revolved around the *x*, *y*, and *z* axes. See Figure 9–33, Figure 9–34, and Figure 9–35, for examples. You can also adjust the lighting and shading of the 3D objects, and map artwork on its dimensional surfaces.

3D Effects are located in the menu bar at Effect>3D, where you choose either Extrude & Bevel, Revolve, or Rotate. An options box appears where you interactively choose which directions (*x*, *y*, or *z*) you would like your object to move and distort. To do this, place, click, then drag the cursor on a corner edge of the box model to effect a certain axis—the edges are color-coded for easy reference (see Figure 9–36). To adjust the box in all three axes combined, click and drag on a side of the box (see Figure 9–37). I suggest turning on the Preview mode so you can see how the changes affect your selected object—each alteration takes longer to render, but gives you a better idea of the final look.

figure | 9-33 |

Extrude and bevel text in three dimensions.

figure | 9-34 |

Rotate and add perspective to text.

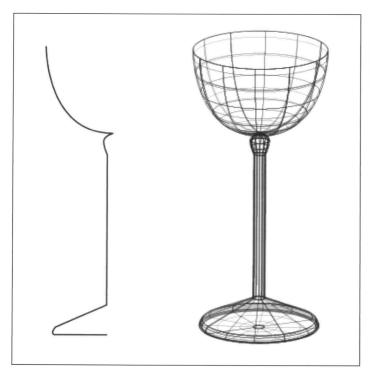

figure | 9-35 |

Revolve a profile of a wine glass around the *y* axis.

figure | 9-36 |

Adjust the y axis of the object.

figure | 9-37 |

Adjust simultaneously the *x*, *y*, and *z* axes of the object.

Expect to spend late nights captivated by the many options in the 3D Effects options box. To get you started, the following steps describe how to use the 3D Revolve effect. Use the glass_3d.ai in the chap9_lessons/samples folder or draw your own paths.

figure | 9-38 |

A profile of a wine glass to be revolved around the *y* axis.

- 1. Draw a profile of an object that, when revolved around an axis, produces a symmetrical shape, such as the profile of a wine glass (see Figure 9–38), a chess piece, a pine tree, or an ornament. Use guides to help you align the top and bottom edges of the profile.
- **2.** Select the profile. Choose Effect>3D>Revolve.

figure | 9-39 |

The 3D Revolve options.

- **3.** Enter your specifications in the 3D Revolve options box. Turn on Preview as you make adjustments to see how it looks on your selected path. See Figure 9–39 for the 3D Revolve options. For the wine glass profile, I chose:
 - Position: Off-Axis Front
 - Revolve angle: 360 degrees
 - Offset: 0 pt from Right Edge
 - Surface Plastic Shading

Click OK. And then expect to wait a couple moments while the effect renders. Check out Figure 9–40.

4. The color of the completed object is specified by the stroke color of the original profile path. To alter the color, make sure the object's original path is selected and change the stroke color. The stroke color in my example is set to a bright blue with an opacity setting at 40% (Window>Transparency). See Figure 9–41.

figure | 9-40 |

The completed Revolve.

figure | 9-41 |

Set the color and transparency on the original profile path—the final revolved object is updated.

- **5.** Fine-tune, if necessary, the original path by selecting and moving individual anchor points with the Direct Selection tool. The Revolve updates with each new adjustment. See the adjusted version of the final wine glass in Figure 9–42.
- **6.** Like all Illustrator Effects, go to the Appearance palette of the selected path to adjust or remove the effect. Double click on the effect in the Appearance palette to open its options box and make adjustments. Or, to completely remove an effect,

figure | 9-42 |

A final version of the wine glass after adjusting individual anchor points of the original path with the Direct Selection tool.

figure | 9-43 |

Remove the 3D Revolve effect from the Appearance palette.

select the effect in the Appearance palette, then in the palette options choose Clear Appearance (see Figure 9–43).

7. Save your file often when using computationally intensive commands such as the 3D Effect.

Graphic Style 3D Effects and the Free Distort Effect

Before sending you out on your own with these newfound tools and commands, I must show you two more things—the 3D Effects graphic styles library and the Free Distort effect.

For quick and easy application of a 3D Effect go to Window> Graphic Styles and in the Graphic Styles palette options choose Open Graphic Style Library>3D Effects (see Figure 9–44). Draw a simple path or geometric shape on the artboard, select it, and then take your pick of any of the predefined dimensional shapes in the 3D Effects Library.

To further modify your 3D effect or any selected path or shape, use the Free Distort Effect; choose Effect>Distort & Transform> Free Distort. Free Distort allows you to bend selected artwork, within a flexible bounding square. Click and drag on any of the four corners of the square and your artwork acts like a gumby doll—see Figure 9–45. In Figure 9–46, you see the results of combining a 3D Effect graphic style with the Free Distort effect. In essence, applying an effect over an effect.

figure 9-44

Open the 3D Effects Graphic Style Library.

figure | 9-45 |

Bend the shape with the Free Distort effect.

figure | 9-46 |

Four examples of using a 3D Effect graphic style with the Free Distort effect—spatial illusion made easy!

SUMMARY

So perhaps after this chapter you've been transported to another drawing dimension. One that's not so flat, but filled with spatial possibilities, including Illustrator's blend, mesh, and liquify tools, and the 3D distort and transform effects.

in review

- 1. What are Smart Guides? Why are they so smart?
- 2. What are the two methods for creating blends?
- 3. To modify individual anchor points of blended, meshed, or warped objects, what tool is used?
- 4. How do you change the brush size of a Liquify tool?
- 5. When making an envelope with a different object, where must the object to be used as the envelope be located?
- 6. How do complex mesh objects affect computer performance?
- 7. What three options are available when using the 3D Effects feature?
- 8. How do you change the color of a revolved 3D object?
- 9. Name four options available in the 3D Effects options box and what they do.
- 10. To adjust or modify an effect, where do you go?

★ EXPLORING ON YOUR OWN

- Access the Help>Illustrator Help menu option. Under Contents read up on Reshaping Objects.
- Practice your blending and gradient making skills with the shells_blend.ai file
 in the chap9_lessons/samples folder. As reference, see the final version called
 shells final.ai.
- 3. Follow Gregory's example mentioned in the first part of this chapter (Figure 9–2). Take a black and white photo of yourself and import it into Illustrator. Use the photo as a template to draw a realistic self-portrait. Identify the light and dark areas of the photo and draw each area with light- and dark-colored filled shapes.
- 4. Create your own perspective boxes (or other dimensional shapes) as shown in Figure 9–1 at the beginning of this chapter. Use Smart Guides to accurately place the paths and shapes.
- 5. Create an abstract design, pattern, or collage using the tools discovered in the chapter. See if you can create a sense of dimensionality in the artwork.

print publishing

charting your course

Chapters 10 and 11 are about what you do when you're ready to present your Illustrator artwork to the world. Where will it go? Will it be printed in a magazine spread, on a CD cover, on the side of a soup can? Will you be able to view it on a web page, a television commercial, a multimedia kiosk? In this chapter you learn what it takes to prepare your artwork for print. It's not quite as easy as hitting File>Print and expecting the document to arrive on paper exactly as you see it on screen. There are a host of considerations you should be aware of, such as the types of printing available and the management of color from screen to print. As well, specific issues unique to the printing process should be on your output radar—halftoning, color separations, transparency, flattening, and resolution to name a few. There's a lot of information—more than I can cover here without completely overwhelming you. However, at the least this chapter provides a starting place for asking the right questions about the printing process.

____ In this chapter you will:

- Learn about the different methods of printing.
- Understand halftoning and the color separation process.
- Know what to do about printing transparencies, gradient meshes, complex paths, and fonts.
- Get familiar with the Print dialog box.
- Be able to ask the right questions when consulting a print service bureau.

A FRIENDLY CONVERSION

Have you ever found yourself in that somewhat awkward situation where you meet someone who doesn't speak the same language as you, but you desperately want that person to understand what you are saying?

"Donde el baño?"

"Huh?"

"Donde el baño?!"

It's this type of situation that often occurs when a computer attempts to talk to a printer; they both speak completely different languages, and unless there is some sort of interpreter the intended outcome might not be what you get. Using our example, instead of being successfully sent to the bathroom (el baño), you might find yourself elsewhere. Luckily, Illustrator comes equipped with its own translator in the form of a quite sophisticated Print dialog box (which I'll describe later, with Figure 10–5). However, to even begin to understand how to use it, you must have some idea of the printing process and the terminology used to prepare artwork for print.

Ways of Printing

There are several ways to get your artwork onto paper—directly from a desktop printer or digital printing press, from a film negative that's used to create a metal plate for a mechanical press, or in the Portable Document Format (PDF) or a PostScript file. Let's delve a little further into each of these options.

Desktop Printer

Without a doubt, you'll want to print off your work on a desktop printer. If not the final version, at least some paper proofs for mock-up and revision purposes. Every desktop printer is different, made by different companies, with different specifications and different levels of printing capabilities. A low-end inkjet printer, for example, deposits ink onto a page much differently than a highend laser printer. It really helps to read up on the specifications for your particular desktop printer, so you can accurately gauge

whether a printer issue is something you can fix on the Illustrator side of things, or is an unavoidable product of your type of printer.

You'll also want to know what resolution your printer will support, and what will give you the best quality—it can vary greatly depending on the type of printer and the paper used. Much of it is trial and error (print it off and see what it looks like). In general, laser printers have a resolution of about 600 dots per inch (dpi). DPI is usually the resolution measurement for printers as opposed to computers, which is pixels per inch (ppi). Inkjet printers have a resolution of between 300 and 720 dpi.

Note: If you need a refresher on what resolution is all about, or just want to know more about resolution related to Illustrator, go to Help>Illustrator Help and under Index do a search for *resolution*.

Digital Printing Press

A digital printing press is a beefed-up version of your typical desk-top computer. As digital printing technologies improve, digital printing services are becoming a more prevalent alternative to traditional offset printing. Because digital printers rasterize Post-Script data—printing directly from your computer file, rather than going through the intermediary film or metal plate stage (see next section)—they can yield quality output with a quick turn-around. Digital printing is ideal for targeted printing jobs and short-run projects that need to be done quickly but at a much higher quality than your desktop printer. The resolution needed to properly print off a digital printing press should match the resolution of the particular output device. Consult the printing service for what resolution your document should be set at.

Mechanical Press

The traditional method for getting your virtual work to hard copy is using a mechanical press termed *offset printing*. A digital file is transferred to a film negative, which is then used to burn a metal printing plate. The metal plate carries the image that the press transfers to paper. If you are printing a photograph or illustration with more than one or two colors in it, things get a little more complicated and expensive. To simulate a full range of colors

figure | 10-1 |

Magnifying a section of the flower, you see its color is produced by halftone dots made up of CMYK ink colors.

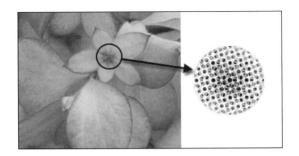

(four-color processing), mechanical printers deposit the four ink colors (CMYK) dot by dot, called *halftones*. See Figure 10–1.

To create continuous tone color using the halftone method, each color must be inked and pressed separately to the paper—in short, the colors are separated out and then layered back together. To do this, each color must have its own metal plate (one plate inked with cyan, one with magenta, one with yellow, and one with black), which are produced from four separate files or film negatives. This is the process of color separation.

The individual colors produced by the mixing of CMYK colors are called *process colors*. You can also identify *spot colors* or custom inks. As you learned in Chapter 5: Using Color, spot colors are special colors made up of premixed inks that require their own printing plate other than the one used for four-color processing.

For printers using the halftone procedure, Illustrator provides options in the Print dialog box for preparing your image for the color separation and subsequent printing process.

PDF or Postscript file

With Illustrator you can also print your file in the Portable Document Format (PDF)—a PostScript-based format that can support both vector and bitmapped data. Printing to PDF is a convenient way to maintain all the attributes of your original Illustrator file into a cross-compatible format. Often print service bureaus will request a PDF version of your file. To set the PDF options, choose a Save command, specify a file name, and choose Illustrator PDF as the file format (Save as type:). Click Save and the Adobe PDF Options dialog box appears, where you can indicate general settings and specific presets, such as one specific for [Press]. See Figure 10–2.

figure | 10-2 |

The Adobe PDF Options dialog box.

GETTING INTO DETAILS

If professionally printing your artwork, either via a digital or mechanical press, is a definite must, alleviate undue headaches and find yourself a reliable print specialist. A good specialist can identify your printing needs and offer appropriate solutions for getting the best quality print job for your specific situation. That being said, don't underestimate the necessity of you also knowing something about the printing process and terminology to facilitate print preparation on your end. Properly setting up your Illustrator file before handing it off to the printer can save you lots of time and possibly money.

Also, have a clear idea of what kind of paper the print job should be done on. For instance, do you envision your creation on porous newsprint or slick, heavy card stock? Different types of paper produce varying color effects and require different specifications. During the final output stages of your document, consult your printing service bureau to find out how best to prepare your file for them, such as in what format and resolution (see information on resolution and screen ruling in next section). Also, be aware that the complexity of your artwork determines a lot about what you need to know to prepare it for print. Transparencies, overprints, gradients, fonts, and complex paths, for example, might require extra attention to print properly.

Resolution and Screen Ruling

Resolution and something called screen ruling are particularly important for outputting the highest quality artwork as possible. For output to printers using halftone dots to render images, consideration must be given to the number of dots to be printed within a given area or screen, or in other words, the "resolution." This consideration is like working with the resolution of bitmap images, which, similarly, are made up of a given number of pixels on a bitmapped grid. Halftone dots are deposited on paper based on a screen ruling—the number of lines or rows within a given screen. Screen rulings for halftones and separations are measured in lines per inch (lpi). The frequency and size of dots are determined by the screen ruling. High lpi creates smaller and tighter dots, like those seen in a glossy magazine or slick brochure. Low lpi creates larger, rougher looking dots, but are easier to print, such as in a newspaper. A general rule is that the resolution, pixels per inch (ppi) or dots per inch (dpi) when referring to halftone printing, of a given piece of artwork is about 1.5 times and no more than 2.0 times the screen frequency. Come again? Okay, imagine, after consulting your print specialist you discover that the screen ruling for the glossy flyer you want to print is 150 lpi and needs to be in the TIFF format (an uncompressed bitmap format). This information gives you some idea of what resolution your TIFF file should be—somewhere between 225 dpi or ppi and 300 dpi or ppi (hence, $150 \text{ lpi} \times 1.5 = 225$). See Figure 10–3. Keep in mind that the resolution of an image and its screen frequency directly relates to what kind of paper it will be printed on and at what quality.

• Newspaper, or similar high porous, coarse papers use screens of 85 to 100 lpi; therefore artwork resolution should be between 128 and 150 dpi or ppi.

TIFF Options	
Color Model: CMYK	ОК
Resolution — Screen	Cancel
○ Medium	
High	
Other 300 dpi	
✓ Anti-Alias	
LZW Compression	
Byte Order ———————————————————————————————————	
Macintosh	
Embed ICC Profile:	

figure | 10-3 |

You can set the resolution of your artwork in the TIFF options box, when you go to export your document.

- News magazines or company publications with medium coarseness use screens of 133 to 150 lpi; therefore artwork resolution should be between 200 and 225 dpi or ppi.
- Fine quality brochures and magazines with slick paper surfaces use screens of 150 to 300 lpi; therefore artwork resolution should be between 225 and 450 dpi or ppi.

Transparency

When printing or exporting an Illustrator file that doesn't recognize Illustrator's transparency effects, Illustrator performs a process called *flattening*. Flattening identifies colored areas that overlap each other and converts the artwork into components that are more easily recognized by other programs and devices. You

can specify flattening settings in the Flatten Transparency dialog box (Object>Flatten Transparency) or in the File>Document Setup. You can also preview how the changes might look when printed in the Flattener Preview (Window>Flattener Preview) and make adjustments in the Advanced section of the Print Options dialog box.

Overprinting

Overprinting directly relates to transparency as it identifies how overlapping colors are considered in the printing process. By setting certain conditions in the Overprint options of the Attributes palette (Window>Attributes), you can prevent knockout, which is when a color appears opaque over a different color instead of transparent. See Figure 10–4. You can preview how changes to overprint options might occur when printed by choosing View>Overprint Preview.

It's really great that Illustrator provides options to preview how your work might appear in the printed format (for example, View>Overprint Preview and the Window>Flattener Preview), but don't let the preview be your only indicator. It's best to get an actual print proof of your work before going for the full run.

figure 10-4

The first option shows the overprint preview of how two colors overlap (one with transparency) with the Overprint fill deselected in the Attributes palette. Second option shows the look with Overprint fill selected.

Gradient Meshes

Depending on the type of printer used, gradients, gradient meshes and blends, particularly with transparency, could produce some unwanted results. Gradients and blends contain continuous tones of color, which are difficult for some printers to print, causing distinct bands of color rather than smooth transitions of color. Some general guidelines for successfully printing gradients and blends are:

- Create blends that change at least 50% between two or more process colors.
- Use short blends—blends that are longer than 7.5 inches can get a little sketchy when printed.
- Use lighter colors if banding occurs between blends.
- Use an appropriate line screen that supports at least 256 levels of gray.
- Adjust the Flatness setting if the curves of the gradient blend or mesh are quite complex. The Flatness setting (as opposed to the Flatten Transparency setting) is found in the Graphics option of the Print dialog box.
- If the gradient or mesh contains transparency, you can work with its resolution (quality of output) setting in the Object>Flatten Transparency options box.

Fonts

I've mentioned this before in Chapter 7 on typography, but it's important to point out again—when exporting and printing fonts you need the corresponding font files to accurately print the document, or, alternatively, embed the font or font family. In either case, it's always a good idea to check the copyright specifications for the fonts used, and if necessary get appropriate permissions for their usage. You can set font downloading specifications in the Graphics option of the Print dialog box.

Complex Paths

Artwork containing complex paths, particularly curved paths with many line segments, might receive a "limitcheck" error message when trying to print to PostScript printers with limited memory. You can adjust how the complex paths are rendered with the Flatness setting option in the Graphics section of the Print dialog box. A high setting (towards speed) results in the creation of a path with longer, fewer line segments, making it less accurate visually, but improving print performance.

ABOUT THE PRINT DIALOG BOX

The Print dialog box sets preferences for how you want your artwork to print. If you have different output options—maybe one specific for desktop printing and then another for creating a film negative—you can customize and save your settings in this box. See Figure 10–5.

To get to the Print dialog box, choose File>Print.

Note: I encourage you to actually open up the Print dialog box in Illustrator and follow along with my description of what's in this box. If you would like a document to play with while in the Print dialog box, choose a premade template file by going to File>New from Template and selecting a template in the Illustrator's Template folder.

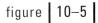

The Print dialog box—it looks scary, but is very useful for specifying and saving your print options.

At the top of the Print dialog box you can choose a Print Preset that you've saved previously, select default, or create a new custom preset. If you are printing the artwork directly to a desktop printer or creating an Adobe PostScript File (see the next note) you select the option under Printer. If your output device supports PostScript, you can also specify a PostScript Printer Description (PPD). Illustrator uses the information in the PPD file to determine which PostScript information to send to a PostScript printer when printing a document, such as fonts specifications, optimized screen frequencies, resolution, and color separations and management.

Note: If your desktop printer doesn't support PostScript, which only a few inkjet printers do, and you want to use some of the specifications that PostScript offers, like the ability to make color separations, you might consider purchasing Adobe Acrobat. In Illustrator you can print the file as an Adobe PostScript file from Acrobat and send the Acrobat file to the inkjet printer.

Let me briefly go through the print options found on the left-hand side of the dialog box, which include General, Setup, Marks & Bleeds, Output, Graphics, Color Management, Advanced, and Summary. Keep in mind that the settings in each option area vary depending on the type of printer selected. There is a ton of information in this one dialog box, so for further details on each of these options see also the Adobe Illustrator User Guide or go to Help>Illustrator Help>Printing Artwork>Using the Print dialog box.

General

The information in the General options is pretty straightforward. Here you specify page copies, media size, width, and orientation and options for printing layers.

Setup

Setup is where you define the printable areas of your artwork. You can set the printer to crop artwork to the artboard, artboard bounding box, or to predefined crop marks. To set up crop marks, you create a rectangle that defines the edges of where you would like the artwork cropped and then choose Object>Crop Area>Make. The crop marks are then indicated on the document and also in the Layers palette. See Figure 10–6 and Figure 10–7.

figure | 10-6 |

Crop marks are created on this template file provided by Illustrator.

You can also adjust the origin placement of the artwork to best fit on the printed page or film negative. If your artwork is larger than a single page you can determine how you would like the multiple pages to print by selecting a tiling option.

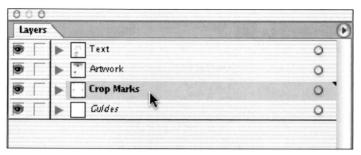

figure | 10-7 |

Crop marks are indicated in the Layers palette.

Marks and Bleeds

In this option you can set up marks and bleed specifications. If your document is to go through the color separation process, it's important to include printer marks on each separation page. These marks are needed for the printing device to accurately align the separations at press time (called *registration*) and verify correct color. See Figure 10–8 for an example of a file with printer marks indicated.

A bleed is defined as any work that spills over or "bleeds" outside of the print bounding box. Color, for example, that you want to bleed to the edge of a page requires a bleed setting. Consult your printer for how much of a bleed you should indicate on your document to ensure that the ink is still printed to the edge of the paper after it is trimmed. Figure 10–6 shows a template file of a business card whose color bleeds beyond the crop marks, ensuring an accurate look after trimming.

Output

The Output options let you control how you create color separations. You can choose which CMYK process and spot colors to separate and, if necessary, convert spot colors to their closest CMYK equivalent.

Graphics

Some of what was discussed in the "Getting into Details" section of this chapter is made clearer in the Graphics options, such as setting the flatness of complex paths and adjusting how fonts download.

figure | 10-8 |

Artwork with printer marks indicated.

Color Management

As discussed in Chapter 5, Using Color, color matching problems can occur when outputting your artwork from one kind of device to another, e.g., screen to print. One solution to alleviate these discrepancies is to use a color management system (CMS), which can translate color accurately between devices. To find out lots more about color management systems go to Help>Illustrator Help>Contents>Producing Consistent Color. If you are using a CMS for your document, you can specify additional color management settings in the Color Management options.

Advanced

Specifications for overprinting and transparencies can be found in the Advanced options, as well as the ability to print artwork as bitmaps (versus vectors) when printing to low-resolution printers.

Summary

Finally, you get to the Summary, which summarizes all the settings you indicated in the Print dialog box. Conveniently, it also provides warnings about any special things you should consider

figure | 10-9 |

The Summary box lets you view all your specifications, and gives you warnings about special print concerns.

regarding flattening, resolution of raster effects, spot and out-of-gamut colors. See Figure 10–9.

Once you've indicated all your print options—I know, there are a lot of them—you choose Print or Save to either print the document to the printer specified or save the document as an Adobe PostScript file if that was specified.

SUMMARY

There's a lot to think about when preparing your artwork for print, but like getting most things right, you learn to ask questions of the professionals in the industry. Additionally, as we began to cover in this chapter, it helps to know what options are available in a program such as Illustrator for streamlining the printing process. Finally, it doesn't hurt either to get a proof or two created of your final work and meticulously edited before running off the full print job.

in review

- 1. Describe halftone printing.
- 2. What's a PDF? What's so great about printing to the PDF format?
- 3. Screen ruling determines what about the halftone process?
- **4.** The resolution of a piece of artwork is usually how many times greater than its screen ruling?
- 5. What does Flatten Transparency do?
- **6.** What's overprinting?
- 7. What does the Flatness setting in the Graphics options of the Print dialog box do?
- 8. How do you create Crop Marks for your artwork?
- 9. What are Printer Marks for?
- 10. What's a bleed?

★ EXPLORING ON YOUR OWN

- Access the Help>Illustrator Help menu option. Under Contents read up on the
 following topics: Printing Artwork (have a cup coffee while reading through
 this lengthy but enlightening source of information), and Producing Color
 Separations, if you are serious into getting your full-color artwork successfully
 printed off a mechanical press.
- Find out if your desktop printer supports PostScript and if you have the ability to specify options for color separations in the Print dialog box. If so, try printing separations for a document that has been saved in the CMYK color document mode (File>Document Color Mode).
- 3. Open up the sample file called **printlogo.ai** in the **chap10_lessons/samples** folder. Take a look at the printer marks that have been specified around the artwork. Using the Help files, investigate what each of the printer marks represent. Also, open up the Print dialog box (File>Print) and see what print options have been saved for this particular document.
- 4. Awaken the detective inside you—call up a printing service (or search online) and inquire about what printing services they offer and what file specifications they require. Be specific with your questions; try out some of the terminology you learned in this chapter.

web publishing

charting your course

A good percentage of illustrative artwork is now being used in the digital format for web pages, multimedia presentations, DVD, and television. When designing graphics for the on-screen space, you must consider other issues than when designing graphics for print (see Chapter 10 for print publishing). Each new version of Illustrator is supplemented with options for saving and preparing artwork and design layouts for the growing digital medium, particularly online. In this chapter you consider the specifics when working with web graphics, such as format, size, and color. Also, special attention is given to image slicing, the SVG and SWF vector formats, and reusable graphics called symbols.

goals

In this chapter you will:

- Become an image optimization master.
- Get a handle on web file formats, including SVG and SWF.
- Get a handle on web image color and compression.
- Discover the reusability of symbols.
- Slice a web page.

OPTIMIZATION

When it comes to publishing graphics for the web, it's all about optimization.

Optimization, when referring to online artwork, is the process of preparing a functionally optimal graphic; it's an artful balancing act between the visual quality of an image and its quantitative file size. There are three interrelated areas to consider in the web optimization process: image format, image color, and image size—all of which directly relate to *image compression*, reducing an image's file size so it looks good on screen and downloads quickly over an Internet connection.

About Compression

An image's file size can be reduced by compression. If you compress a bitmap image too much—make it smaller in file size—you can lose visual quality. For instance, it might lose its *anti-aliased* effect, which is the smoothing of pixelated edges through a gradation of color, or it could *dither*, which is when colors that are lost during the compression are replaced by colors within the reduced palette (see Figure 11–1 and Figure 11–2).

figure 11-1

Anti-aliasing closeup creates a stairstep effect of color gradation. When viewed at a distance the edge of the object looks smoother.

figure | 11-2 |

Dithering attempts to simulate colors that are lost in the compression process.

There are two basic types of compression, lossy and lossless (sometimes called nonlossy). Lossy compression actually discards data to make a file smaller. Let's say you're optimizing a line of pixels into the JPEG format, which uses lossy compression. Ten of the pixels are white, followed by a gray pixel, and then five more white pixels. With lossy compression the computer reads the line as 16 white pixels; the gray pixel, being the odd one in the sampling area, is converted to white.

Lossless compression, on the other hand, does not eliminate detail or information but instead looks for more efficient ways to define the image, such as through the use of customized color tables. Ultimately, how compression is applied to images varies greatly, depending on the image's format, color, and size.

Image Format

Traditionally most web images are saved in the bitmap formats GIF, JPEG, or PNG. Bitmap images, as you probably recall from previous chapters, are reliant on resolution to determine their file size and quality. Because of this, bitmap images are generally larger in file size than vector graphics, and when it comes to "the web" that means a much bulkier download. Now, vector-based file formats—including SWF and SVG—have emerged that allow us to save and view graphics as streamlined paths, shapes, text, and effects in the online environment. Such graphics are scalable in

size and easier to download—a wonderful combination for experiencing more interactive and animated imagery on the web. Also when creating content for resource-limited hand-held devices, like what you see on that little screen on your personal data assistant (PDA).

The file format you choose for an optimized image has to do with the color, tonal, and graphic characteristics of the original image. In general, continuous-tone bitmap images (images with lots of shades of color) such as photographs are best compressed in the JPEG or PNG-24 formats. Illustrations or type with flat color or sharp edges and crisp detail, are best as GIF or PNG-8 files. Vector-based graphics or animations are either saved in the SVG or SWF (Macromedia Flash) formats. Below is a bulleted rundown of the characteristics of each web-based graphic format—all of which you can export from Illustrator. Further clarification of these characteristics is presented in the next two sections—Image Color and Image Size.

Graphic Interchange Format

The Graphic Interchange Format(GIF):

- Supports an 8-bit color depth. Bit depth determines the amount and range of color an image can contain: a 1-bit image supports 2 colors, black and white: an 8-bit image can support up to 256 colors. A customized 256-color palette is referred to as *indexed* color.
- Works best compressing solid areas of color, such as in line art, logos, or illustrations with type.
- Is supported by the most common web browsers, such as Internet Explorer, Netscape, AOL, and Safari.
- Can be animated.
- Traditionally uses a *lossless* compression method. Lossless compression is when no data is discarded during the file reduction process (see previous section on compression). You can save a GIF file multiple times without discarding data. However, because GIF files are 8-bit color, optimizing an original 24-bit image as an 8-bit GIF will generally degrade image quality.

Note: Illustrator and Photoshop also allow you to create a *lossy* version of a GIF file. The lossy GIF format includes small compression artifacts (similar to those in JPEG files) but yields significantly smaller files.

- Can be interlaced, so images download in multiple passes, or progressively. The downloading process of interlaced images is visible to the user, assuring the user that the download is in progress.
 Keep in mind, however, that interlacing increases file size.
- Includes dithering options (the process of mixing colors to approximate those not present in the image).
- Supports background transparency and background matting, which is the ability to blend the edges of an image with a Web page background color.

Joint Photographic Experts Group

The Joint Photographic Experts Group (JPEG) format:

- Supports 24-bit color (millions of colors) and preserves the broad range and subtle variations in brightness and hue found in photographs and other continuous-toned images (such as gradients).
- Is supported by the most common web browsers.
- Selectively discards data. Because it discards data, JPEG compression is referred to as *lossy*. The compression is set based on a range between 0 to 100% or 1 to 10. A higher percentage setting results in less data being discarded. The JPEG compression method tends to degrade sharp detail in an image, particularly in images containing type or vector art. Because of the nature of JPEG compression, you should always save JPEG files from the original image, not from a previously saved JPEG.
- Can be interlaced, so images download in multiple passes.
- Does not support transparency.
- Does not support animation.

Portable Network Graphic-8

The Portable Network Graphic (PNG-8) format:

• Uses 8-bit color. Like the GIF format, PNG-8 efficiently compresses solid areas of color while preserving sharp detail, such as that in line art, logos, or illustrations with type.

- Has not traditionally been supported by all browsers, but this is changing. It's advisable to test images saved in the PNG format on browser platforms you and your audience might be using to view web pages.
- Uses a lossless compression method, in which no data is discarded during compression. However, because PNG-8 files are 8-bit color, optimizing an original 24-bit image as a PNG-8 can degrade image quality. PNG-8 files use more advanced compression schemes than GIF, and can be 10 to 30% smaller than GIF files of the same image, depending on the image's color patterns.
- Can be indexed, like the GIF format, to a specific 256-color palette (such as adaptive or Web).
- Includes dithering options (the process of mixing colors to approximate those not present in the image).
- Also like the GIF format, supports background transparency and background matting (ability to blend the edges of the image with a web page background color).

Portable Network Graphic-24

The Portable Network Graphic (PNG-24) format:

- Supports 24-bit color. Like the JPEG format, PNG-24 preserves
 the broad range and subtle variations in brightness and hue found
 in photographs. Like the GIF and PNG-8 formats, PNG-24 preserves sharp detail, such as that in line art, logos, or illustrations
 with type.
- Uses the same lossless compression method as the PNG-8 format, in which no data is discarded. For that reason, PNG-24 files are usually larger than JPEG files of the same image.
- Like PNG-8, is not necessarily supported by all browsers.
- Supports background transparency and background matting (the ability to blend the edges of the image with a web page background color).
- Supports multilevel transparency, in which you can preserve up to 256 levels of transparency to blend the edges of an image smoothly with any background color. However, multilevel transparency is not supported by all browsers.

Small Web File

The Small Web File (SWF) format:

- Supports full-screen, scalable, vector graphics and animated objects.
- Is a Macromedia Flash format that must be viewed using Macromedia's Shockwave and/or Flash Player. Any web browser equipped with the Flash Player can view SWF formatted artwork. This player is free and can be downloaded from the Macromedia web site (www.macromedia.com).
- Is a cross-compatible file format for importing into Macromedia's Flash program.

Note: If you're a Macromedia Flash user, it's good to know that artwork on Illustrator layers can be converted to SWF frames for use in Flash.

- Supports the use of reusable symbol objects (see About Symbols section later in this chapter).
- Uses a sophisticated, lossless compression scheme.

Scalable Vector Graphic

Scalable Vector Graphic (SVG) format:

- Supports full-screen, scalable, vector graphics and animated objects.
- Is entirely XML-based, which is quite advantageous for web developers and designers. Extensible Markup Language (XML) is a flexible text standard that has become widely used as a means to exchange data on the web and elsewhere.
- Supports the use of JavaScript to create interactive events directly
 on your graphics, such as button rollover actions. This can be directly done in Illustrator using the SVG Interactivity palette
 (Window>SVG Interactivity).
- Requires the SVG plug-in, which is normally installed with Illustrator. To download the plug-in, if necessary, go to www.adobe.com/svg.
- Supports the use of reusable symbol objects (see About Symbols section).

Image Color

I've mentioned this before, but here I go again—photographs and artwork to be viewed on-screen, such as on a web page, must be saved in the RGB color mode. Why? To answer that question, visit Chapter 5: Using Color. To convert your artwork to the RGB color mode, choose File>Document Color Mode>RGB Color.

Color Reduction Algorithms

I know, the words "color reduction algorithms" sound so geeky, but that's what Adobe calls the methods used to generate a specific color table for an optimized image. You will get a better idea of how color tables work in Lesson 1. Color reduction algorithms apply only to the GIF and PNG-8 formats. Because these two formats support the 8-bit format, an image with 256 colors or less, the color tables determine how the computer calculates which of the 256 colors of the image to keep.

Note: If the original image already has less than 256 colors, you can adjust the maximum number of colors that are calculated, further reducing its size.

Each color reduction palette produces slightly different results, so it's a good idea to understand how each type works its magic. The descriptions for the following first five color tables I extracted directly from the Illustrator Help files. In addition are a few more color tables that you choose in the Save for Web settings for both the GIF and PNG-8 formats.

Perceptual Creates a custom color table by giving priority to colors for which the human eye has greater sensitivity.

Selective Creates a color table similar to the perceptual color table, but favoring broad areas of color and the preservation of web colors. This color table usually produces images with the greatest color integrity. Selective is the default option.

Adaptive Creates a custom color table by sampling colors from the spectrum appearing most commonly in the image. For example, an image with only the colors green and blue produces a color table made primarily of greens and blues. Most images concentrate colors in particular areas of the spectrum.

Web (also called the web-safe palette) Uses the standard 216-color color table common to the Windows and Mac OS

8-bit (256-color) palettes. This option ensures that no browser dither is applied to colors when the image is displayed using 8-bit color. Using the web palette can create larger files, and is recommended only when avoiding browser dither is a high priority.

Custom Preserves the current perceptual, selective, or adaptive color table as a fixed palette that does not update with changes to the image.

Black and White Builds a color table of only two colors—black and white.

Grayscale Creates a custom table of grays, black, and white.

Mac OS and Windows Builds an 8-bit palette, capable of displaying 256 colors, using the color table of the system you select.

Image Size

Size does matter. But wait . . . before I get into that, I need to discuss resolution again. Remember resolution, the somewhat illusive concept of measuring bitmap images in pixels per inch (ppi)? If you recall from Chapter 10, the resolution of artwork going to print varies depending on where it's being printed and on what kind of paper stock. For online display, an image's resolution is much easier to grasp (yippee!); it needs to match only a standard monitor's resolution, which is 72 ppi for Mac users and 96 ppi for Windows users.

Of course none of this resolution stuff applies to vector-based graphics, such as those saved in the SWF or SVG formats. As previously mentioned, these types of images are unique in their application to the web—they are inherently scalable and compact in size. So, keep in mind that much of what we are talking about in regards to file size and compression applies to bitmap (or rasterized) images. Until more web designers become hip to using the latest online vector graphic formats, much of the graphics we see on the web are in a bitmap format.

A bitmap image's size is directly related to its resolution. Image size can be referred to in two ways, and both impact optimization. First you have the actual *dimensions* of an image, for example 5 by 5 inches or 400 by 600 pixels. Then, you have an image's *file size*—its actual weight, per se, in digital bits. This is measured in bytes, kilobytes, megabytes, or gigabytes. A byte is 8 bits, a kilobyte (KB)

is 1,024 bytes, a megabyte (MB) is 1,024 kilobytes, and . . . you get the idea . . . a gigabyte (GB) is 1,024 megabytes. How big is too big for a web image? Well, it depends on how many images you have on a single web page, whether they are bitmap or vector based, dimensionally large or small.

I prefer to keep my web images, especially bulky bitmap ones to no more than 10 to 20 KBs each in file size. In fact, when building web pages, it's not uncommon that a client will ask that I keep the total file size of *everything* on a web page under 30 KB for those viewers with slow Internet connections. The ultimate, of course is to actually post your optimized images to the web and test how long it takes to download them on different Internet connections.

About Symbols

A symbol is a reusable object. You can use a symbol over and over again in an illustration, and unlike the traditional way of duplicating an object, it produces copies of a much smaller file size. This is great when developing graphics for the bandwidth-dependent, online environment. Imagine you need to create an illustration of a school of swimming minnows. It will eventually go to the web, so you want to keep the artwork's file size down. First, you draw a minnow. Then you save it as a symbol in Illustrator's Symbol palette or library (Window>Symbols). Once you save the symbol in the Library, you drag virtual copies, called *instances*, of the symbol to your artboard. Each instance is linked to the original symbol in the Library, resulting in an overall smaller file size.

You can redefine an original symbol, change its attributes, and the instances of that symbol in the artwork will also be redefined. You also can modify instances of a symbol, by using the Symbolism tools in the toolbox. Modifications might include scaling, rotating, moving, coloring, or duplicating instances (see Figure 11–3 and Figure 11–4). Options for the Symbolism tools are available when you double click on any of the Symbolism tools in the toolbox (see

figure | 11-3 |

The Symbolism tools available for modifying symbol instances.

figure | 11-4 |

Examples of modified instances of a fish symbol.

	S	ymbolism To	ols Options		
Diameter:	200 pt	Method:	User Define	d 🛟	(ok
Intensity:	10 🕨 🗆 Use	Pressure Pen			Cancel
Symbol Set D	ensity: 5)			
B .8'	3 3	♦ - ⊖ - 9	2		
Scrunch:	Average	\$ Screen:	Average	*	
Size:	Average	\$ Stain:	Average	*	
Spin:	Average	\$ Style:	Average	•	
	sh Size and Inten				

figure | 11-5 |

Options for the Symbolism tools.

Figure 11–5). You can also choose many premade symbols by going to Window>Symbol Libraries.

Using symbols is highly compatible with the SWF and SVG vector-based file formats. A really cool thing is that you can save an SWF file of Illustrator symbols and then import the file directly into Macromedia's Flash program. The symbols will appear in Flash's symbol library and can be placed on a single frame or multiple frames, ready to be animated. Check out Figure 11–6 and Figure 11–7.

figure | 11-6 |

Symbols located on individual layers in Illustrator.

figure | 11-7 |

Symbols imported from Illustrator to the Macromedia Flash program. The symbols appear in the Flash Library and their instances as individual frames on the Timeline.

Save for Web

Think of the Save for Web feature as a fitness program for your artwork. Depending on your image's body type (format), you can try out various fitness regimes (compression schemes) to produce the best looking and most lean image possible. A two or four-window view lets you compare and contrast an image's optimization settings next to the original file. See Figure 11–8.

As discussed in the section on image formats, there are some general guidelines for what kind of artwork to save as what kind of format—photos as JPEGs, line art as GIFS. However, the finesse to finding just the right size and quality comes from subtly adjusting the options in the Save for Web dialog box. A simple adjustment to the bit depth of a GIF image, for example, can reduce the file size of an image immensely, resulting in a much more efficient Internet download. There are a lot of options to choose from in the Save for Web dialog box, but don't let that overwhelm you. When

figure | 11-8 |

The Save for Web window is filled with options for optimizing your artwork, including four window viewing for contrasting different optimization settings.

you are ready to know what each option is all about, I suggest reviewing that information in the Illustrator Help files. For now, I recommend just getting down some of the basics and trusting your visual instincts when you start comparing and contrasting settings in the Save for Web dialog box—something you get the opportunity to do in the next lesson.

Lesson 1: Preparing Artwork for the Web

In this lesson, you optimally save for the web a basic black and white logo, originally in the TIFF format, using the settings in Illustrator's Save for Web dialog box.

Setting Up the File

- 1. In Illustrator, choose File>New. Name the file: **optimization1**; size: 640 × 480; color mode: RGB
- Choose File>Place and in the chap11_lessons/assets folder select the sbblogo.tif. Make sure Link is unchecked and choose Place.
- 3. Choose View>Pixel Preview to view the graphic as it might appear when rasterized into the GIF, JPEG, or PNG formats. Note the difference visually when Pixel Preview is turned off and on (see Figure 11–9 and Figure 11–10). It's good to turn on Pixel Preview when you want to control the precise placement, anti-aliasing, and size in the final rasterized object.

figure | 11-9 |

Example of artwork with Pixel Preview turned off. Notice the uneven edges of the shapes.

figure | 11-10 |

Example of artwork with Pixel Preview turned on. Antialiasing smooths the edges.

Setting the Save for Web Options

- **1.** Select the logo.
- **2.** Choose File>Save for Web.
- **3.** In the Save for Web window, select the 4-Up window tab in the upper left corner of the window. A four-window view of the logo becomes available (see Figure 11–11).
- **4.** Click on the first window to highlight it—a black bar appears around the image. Notice that the first window shows the

figure | 11-11 |

The 4-Up window of the Save for Web window.

original image at a file size of 116 K. Also, in the information area to the right of the dialog box, notice the Settings are set to Original.

- **5.** Click on the window to the right of the first window—a black frame appears around the image, and the settings for the image become available.
- **6.** Notice the viewing annotations at the bottom of the selected window—this provides valuable information about the optimizations settings for that particular window, including format type, size, estimated download time, and Color palette (table) specifics.
- 7. Notice also that the download time is determined by a specified Internet speed. By default this is set to the lowest possible modem speed, 28.8 Kbps (kilobytes per second). Adjust this setting to a more standard 56 Kbps modem speed—click on the arrow right above the selected window, and from the Preview Menu choose Size/Download Time (56.6 Kbps Modem/ISDN). See Figure 11–12.
- **8.** Under Settings, leave it [Unnamed]. Then select the following options (see Figure 11–13):
 - Optimized file format = GIF
 - Color reduction algorithm = Grayscale
 - Dither algorithm = No Dither

figure | 11-12 |

The Preview Menu.

figure | 11-13 |

Settings for the second window.

- Uncheck = Transparency
- Uncheck = Interlaced
- Lossy = 0
- Colors = Auto
- Matte = None
- Web Snap = 0%
- **9.** Notice the Color Table for the selected window—it indicates all the colors that are being used in the image; this is determined by the color reduction algorithm setting (Grayscale) and the maximum number of colors in the algorithm setting (Auto). The swatches with a diamond in the middle indicate

figure | 11-14 |

A color table indicates all the colors that are being used in an optimized image.

web-safe colors (see color reduction algorithm section for more info on the web-safe color table). The others are in the general RGB color space. Roll and hold (don't click) your cursor over a swatch to reveal the color's attributes (see Figure 11–14).

- **10.** Now, select the third window and adjust its settings differently:
 - Optimized file format = GIF
 - Color reduction algorithm = Web
 - Dither algorithm = Pattern
 - Uncheck = Transparency
 - Uncheck = Interlaced
 - Lossy = 0
 - Colors = Auto
 - Matte = None
 - Web Snap = 0%
- 11. In the Color Table for the selected window, notice each of the swatches has a diamond icon in the middle. These indicate that all of the colors are within the web-safe color palette. Roll and hold (don't click) your cursor over one of the swatches, and the hexadecimal color number is revealed.

- **12.** Now, select the fourth window and alter its settings:
 - Optimized file format = JPEG
 - Compression Quality = Maximum
 - Quality = 80
 - Download passes = Progressive
 - \bullet Blur = 0

Comparing and Contrasting Settings

- Okay, so take a close look at what each optimization setting has
 done to the artwork. Magnify each window with the Zoom tool
 (located to the left of the Save for Web window), and really examine the artifacts of each compression scheme. Use the Hand
 tool to move the magnified artwork around in a window.
- **2.** Now, double click on the Zoom tool icon to set the view of each window back to the original artwork size. Which version looks best to you?
- **3.** Compare and contrast the viewing annotations at the bottom of each window. What are the size differences? Is the one you visually like the best a reasonable size for web display (under 10K for example)?

Getting Picky

- 1. Okay, let's fine-tune a little bit and try to reduce the file size of the artwork even more without sacrificing quality. Select the second window (top right side).
- **2.** Change the color reduction algorithm to selective, and reduce the colors to 128. The file size is reduced, but it doesn't look any better. The gradient in the logo (the beam of light coming from the doorway) is banding and proving difficult to look good. This is because gradient blends are made up of many shades of color.
- **3.** Let's look at window four—the JPEG. The gradient in this version looks good, but the file size is too big.
- **4.** Select window four and change the JPEG compression quality to Medium. The file size is lower, but the artwork is not looking as good. Where's the happy medium?

- **5.** Type in a quality setting of 50 and hit Tab on the keyboard. That looks pretty good and the file size is more respectable.
- **6.** Select Save to save this version of the file. Name the file **web logo.jpg** and for format choose Images Only. Save the file in your **chap11_lessons** folder.

Note: If you don't want to save the file right away, choose Done rather than Save. This will close the Save for Web window, but maintain your optimization settings.

IMAGE SLICING

Image slicing is dividing up areas of an image or a complete web page layout into smaller independent files. If you are familiar with constructing web pages and working in HTML, you probably have a pretty good understanding of the benefits of slicing. If you are new to web page design and development this might seem like a somewhat crazy thing to do to your artwork, but slicing really is useful for the following reasons:

- Accurate HTML table placement.
- Creating independent files, each containing its own optimization settings.
- Creating smaller, independent files for faster download.
- Creating interactive effects, such as button rollovers.

Lesson 2: Slicing a Home Page

In this lesson, you revisit the web page layout created in Chapter 8: Object Composition. Using the Illustrator slice tool, you will slice and optimize areas of the layout for optimal web performance.

Setting Up the File

- 1. Open chap11L2.ai located in the chap11_lessons folder.
- **2.** Choose View>Actual Size and View>Pixel Preview.
- **3.** Select Shift_Tab on the keyboard to hide unneeded palettes.
- 4. Choose Window>Layers.

figure | 11-15 |

The web template and guides are used for accurate placement of slices.

- **5.** Hide all the layers, except the layer called **web_template**.
- **6.** Unhide the layer called **Guides.** You will use the template and guides to accurately place the slices you create in the next section (see Figure 11–15).

Making Slices

- **1.** Choose Object>Slice>Clip to Artboard, to keep your slices defined to the artboard area.
- **2.** Create a new layer in the Layers palette and name it **slices.** The slice areas that you define will be saved in this Layer.

Note: when you make slices you don't actually "cut up" your artwork, but create an overlay of divided areas that determine how the individual files will be created when saving the document.

- **3.** Select the Slice tool in the toolbox (see Figure 11–16).
- **4.** Position the point end of the slice tool in the upper left corner of the template and click and drag, defining a box around the green **header/ top navigation** area (see Figure 11–17). Notice a number for the slice is indicated in the upper left corner of the defined box. You can choose to show or hide the slice number or change its color in Illustrator's Preferences (Preferences>Smart Guides & Slices).
- **5.** Create another divided area with the slice tool, covering the pink **section title** area.

figure | 11-16 |

The Slice tool.

	header / top navigation	
logo	section title	· ·

figure | 11-17 |

Click and drag down to define a slice area

logo	header / top navigation
02 🖾	section title
03 🖾 05 🖾	
of Side buttons	
07 ⊠	
08 🖸	
03 🖾	
10 🖾	main copy
photo	
11 🖾	

figure | 11-18 |

Divide each section (content zone) with the Slice tool.

- **6.** Now, slice the main copy area the light orange area. Don't add the side buttons to this slice!
- **7.** Finally, define a slice for each side button, the photo area, and the orange spaces above and below the photo area. Use the guides to accurately align the slices—check out Figure 11–18 for reference.

Note: If you make a mistake—no worries—just edit undo and try your slice again. Each individual slice can also be deleted in the Layers palette.

- **8.** Choose View>Actual Size.
- **9.** Save the file **chap11L2_yourname.ai**, and place it in your lessons folder.
- **10.** Unhide all the layers to see how the slices overlay the actual web-page layout.
- 11. The top navigation bar needs to be further divided up. The title areas—overview, enrollment, preparation, and help—will eventually become linkable rollover buttons. You won't be creating the rollover actions or links in this lesson; however, you will prepare the slices for that next step in the process.
- **12.** Select the Slice tool again in the toolbox. You will create a new row of slices. Place the Slice tool in the upper left corner of the header where the textured navigation bar begins (see Figure 11–19 for help on finding this spot).
- **13.** Click and drag, creating a box along the textured area until you hit the vertical guide right before the word **overview**. See Figure 11–20.

figure | 11-19 |

Place the Slice tool in the upper left corner of the header where the textured navigation bar begins.

figure | 11-20 |

Create a new slice in the top navigation area.

figure | 11-21 |

Create six new slices, defined around each button title and the side margins of the navigation bar.

figure | 11-22 |

The Slice Select tool.

14. Continue creating divided areas around each of the button titles, similar to Figure 11–21. Keep the slices aligned across the document.

Note: Slicing always occurs in a gridlike pattern. Even if you don't define a slice in a particular area, Illustrator automatically creates one to maintain the table structure necessary for importing into an HTML page.

15. Save your file.

Note: If you need to select and modify individual slices, use the Slice Select tool, hidden under the Slice tool in the toolbox (see Figure 11–22). There are also options for individually selected slices at Object>Slice>Slice Options, where you can create a name for the sliced area, add a link (URL) or an Alt tag to it (see Figure 11–23).

figure | 11-23 |

The Slice options.

Slice Options	
Slice Type: Image	ОК
Name: over_button_slice	Cancel
URL:	
Target:	•
Message:	
Alt:	
Background	; None

figure | 11-24 |

Select the Slice Select

Optimizing and Saving the Slices

- 1. Choose File>Save for Web. Select the 2-Up Window option. On the left side is the original artwork, on the right will be the one you modify. Make sure the right side is selected (with a black frame around the window).
- **2.** Select the Slice Select tool located on the left side of the window (see Figure 11–24).
- **3.** Select slice number 1 in the second window—it will highlight in yellow. Adjust the optimization settings of this sliced area. I chose JPEG, Medium, quality 50 because of the many gradations of color in the header and logo graphics.

figure | 11-25 |

Optimization settings for one of the side buttons

- **4.** Next, select the first side button and adjust the optimization settings. I chose GIF, Adaptive, No Dither, and reduced the Colors to 8, producing a very efficient graphic (see Figure 11–25).
- **5.** Select each of the other slices and optimize them to your liking—balance the image file size with visual appeal.
- **6.** Turn off the slice view located in the tools area to the left of the window to view the final, optimized artwork (see Figure 11–26).
- **7.** Okay, the big finale. Choose Save in the Save for Web window.
- **8.** In the Save Optimized As box, enter the following (Figure 11–27):
 - Save As: mywebpage.jpg
 - Format: Images Only

figure | 11-26 |

Option to turn off slice visibility.

figure | 11-27 |

The Save Optimized As box.

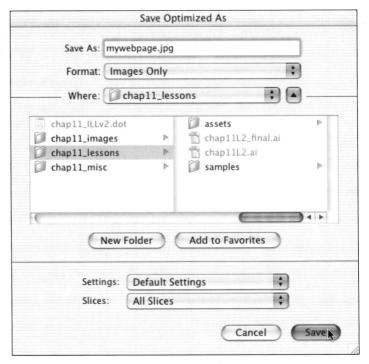

figure | 11-28 |

The Saving Files option in the Output Settings.

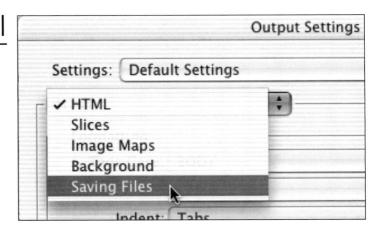

- Where: your lesson folder
- Settings: Default Setting
- Slices: All Slices

Wait, before you hit Save, I want to show you something. Under Settings choose Other, and in the Output Settings choose the Saving Files option (see Figure 11–28). In the Saving Files options make sure Put Images in Folder is checked

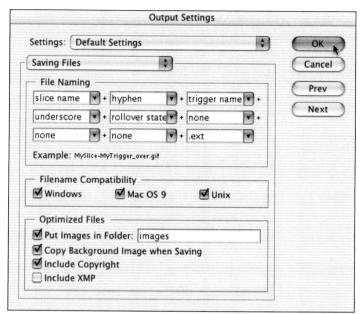

figure | 11-29 |

Check the Put Images in Folder option.

and that **images** is indicated for the folder name (see Figure 11–29). I realize there's a lot of other stuff in this dialog box to distract you, but that's stuff for later, when you really get into web design work using Illustrator. For now, please choose OK.

9. Now, hit Save to save the individually divided files to the images folder that you indicated above. The images folder will be located in your lessons folder. Minimize the Illustrator program and go find this folder. Open it up and amazingly all your sliced images are there! See Figure 11–30.

figure | 11-30 |

Find your saved images on your computer.

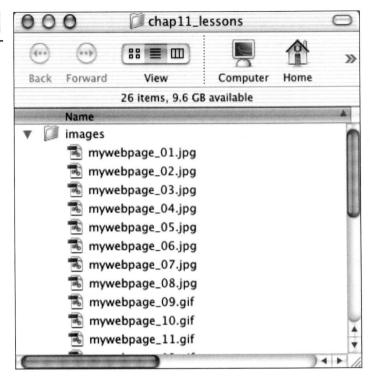

SUMMARY

Would you agree that Illustrator is more than just drawing tools? It's a resource for exploring the elements of drawing and design, and producing a finished product not only suitable for print, but for the World Wide Web.

in review

- 1. Describe image optimization.
- 2. Photographs are best saved in what format? What about graphics with gradient blends and meshes?
- 3. To view SVG and SWF formatted graphics, you must have what? And, where do you get it?
- 4. What image formats use color reduction algorithms and why?
- 5. How many bytes are in a kilobyte? Why is that important to know?
- 6. What's dithering?
- 7. How are symbols useful for web graphics?
- 8. Name three useful things about slicing images.
- 9. Where do sliced images go once you save them?
- 10. Name the five elements of visual design.

≠ EXPLORING ON YOUR OWN

- For more information about web graphics with Illustrator spend some time in the Help files-Help>Illustrator Help>Creating Web Graphics. Information not covered in this chapter that you might want to read-up on is in the section titled Creating Image Maps.
- 2. If you're a web designer the SVG and SWF file formats are definitely something to look into, if you haven't already. For more information on using SVG with Illustrator see Help>Illustrator Help>Creating Web Graphics>Creating Web Graphics with SVG, or visit the World Wide Web Consortium (W3C) site at http://www.w3.org/Graphics/SVG. For more information on the SWF format, visit the Macromedia site at www.macromedia.com.
- Using what you've learned thus far about the Save for Web window, decide which optimization settings are best for the example artwork, weblogo2.ai, located in the chap11_lessons/samples folder.

index

index

A	Angle box, 122
"Adam's Eye" (vector object	Animation, 20, 319, 321
construction), 53–62	Anti-aliased effect, 316, 328
step (a) setting up the file, 53–54	AOL, 318
step (b) importing a bitmap, 55–58	Appearance palette, 143, 144-47, 221,
step (c) exploring lines, 58–59	291, 292
step (d) filling a shape, 60	Apple Computer, 190
step (e) adding value and texture, 61	Arc tool, 80, 81
step (f) adding color, 62	Arc Warp envelope, 279
Add Anchor Point tool, 97	Architects, 20
Additive colors, 103	Area, typing in an, 178–81, 198–200
Adobe Acrobat, 307	Area type options, 199
Adobe Illustrator, 50, 318	Art Brush options, 151
description and capabilities of, 20-21	Art brush strokes, 140, 141
font formats, 190	Art Fundamentals, Theory and Practice
hand-on investigation of, 3	(Ocvirk and contributors),
Adobe Illustrator CS, 190, 192–93, 242	51, 235
Adobe Photoshop, 21, 50, 144, 242,	Artboard, 26, 27, 250
262–63, 318	Artistic Effects, 155, 157
Adobe Postscript, 189	Artistic menu, 144
Adobe PostScript file, 307, 311	Attributes palette, 304
Adobe Text Engine, 192	
Advanced options, 310	В
Adventures in Design: Making a Wine	Background matting, 319, 320
Label, 262–65	Background transparency, 319, 320
Adventures in Design: The Moods of	Balloons lesson in gradient meshes,
Color, 130–31	282–86
"ai" (native file extension for all	Basic lines and shapes, 72–81
Illustrator files), 32	Bevel join, 139, 140
Align palette, 164, 165, 244, 245, 257	Bezier curves, 82–83
Align tool, 246	Bezier, Pierre, 82–83
Analogous colors, 125	Biomorphic (organic) shapes, 70, 79
Analytic geometry, 52	Bitmap artwork importation, 240
Anchor points, 51, 82, 88	Bitmap images, 47–48, 144, 317, 323
to make a zigzag line, 85	Bitmap-only based formats, 50-51

Bitmaps, 21	Color, 51, 52, 62, 100–131
Black, 106	Adventures in Design: The Moods of
Black and white color table, 323	Color, 130–33
Bleeds, 309	applying color, 108–12
Blend options, 270, 275	color models, 103–7
Blend tool, 269–76	CMYK color model, 105–7
Blends in spatial illusions, 269–76	Grayscale color model, 103
BMP, 50	HSB color model, 105
Border layer, 18, 19	RGB and Web Safe RGB color
Bounding areas, 164, 184	model, 103–4, 115, 122
Bounding box, 76, 160, 170, 177,	color modes, 107–8
178, 309	color space or gamut, 102
Brightness, 105, 111	computer screen (RGB) gamut, 102
Brush libraries, 141	in design, 125–26
Brush styles, 148–52	Lesson 1: Vegas Lady, Part 1, 113–20
Brushes, 136, 140–42	step (a) setting up the file, 113
Brushes palette, 61, 141, 150, 162-64	step (b) applying color to fills,
Building a Web Page Design (lesson in	114–17
object composition), 249-59	step (c) applying color to
Bulge Warp envelope, 279	strokes, 118
Business cards, 175, 205, 206	step (d) saving colors, 118–20
Butt cap, 139	Lesson 2: Vegas Lady, Part 2, 120–25
Bytes, 323–24	step (a) setting up the file, 120–21
	step (b) applying a linear gradient,
C	121–23
Calligraphic brush strokes, 140, 141	step (c) applying a radial gradient,
Caps and joins, 138–40	124–25
Character menu, 188	printer color (CMYK) gamut, 102
Character palette, 186, 196, 203, 255	visual (human) gamut, 102
Character window, 16, 17	Color chords, 125–26
Chiseled graphic style, 152	Color insert, 136, 143
Circles lesson in blends, 272–73	Color management, 310
Clear appearance option, 292	Color management system (CMS), 310
"Click happy," 88	Color matching problems, 310
Click versus click and drag, 84	Color models, 103–7, 125
Clipping masks, 221–22	Color modes, 107–8, 156
Clipping Masks (lesson in object	Color of font, 211
composition), 232–35	Color palette, 62, 103, 104, 105, 106, 108,
Closed curved paths/shapes, 89–92	109, 114, 121, 122, 123, 126, 138
Closed lines, 70	Color Picker, 108, 109-11, 113, 114,
Closed paths, 184, 185	138, 252
Closed straight paths/shapes, 85–86	Color ramps, 121
Closing a path, 85–86	Color separation, 300, 307, 309
CMS. See Color management system	Color shading in spatial illusions, 268-69
CMYK color model, 105–7, 157,	Color space or gamut, 102
300, 309	Color spectrum, 125–26

Color stops, 121, 122, 123	Custom brush, 161–64
Color swatch books, 107	Custom color table, 323
Color table, 330, 331	
Color wheel, 125	D
Coloring layer, 113, 114	Dashed lines, 140
Combining and editing straight and	Default preferences, 36
curved paths, 92–98	Delete Anchor Point tool, 97
Combining paths and shapes, 216–22	Descartes, Renè, 52
Composition. See Object composition	Design
Compound paths and shapes versus	in color, 125–26
simple paths and shapes, 218–19	and composition, 235
Compound paths, shapes, and the	Design principles, 45, 51–52
Pathfinder palette, 218–21	Designing with type, 205–11
Compression settings, 50	font selection and size, 208-11
Computer graphics programs, 45, 46	contrast, 210–11
Computer screen (RGB) gamut, 102	proportional versus fixed pitch,
Connect-the-Dots Logo Tour, 4–20	208–9
step(a) importing the sketch, 507	serif versus sans serif, 209-10
step (b) drawing the background	spacing and alignment, 206-8
mountains, 7–10	justification, 208
step (c) drawing the hill, 10–11	leading or line spacing, 206–7
step (d) drawing the path, 11–12	line length, 206
step (e) drawing the house, 12–14	word and letter spacing, 207–8
step (f) drawing the light beam, 14–15	See also Typography
step (g) making smoke, 15–16	Desktop printers, 298–99
step (h) creating the title, 16	Digital format, 4, 20, 21
step (i) making the final border, 18	Digital graphics, 46
step (j) unveiling the final logo,	Digital printing presses, 299
18–20	Dim Images, 57
Content zones, 237–38	Dimensions of an image, 323
Context menus, 26, 30	Direct Selection tool, 95, 98, 224, 272,
Continuous tone color, 300	275, 278, 279
Continuous tone images, 48, 318, 319	Direction handles, 82, 88
Contrast in type design, 210–11	broken and unbroken, 93–94
Convert Anchor Point tool, 96–98	Direction lines, 82
Converting vector outlines to bitmapped	Direction of text, 211
pixels, 50	Direction points, 82
Cool hues, 126	Discover tour, 2–22
Coordinate systems, 52	Distort & Transform effects, 273
Copyright laws, 188, 189, 239, 265	Dithering, 316, 317, 319, 320
Corel Draw, 50	Divide option, 230
Creating Groups (lesson in object	Document title bar, 37
composition), 222–28	Dots per inch (dpi), 299, 302
Crop label, 231	Dotts per men (apr), 299, 302 Dotted lines option, 268
Crop marks, 307–9	Downloading, 318, 319, 326, 329
Curved paths, 86–89	dpi. See Dots per inch
Cui vea paulo, 00-07	api. see Dots per men

Dragging and dropping in importing, 242 Drawing lines and shapes, 66–99 basic lines and shapes, 72–81 step (1) setting up the stroke and fill attributes, 72 step (2) making geometric shapes, 72–76 step (3) transforming lines and shapes, 76–77 step (4) making rectilinear shapes, 78–79 step (5) making biomorphic shapes, 79 step (6) making irregular shapes and grouping them, 80–81	E Edit>Redo, 31 Edit>Undo, 9, 31, 32 Effect>Sketch, 143, 144, 155–57 Ellipse tool, 160 Ellipse tool options box, 194 Embedded artwork, 240 Encapsulated Postscript (EPS) format, 51, 242 Envelope Distort Command, 280–81 Envelopes in spatial illusions, 278–82 EPS. See Encapsulated Postscript (EPS) format Etch A Sketch, 82 Exclude option, 230 Expand option, 220
combining and editing straight and curved paths, 92–98 step (1) setting up the stroke and fill	Extensible Markup Language (XML), 321 Extrude & Bevel, 286, 287 Eyedropper tool, 116, 122, 171
attributes, 92 step (2) putting straight and curved lines together, 92–95 step (3) converting and editing straight and curved paths, 95–98 drawing precise straight and curved paths, 83–92 step (1) setting up the stroke and fill attributes, 83 step (2) straight lines, 83–85 step (3) making closed straight paths/shapes, 85–86 step (4) drawing curved paths, 86–89 step (5) drawing closed curved paths/shapes, 89–92 geometric, freeform, and precision drawing, 70–72 Pen tool, 82–83 simplicity of lines and shapes, 68–69	File size of an image, 323 Fill and color, 108 Fill color box, 8, 62, 92 Fill variations, 137, 142–44 Filter>Sketch, 143, 144 Fish Painting, 148–60 Fisheye Warp settings, 57 Fixed versus proportional pitch, 208–9 Flag Warp envelope, 279 Flash library, 326 Flattening, 303–4 Font embedding, 187, 188, 189 Font families, 188 Font formats, 189–92 Font selection and size, 208–11 Font technologies, 189 Fonts, 187–93 Fonts in the printing process, 305–6 Food brush library, 204
Drawing precise straight and curved paths, 83–92 Drawing space, 5 Drop Shadow line, 154 Dyad (complement or opposite), 125–26	Form of font, 211 Formatting type, 185–87, 202–3 Four-color processing, 107, 300 Free Distort effect, 293–94 Free Transform bounding box, 76, 84 Free Transform tool, 278

Freeform drawing, 70–72	H
Freeware, 188	Halftones, 300, 302
Fude art brush outline, 145	Hand tool, 37, 38, 40
•	Hands-on with Pathfinder (lesson in
G	object composition), 228-32
Gamut warnings, 111, 122	Headlines, 203–4
GBs. See Gigabytes	Helvetica font family, 188
General preferences, 34, 35	Hexadecimal, 104, 252, 253
Geometric, freeform, and precision	Hidden window palettes, 5, 9
drawing, 70–72	Horizontal type, 176, 182
Geometric shape tools, 218	HSB color model, 105
Geometric shapes, 69, 70, 71, 72–76	HTML, 333
Getting personal, 33–36	Hues, 105, 111, 125, 126
GIF. See Graphic interchange format	
Gigabytes (GBs), 324	I
Glass lesson in spatial illusions, 288–92	I-beam cursor, 177
Glyph variations, 190–91, 192	Illusions. See Spatial illusions
Gradient blends, 282	Illustrator interface, 25, 26
Gradient combinations, 125	default preferences, 36
Gradient fill box, 124	Macintosh version, 28
Gradient Mesh options box, 284	Illustrator viewing area, 5, 6
Gradient meshes in the printing	Image color in optimization, 322–23
process, 205	Image compression in optimization,
Gradient meshes in spatial illusions,	316–17
282–86	Image Effects palette, 152
Gradient palette, 108, 112, 121,	Image filters, 240
122, 124 Gradient slider, 122	Image formats in optimization, 317–21
	Image resolution, 47, 48, 49
Gradient tool, 108, 112, 124, 160 Graphic designers, 4, 20, 45	Image size in optimization, 323–26
Graphic designers, 4, 20, 45 Graphic disciplines, 20	Image slicing, 333–42
Graphic images, 20	Image types and formats, 50–51
Graphic interchange format (GIF), 50,	Importable file formats, 239–40
278, 318–19, 322	Imported text, 198–99
Graphic Style Libraries, 143	Importing files, 240–42, 252–55
Graphic style 3D effects library, 293	Indexed color, 318 Inkject printers, 298, 299
Graphic styles, 152–55, 186	Instances of symbols, 324, 325
Graphic Styles palette, 143, 154	Interactive media, 20
Grayscale color model, 103	Interface Highlights, 26–32
Grayscale color table, 323	step (a) identifying landmarks,
Grids, 244, 246–47	26–30
Group Selection tool, 216–18, 219, 224,	step (b) marking the territory,
272, 273	30–32
Grouping, 216–18	Internet Explorer, 318
Creating Groups, 222–28	Invitations, 175
Guides, 244, 247–48, 250–52	Irregular shapes, 70, 80–81

Irregular shapes, 70, 80-81

J	Lossy compression, 317, 318, 319
JavaScript, 321	lpi. See Lines per inch
Joins and caps, 138–40	LZW, 51
Joint photographic experts group (JPEG),	,
50, 278, 317, 319, 332	M
JPEG. See Joint photographic experts	Mac OS and Windows color table, 323
group	Macintosh, 190
Jumping in, 4	Macromedia Fireworks, 50
Justification, 208	Macromedia Flash, 21, 50, 318, 321,
justification, 200	325, 326
K	Macromedia Freehand, 50
KBs. See Kilobytes	Macromedia Freehand file, 242
Kerning, 207–8	Macromedia Shockwave, 321
Keyboard shortcuts, 26	Macromedia web site, 321
Kilobytes (KBs), 323–24	Magnification of the document window,
14400/100 (1420), 120 21	30, 37, 56
L	Marks and bleeds, 309
Laser printers, 298, 299	Masking, 221–22
Layer options, 55, 57	Masks
Layers palette, 5, 8, 54, 58, 62, 114, 115, 118,	clipping, 221–22
198, 220, 243, 244, 245, 258, 282	Clipping Masks (lesson in object
Layers visibility option, 54	composition), 232–35
Layout process, 236–48	MBs. See Megabytes
Leading or line spacing, 206–7	Mechanical printing presses, 299–300
Learning style, 3	Megabytes (MBs), 324
Legacy text, 192–93	Menu bar, 26, 28
Letter and word spacing, 207-8	Merge label, 231
License agreements, 188, 189	Mesh grid, 279–80
License free fonts (freeware), 188	Mesh tool, 280, 282, 284
Line length, 206	Metal printing plates, 299, 300
Line Segment tool, 78, 79, 80, 81	Microsoft Corporation, 190
Linear gradients, 112, 121–23	Minus Back label, 231
Lines, 51, 68–69	Miter join, 139
See also Drawing lines and shapes	Monochromatic, 125
Lines layer, 58	Moods of color, 130–31
Lines per inch (lpi), 302	Multilevel transparency, 320
Link palette, 240, 241	N
Linked artwork, 240	
Linked files, 276	Naming the layer, 56
Liquify tools spatial illusions, 276–78	Navigational features, 25
Locked layers, 241	Navigator palette, 37, 39–40
Locked window palettes, 5, 9	Nesting, 218
Locking layers, 57	Netscape, 318 New Brush icon, 162
Logo, Stratton Buyer Brokerage, 2–22	New Document dialog box, 26, 27
Logos, 175	New Swatch icon, 119
Lossless compression, 317, 318, 320, 321	Tien owaten reon, 117

Nonlossy compression, 317	step (d) adding the text, 255–57
Nonprintable area of a document, 27	step (e) adding the logo, 257–59
	Object>Group, 81
0	Object>Rasterize, 50
Object composition, 214–65	Object>Ungroup, 81
Adventures in Design: Making a Wine	Ocvirk, Otto G. and contributors, Art
Label, 262–65	Fundamentals, Theory and
combining paths and shapes, 216-22	Practice, 51, 235
clipping masks, 221–22	Offset printing, 299
compound paths, shapes, and the	One-point perspective, 268
Pathfinder palette, 218–21	Online artwork, 316
grouping, 216–18	See also Web publishing
defined, 235–36	Opacity, 14, 15, 142, 154, 290, 304
layout process, 236-48	Open lines, 70
step(a) starting with an idea, 237	Open paths, 182
step (b) making a mock-up, 237–38	OpenType font format, 190–92
step (c) gathering content, 238–40	Optical option, 207
step (d) assembling content, 240–48	Optimization, 316–27
step (e) fine-tuning, 248	Optimization settings, 339
Lesson 1: Creating Groups, 222–28	Organizing in importing, 243
step (a) setting up file, 222	Outline label, 231
step (b) grouping face parts, 222–24	Output Settings, 340, 341
step (c) examining groups in the	Overflow of text, 179, 180
Layers palette, 225	Overprinting, 304–5
step (d) creating a beanie cap,	
225–27	P
step (e) finishing the character, 228	Paintbrush tool, 15, 16, 33, 140, 141,
Lesson 2: Hands-on with Pathfinder,	142, 148
228–32	Palettes, 26, 28–29
step (a) setting up the file, 228–29	Pantone, 107
step (b) exploring the shape modes,	Paper for printing, 301, 302-3, 323
229–30	Paper proofs, 298, 304
step (c) exploring the Pathfinders,	Paragraph palette, 186, 203
230–32	Paste Remember Layers option, 258
Lesson 3: Clipping Masks, 232–35	Pasting in importing, 241–42
step (a) setting up the file, 232	Path, typing on a, 182–84, 194–97
step (b) creating the mask effect,	Path tool, 196, 197
232–33	Pathfinder options, 219, 220
step (c) creating another clipping mask, 233–35	Pathfinder palette, 218–21, 219, 220, 221
Lesson 4: Building a Web Page Design,	Hands-on with Pathfinder (lesson in
249–59	object composition), 228–32
step (a) setting up the file, 249–50	Paths and shapes, combining, 216–22
step (b) creating guides, 250–52	Paths blending lesson, 274–76
step (c) importing and creating	Paths/shapes layer, 60
content, 252–55	Pattern brush strokes 141

Patterns, 164–71	Preview Menu, 329, 330
applying and transforming patterns,	Preview mode, 286
169–71	Primary colors, 103
in fills, 143	Print dialog box, 306–11
irregular patterns, 166–69	Print proofs, 298, 304
regular patterns, 164–65	Print publishing, 296–312
PDA. See Personal data assistant	Print dialog box, 306–11
PDF. See Portable Document Format	advanced options, 310
Pen tool, 8, 9, 59, 67, 71, 218	color management, 310
with cross mark, 84	general, 307
in drawing lines and shapes, 82–83	marks and bleeds, 309
practice with, 94, 98	output, 309
Pencil tool, 59, 79	setup, 207–309
Perceptual color table, 322	summary, 310–11
Personal data assistant (PDA), 318	printing process, 301–6
Photographs, 48, 318, 322	fonts, 305–6
PICT, 51	gradient meshes, 205
Pixel Preview, 327, 328	overprinting, 304–5
Pixels, 21, 47, 48, 302	resolution and screen ruling, 299,
Pixels per inch (ppi), 47, 48, 299, 302, 323	302–3
Placing in importing, 240, 241	transparency, 303–4
PNG-8. See Portable network graphic-8	types of printing, 298–301
PNG-24. See Portable network graphic-24	desktop printers, 298–99
Point, typing at a, 176–78	digital printing presses, 299
Points (stroke weight measurement),	mechanical presses, 299–300
138, 139	Portable Document Format (PDF)
Portable Document Format (PDF) or	or PostScript file, 300–301
PostScript file, 189, 300–301	Print specialists, 301
Portable network graphic-8 (PNG-8),	Printer color (CMYK) gamut, 102
319–20, 322	Process colors, 107, 300
Portable network graphic-24	Projecting cap, 139
(PNG-24), 329	Proportional versus fixed pitch, 208–9
Ports, 180, 181	Pucker tool, 277
PostScript Printer Description (PPD), 307	1 401.01 10 01, 277
PostScript printers, 306	Q
PPD. See PostScript Printer Description	Quality (resolution), 21
ppi. See Pixels per inch	Quanty (1000101011), 21
Precise Cursors, 34, 35	R
Precision drawing, 70–72	Radial center, 124
Preferences, 16, 25	Radial gradients, 112, 124–25
default, 36	Raster Effects Settings, 155
deleting, 36	Rasterization, 50, 144, 157, 299
setting, 33–35	Recipe Card Lesson, 193–204
Preparing Artwork for the Web (lesson),	Rectangle tool, 18, 30, 31, 72, 164,
327–33	253, 254

Rectilinear shapes, 70, 78–79	Serif versus sans serif, 209–10
Reflect tool, 226, 227	Shadow effect, 136
Registration, 309	Shape modes, 229–30
Resolution, 323	Shapes, 51, 61, 68–69, 70
image, 47, 48, 49	See also Drawing lines and shapes
and screen ruling, 299, 302-3	Shells lesson in blends, 270–72
Reusable symbol objects, 321, 324	Show All Swatches option, 123
Revolve option, 286, 287, 290	Simple paths and shapes versus
RGB spectrum ramp, 122	compound paths and shapes,
RGB and Web Safe RGB color model,	218–19
103–4, 115, 122, 144, 155, 156,	Simplicity of lines and shapes, 68-69
157, 322	Size of font, 210
Rich Text Format (RTF), 198	Slice options, 338
Rotate option, 286, 287, 288	Slice Select tool, 337, 338
Rough Charcoal art brush, 150, 151	Slice tool, 333, 334, 335, 336
Rough Pastels, 157	Slicing a Home Page (lesson), 333–42
Roughen effect, 273, 274	Small web file (SWF), 51, 321, 325
Round cap, 139	Smart Guides, 244, 247–48, 252
Round join, 139, 140	Snap to Grid or Point, 244, 248
RTF. See Rich Text Format	Space, 268–69
Ruler Guides, 247	See also Spatial illusions
Rulers, 244, 245–46	Spacing and alignment of type, 206–8
	Spatial illusions, 266–95
\$	blends, 269-76
Safari, 318	circles lesson, 272–73
Sans serif, 209–10	paths blending lesson, 274–76
Saturation, 105, 111	shells lesson, 270–72
Save Optimized As box, 339, 340	envelopes, 278–82
Save for Web feature, 326–27, 329	Envelope Distort Command, 280–81
Save for Web options, 328–32	mesh grid, 279–80
Saving your work, 5	warp shape, 278–79
Scalable vector graphic (SVG), 21, 51,	gradient meshes, 282–86
321, 325	balloons lesson, 282–86
Scale tool, 170	graphic style 3D effects and the Free
Scaling text at a point, 180	Distort Effect, 293–94
Scatter brush strokes, 141, 158-59, 163	liquify tools, 276–78
Scissors tool, 195–96	making space, 268-69
Scratchboard, 27	3D effects, 286–92
Screen modes, 37, 41–42	glass lesson, 288–92
Screen ruling, 299, 302–3	Sparkle layer, 55
Scribble Effects, 144	Spiral tool, 234
Selection tool, 7, 16, 40, 58	Spot colors, 300
Selective color table, 322	Squeeze Warp envelope, 279
Sense of space, 134, 267	Star tool, 30, 31
See also Spatial illusions	Status bar, 26, 30, 37, 41, 42

Straight lines, 83–85	Transformation tools, 240
Straight paths, 83–84	Transparency palette, 142, 154, 291
Stroke, 134	Transparency in the printing process,
Stroke box, 13, 118	303–4, 319
Stroke caps, 139	Transparency slider, 142
Stroke color, 108, 118	Trim label, 231
Stroke joins, 139–40	TrueType font format, 190
Stroke option, 62	TRUMATCH, 107
Stroke palette, 138, 140, 231, 268	Tweak effect, 274
Stroke variations, 137, 138–42	
	Two-dimensional artwork, 267, 268
Stroke weight, 138	Type 1 font format, 190
Structure of font, 211	Type>Create Outlines, 185, 187
Sub-layers, 59	Type menu, 188
Subtract option, 230	Type on a Path options box, 183,
Subtractive colors, 106	184, 185
Survival techniques, 44–64	Type tool, 16, 17, 38, 176, 178, 184, 185
SVG. See Scalable vector graphic	Typographic layout and design, 21
SVG Interactivity palette, 321	Typography, 174–213
Swatch books, 133	fonts, 187–93
Swatch Libraries, 107	copyright laws, 188, 189
Swatch Options, 119, 120	defined, 187–88
Swatches palette, 8, 60, 108, 111, 113, 117,	formats, 189–92
118, 119, 120, 123, 124, 125, 138,	Lesson: Recipe Card, 193–204
143, 168, 169	step (a) setting up the file, 194
SWF. See Small web file	step (b) creating type on a path,
Symbol palette or library, 324	194–97
Symbolism tools, 324, 325	step (c) creating type in an area,
Symbols, 324–26	198–200
5y1110013, 324 20	step (d) wrapping text around an
T	object, 200–201
·	•
Template layers, 7	step (e) formatting the text, 202–3
Text bending around and ellipse, 182	step (f) adding a headline, 203–4
Texture, 51, 52, 61	step (g) adding the final look, 204
See also Value and texture	type tips, 184
Thick Pencil art brush, 150	typing in an area, 178–81, 198–200
Threaded text option, 180, 181, 182	typing on a path, 182–84, 194–97
3D effects in spatial illusion, 286–92	typing at a point, 176–78
TIFF, 50–51, 242, 278, 302, 303	See also Designing with type
Tiling option, 308	
Tissue Paper Collage, 145–46	U
Title layer, 16	Unhiding drawing layers, 18, 19
Tool tips, 28	Unhiding layers, 10, 54
Toolbox, 5, 26, 27–28, 29	
Tracking, 207	V
Transform handles, 177, 178	Value, 51, 52, 61
Transform palette window, 56	Value and texture, 134–73
1	5

Appearance palette, 144–47 fill variations, 137, 142–44 Lesson 1: The Fish Painting, 148–60 step (a) setting up the file, 148 step (b) applying brush styles,	View>Show Edges, 41 Viewing modes, 37, 40–41 Visual (human) gamut, 102 Visual quality and resolution, 48
148–52	W
step (c) applying graphic styles,	Warm hues, 126
152–55	Warp options, 57, 279
step (d) applying an effect, 155–57	Warp shape, 278–79
step (e) applying a scatter brush,	Web-based graphic formats, 318–21
158–59	Web browsers, 318, 319
step (f) making water and	Web page design, Building a Web Page
waves, 160	Design (lesson in object
Lesson 2: Playing with Custom Brush	composition), 249-59
Styles and Patterns, 161–71	Web publishing, 314–43
step (a) setting up the file, 161	image slicing, 333–42
step (b) creating a custom brush,	Lesson 1: Preparing Artwork for the
161–64	Web, 327–33
step (c) defining a regular pattern,	step (a) setting up the file, 327–28
164–65	step (b) setting the Save for Web
step (d) creating an irregular	options, 328–32
pattern, 166–69	step (c) comparing and contrasting
step (e) applying and transforming	settings, 332
patterns, 169–71	step (d) fine-tuning, 332–33
stroke variations, 137, 138–42 brushes, 140–42	Lesson 2: Slicing a Home Page, 333–42
caps and joins, 138–40	
texture defined, 136–37	step (a) setting up the file, 333–34 step (b) making slices, 334–38
value defined, 136	step (b) making siless, 334–36 step (c) optimizing and saving the
Vanishing points, 268	slices, 338–42
Vector- and bitmat-based formats,	optimization, 316–27
51, 317	image color, 322–23
Vector artwork importation, 240	image compression, 316–17
Vector graphics, 47, 49, 144, 321, 323	image formats, 317–21
Vector illustration, 52, 82	image size, 323–26
Vector object construction, 53-62, 221	Save for Web feature,
Vector technology, 45	326–27, 329
Vectors, 20–21	symbols, 324–26
Vegas Lady. See Color	Web-safe palette, 322–23
Vertical Align Center, 164, 165	Web Safe RGB color model, 103–4, 111,
Vertical type, 176, 182	115, 122
View>Actual Size, 37	Weight of font, 210
View>Fit in Window, 37	White, 103
View>Hide Edges, 41	Window>Brushes, 15, 16
View>Outline, 41	Window>Transparency, 15
View>Preview, 41	Windows, 190

Word and letter spacing, 207–8 Workflow techniques, 20 World Wide Web, 20 Wrapping text around an object, 200–201 X

x, y, and z axes, 286, 288 XML. *See* Extensible Markup Language

Z

Zoom tools, 30, 37, 38, 41, 58, 124